2017

D0079938

CLOSE-UP
PHOTOGRAPHY

DISCARDED

From Nashville Public Library

Property of
The Public Library of Nashville and Davidson County
225 Polk Ave., Nashville, Tn. 37203

DISCARDED
From Nashville Public Library

CLOSE-UP PHOTOGRAPHY

ALAN R. CONSTANT

Focal Press

Boston Oxford Auckland Johannesburg Melbourne New Delhi

Focal Press is an imprint of Butterworth–Heinemann.
Copyright © 2000 Butterworth–Heinemann

 A member of the Reed Elsevier group

All rights reserved.

All trademarks found herein are property of their respective owners.

No part of this publication may be reproduced, stored in a retrieval system, or transmitted in any form or by any means, electronic, mechanical, photocopying, recording, or otherwise, without the prior written permission of the publisher.

∞ Recognizing the importance of preserving what has been written, Butterworth–Heinemann prints its books on acid-free paper whenever possible.

AMERICAN FORESTS
GLOBAL RELEAF 2000
Butterworth–Heinemann supports the efforts of American Forests and the Global ReLeaf program in its campaign for the betterment of trees, forests, and our environment.

Library of Congress Cataloging-in-Publication Data
Constant, Alan R. (Alan Robert), 1960–
 Close-up photography / Alan R. Constant.
 p. cm.
 Includes bibliographical references and index.
 ISBN 0-240-80380-9 (pbk. : alk. paper)
 1. Photography, Close-up--Amateurs' manuals. 2. Macrophotography--Amateurs'
 manuals. 3. Photography, Table-top--Amateurs' manuals. I. Title.
 TR683.C65 1999
 778.3'24 21--dc21 99-030127
 CIP

British Library Cataloguing-in-Publication Data
A catalogue record for this book is available from the British Library.

The publisher offers special discounts on bulk orders of this book.
For information, please contact:
Manager of Special Sales
Butterworth-Heinemann
225 Wildwood Avenue
Woburn, MA 01801-2041
Tel: 781-904-2500
Fax: 781-904-2620

For information on all Butterworth-Heinemann publications available, contact our World Wide Web home page at: http://www.focalpress.com

10 9 8 7 6 5 4 3 2 1

Printed in China

DEDICATION

To my father,
John T. (Jack) Constant (1927–1998),
who bought me my first camera for Christmas
when I was ten and introduced me to photography,

and

Maria Zorn, A.P.S.A., A.N.E.C.,
whose instruction and enthusiasm for nature
and photography awoke a keen interest for both
in me and inspired me to pursue my investigation of
this fascinating miniature world.

CONTENTS

Preface

I have been involved with photography since 1970 and with close-up and nature photography since the late 1980s. They are exciting fields, and both use very similar photographic methods and techniques—many identical.

My real beginning with close-up photography took place sometime around 1972 when my father purchased a set of extension tubes for a camera he had. We knew absolutely nothing about using them. The manufacturer's instructions that came with the tubes were hopeless, filled with meaningless charts, tables, and calculations. You had to know how to use the tubes to make any sense out of the instructions.

At the time, the only books on close-up photography in the local library were just picture books with little information on how they were taken. TTL metering systems (technical terms found throughout are defined in the Glossary) were in their infancy and nobody even dreamt of a TTL flash, which have revolutionized the field and made it relatively easy for the average hobbyist.

In 1987, Mohawk College was offering a new nature photography course, and *I finally learned how to use extension tubes* (plus a lot more, of course). My close-up work improved dramatically over the ten-week course—in fact, it was much better than most of my other work!

About a year later, I jumped at the chance to take a new course on macro photography that the college was starting. I was introduced to more about various photographic equipment, methods of magnification, exposure compensation techniques, and creative work.

Wanting to expand on these basics, I joined a local photo club and began attending nature photography workshops and seminars. I also searched out books and magazine articles.

I was unable, however, to find any comprehensive books that really covered the field well, were understandable for someone at my level (i.e., amateur), *and* were up-to-date.

A couple of books were well over my head, being written for scientists who required absolute precision in their photography. Many only touched briefly on various aspects of close-up work. And more than a few told me such things as you can take wonderful close-ups using a bellows, but contained absolutely nothing about how to *use* a bellows!

I found two excellent books by John Shaw that proved most helpful (see Bibliography), but they were dedicated specifically to nature photography in the field. Unfortunately, I also wanted to photograph my model airplanes, coins, stamps, and

all sorts of other things, and nature photography books do not have information on tabletop photography, polarized light photography, using floodlights, artificial backgrounds, or many other topics, since there are no equivalents for them in the field. I had to learn many of these methods and techniques through trial and error.

As I listened to guest speakers and other photographers in the club and to the questions asked, and as I continued my reading, I learned that there is a lot of misinformation and just plain *wrong* information about close-up photography still going around. Like many an urban legend or rumor that has long been entirely disproved, the misinformation about close-up photography refuses to die.

This book began as class notes for a night school class I taught and I decided to expand it into a basic illustrated text for the beginner-through-advanced amateur, one that would contain enough information to get started and keep on going on a wide variety of subjects, rather than being limited to one specific area.

I wanted my book to be easy to read and follow. I also wanted it to cover the many areas that were difficult to find accurate or useful information on—including a lot of "*things nobody ever told me*" that cost me a lot of time and film to learn. And I hope to correct some of the misinformation on close-up photography that is still circulating.

All the mistakes, goofs, gaffs, and dumb things that I mention you can do if you're not careful, I have done myself at one time or another (except for the dumb things to do in photographing animals)—and some I still do. That's how we learn.

I am assuming that the reader has a very basic understanding of photography, or at least knows the various controls on the camera, where to locate them, and what most of the normal accessories and lenses look like. When I started, things like shutter and film speed dials, aperture rings, light meters, timers, and depth-of-field preview buttons were pretty much the same on most 35mm SLR cameras. But now electronic cameras have replaced all these with buttons and digital readouts that could be almost anywhere on the camera, so it is up to you to learn where they are and how to operate them on your own equipment.

I hope I have been successful in accomplishing what I set out to do, and I hope the reader finds it useful.

Alan R. Constant
January 1999

PART I

TECHNICAL

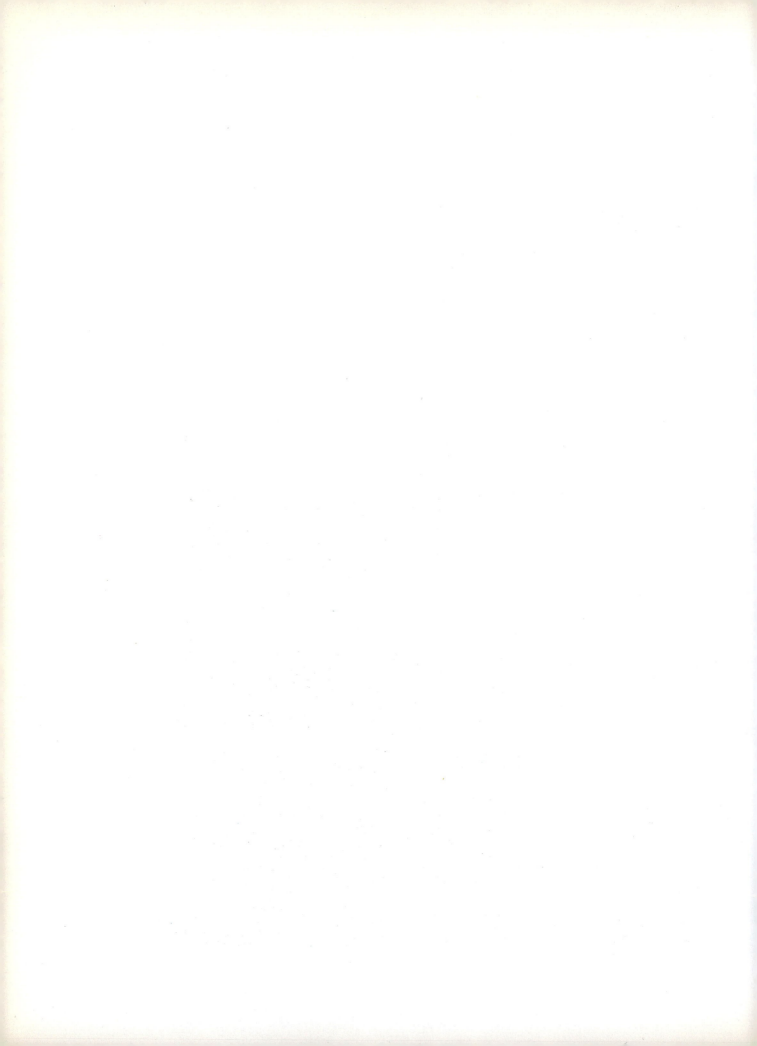

CHAPTER 1

INTRODUCTION

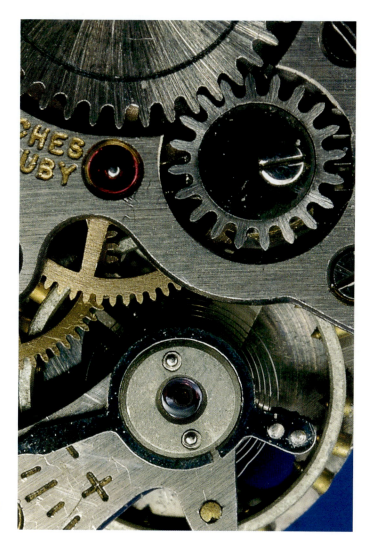

FIGURE 1.1 Windup watches make terrific subjects for close-up photography—if you can still find one!

With a camera we can record images of the world around us as it actually appears. If we add some specialized equipment, we can see things that are too small or too fast for us to see with unaided eyes. We can also create spectacular images and art either by recording small segments of reality or twisting, distorting, and manipulating reality within the camera, darkroom, or with digital imaging.

For the majority of everyday subjects, you can purchase a range of different lenses that will bring them closer or give a wider or narrower field of view. Unfortunately, you are limited in how small a subject may be photographed with unaided ordinary lenses. They simply will not focus close enough to fill the frame with a subject smaller than about eight to ten times the size of the negative.

This is quite unacceptable if one wants to photograph anything much smaller than about one-third the size of a page of writing paper. The image on film would be so small and lacking in detail as to be, in most cases, quite useless.

When asked, even many photographers will instantly jump to the conclusion that those fantastic close-ups of insects or the inner workings of a wristwatch must have been done with very sophisticated (and consequently very expensive) equipment. That's not always true. Many photographers may already own most of the equipment needed and can be on their way to exploring the close-up world with an investment in additional equipment of little more than the cost of two or three rolls of film!

There are three basic ranges of close-up photography:

CLOSE-UP RANGE—The size of the image on film ranges from about 1/10 life size to life size.

MACRO RANGE—The size of the image on film ranges from about life size to roughly twenty times life size.

MICRO RANGE—The size of the image on film is greater than twenty times life size. To obtain magnifications in this range requires a good microscope, which will only be touched upon in this text.

Although "Macro" and "Close-up" technically refer to image sizes in specific ranges, they are often used interchangeably.

All but a few lenses specifically designed to work in the close-up and macro ranges require some form of additional equipment to allow them to focus within these ranges. The equipment required depends mainly upon how small the subject to be photographed is and, to a great extent, upon the quality of the results desired.

Photographing the eyes of a spider is going to require more specialized equipment than is required for photographing an entire butterfly. If you want to take a photograph at twice life size with sharpness from edge to edge, you require different equipment and methods than if you only want a good twice life-size image.

When you delve into this world, you not only magnify the subject, you also magnify every little problem. You may even discover a few you never knew existed, for their effects are so insignificant in general photography that they are ignored.

It can often take an hour or more to get a single shot just right, and many times the working conditions are less than ideal or comfortable. Nature photography, for example, can be downright wet, dirty, and frustrating as you lay on the cold, damp ground while waiting for the wind to die down long enough to get your shot,

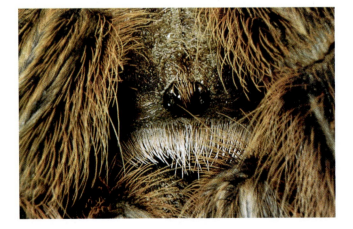

FIGURE 1.2 Eyes of a Chilean Red tarantula.

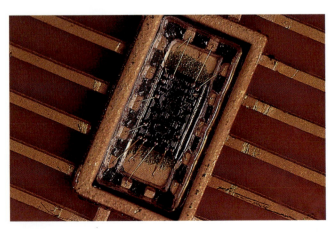

FIGURE 1.3 Wiring details of an integrated circuit board.

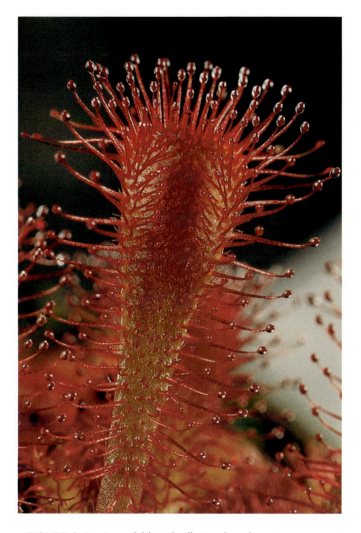

FIGURE 1.4 Beautiful but deadly Sundew plant. Insects become entrapped in the glue-tipped tentacles and are consumed for nourishment by enzymes in the leaf.

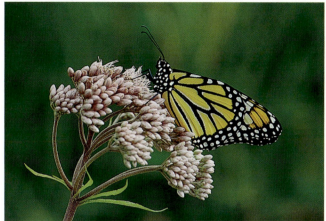

FIGURE 1.5 Monarch butterfly on Joe Pye weed.

meanwhile being eaten by hordes of hungry mosquitoes, black flies, and horse flies.

Getting the camera into position in some cases may be quite a chore, and looking through the viewfinder can require the skills of a circus contortionist.

Many times the circumstances make it impossible to get the shot the way you'd like, and you must settle for a compromise or even no shot at all. At other times, trying to get the shot can be very frustrating and any attempts seem futile, but the effort is all worth the while when things work and you get a great shot.

Close-up photography is most definitely *not* for the impatient or the "point and shoot" photographer. You have to be dedicated and willing to spend a lot of time setting up and composing each shot. Close-up photography requires a lot of concentration and thought to be successful. The best results are accomplished when you work alone or with someone who is as keenly interested in the field as you are. You cannot be creative when all you hear is "Hurry up! Why do you need a half an hour to take a picture? It only takes me ten seconds!" Creativity goes right out the window and, at best, all you get are "record shots."

Close-up technique is not going to be learned by just reading a book or practicing for a weekend or two. It takes a lot of time, and a lot of film will be wasted—although if you learn from your mistakes, it isn't really a waste.

Close-up photography is a very finely balanced equilibrium system, and everything concerning the technical end involves a "give and take" much more so than any other type of photography. Compensating for one problem can create several others, so the photographer must achieve a balance of all the factors in order to get a properly exposed photo that is pleasing to look at.

This book is divided into two distinct sections. The first part is technically oriented and covers the theoretical aspects of getting a properly exposed image at the desired magnification, as well as the required equipment and methods.

The second part deals with more practical and creative close-up photography. I am a firm believer in the principle that one must have a basic understanding of the technical before one can be creative. All the creative genius in the world is of little use if a photographer is unable to get the proper exposure, focus, or to use depth of field effectively.

The technical side of close-up photography includes some very complex mathematical formulas as well as some theoretical physics, which may frighten or confuse many. But much of it is helpful to understanding what goes on when we take a photograph if it is explained simply, as I hope I have done. When we know why something happens or how it works, we are better prepared to deal with any unusual situations or problems that may arise than we are by blindly following a chart, table, rule of thumb, "what the camera meter says," or bracketing.

Often these formulae will only be of interest to someone with older equipment (i.e., no built-in through-the-lens light meter) or someone who wants to do a lot of macro work with a non-TTL flash or by using multiple flash units. For the type of photography most will be doing, the simple methods often work well enough. If you need scientific accuracy and precision, then this is not the book for you.

There is a lot to be learned and much of it is not difficult. Just be patient and take your time. *Don't try to do too many things at once.* I also suggest you read the areas of the text concerning what you are trying to do several times slowly so all the information is clear. I know that I'm guilty of reading things over, thinking that I've gotten things down, and afterwards ending up in a mess because I'd misread, misunderstood, or completely missed something in the instructions.

With close-up photography, you don't have to travel to some exotic location, await ideal weather conditions, or attend special events to find subjects. Nor does it require a large studio with wall-sized backgrounds and stadium floodlighting. There are hundreds of possibilities within your own home and yard, and a lot can be done on a kitchen table or workbench. It is quite enjoyable when everything turns out right, and people always seem to be interested in looking at close-up photos, no matter what the subject.

MEASUREMENTS

The measurements used throughout the book may be somewhat confusing as I use both metric and English units, which are also sometimes mixed.

All you need to know for the purposes of conversion in this book are the following:

English system: the basic unit is the inch. There are twelve inches in a foot, three feet in a yard, and 5280 feet in a mile.

Metric system: the basic unit is the millimeter. There are 10 millimeters in a centimeter, 100 centimeters in a meter, and 1000 meters in a kilometer.

CONVERSIONS

1 inch = 25.4 millimeters
1 foot = 30.48 centimeters
1 kilometer = .6 miles

LEARNING STAGES

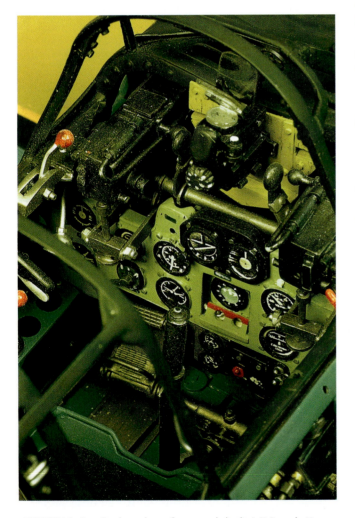

FIGURE 1.6 Cockpit shot of a scratch built 1/12-scale Zero fighter.

In the early learning stages it is very important to keep good notes on what you have done. Otherwise, by the

	Roll #7	June 23, 1997			
			Kodachrome 64		
1	Daisy	200mm	75mm ext.	f5.6 1/60	
2	Daisy	200mm	75mm ext.	f5.6 1/30	+1 stop
3	Daisy	200mm	75mm ext.	f5.6 1/125	-1 stop
4	Daisy (close)	50mm reversed on 100mm ext.		f8 1/4	

FIGURE 1.7 Keep notes for each roll of film. Record data such as subject, equipment used, and exposure.

time the film is processed, you will have forgotten most of the details.

I carried a notebook in which I recorded for each roll of film the frame number, equipment setup used (lens, extension, magnification, filters, exposure settings, lighting setup, etc.), and a description of the shot itself. I matched this data to the picture to determine not only what worked well, but also what didn't work. I could then fine-tune my techniques and methods. When more proficient, you will only need to keep notes on new methods and experiments.

An excellent method someone I met used was to carry a mini-cassette recorder with a voice-operated microphone. He described everything he did as he made the shot. It was less trouble than paper and more useful, as he could make lengthy comments without all the bother of stopping to write it down.

It may also help to draw a sketch or sketches of any setups in your notes. By the time the film is processed, you will probably have forgotten where you placed everything.

Bracketing exposures is also essential during the learning phase. It is very easy to make exposure calculation

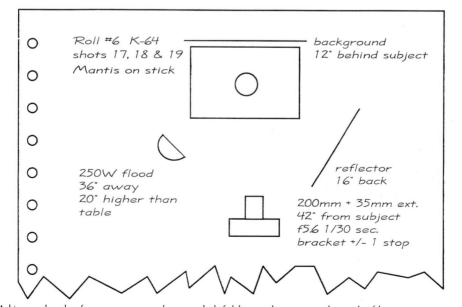

FIGURE 1.8 Making a sketch of your setup can be most helpful later when you evaluate the film or want to reproduce the setup.

errors, and in many cases it may be very difficult to get an accurate meter reading even with TTL or spot metering. You might also find that you prefer the appearance of a shot that is over- or underexposed by 1/2 to 1 stop than one that is dead on. With experience, you will learn when to increase or decrease exposure to get the results you want, and when you may need to bracket the exposures.

I also recommend that beginners avoid both flash and active subjects until they feel comfortable with their basic skills. Having to deal with flash pitfalls and problems (especially non-TTL flashes), or insects that won't stay still, when you are just starting out will likely result in a very full garbage can—and endless frustrations—that can quickly turn someone right off the subject.

Beginning photographers must also develop their own methods, techniques, and tastes—most importantly, their own style. For this reason, I discourage beginners from entering images in photo club competitions in the early stages. Too often beginners assume that the judges are really experts on all aspects of photography, and they try to please them rather than themselves, thus becoming confused by many vastly differing (and frequently opposing) opinions as to what is good and what is not.

If you do something one way and someone tells you that you're doing it wrong, try it their way, compare the results, then do it the way that gives you the results *you* like best. In photography there are many ways to do things, and what works for one person will not work for another. In some instances the method may defy all logic and reason, but if it works then do it. (This advice even goes for what I say in this book.)

CHAPTER 2

THE CAMERA

Although all cameras are basically the same, not all can be used for close-up or macro photography, and of those that can, some are better suited than others.

To do any serious close-up work (especially high magnification), you *must* have a Single Lens Reflex (SLR) camera or a view camera where you are actually looking through the picture-taking lens when composing and focusing. The problems encountered with parallax, framing, focusing, and depth of field when you get really close simply make any other type of camera (like a rangefinder) impractical if not nearly impossible to use. You might be able to get close-up photos, but it will be difficult, and they most certainly will not be as good.

An SLR is much easier to work with than a view camera, particularly when working with moving subjects, working in tight areas, or using creative techniques like deliberate vignetting.

There are currently a very wide range of SLRs on the market, with the 35mm format being the most common, least expensive, and easiest to use—although even many of those available may not be suitable for close-up work for other reasons.

Some camera systems offer a full range of macro equipment, from simple close-up lenses and macro lenses to bellows and specialized high-magnification macro lenses. Others offer very little, perhaps a macro lens or two, and some offer nothing at all. Third-party manufacturers may offer accessories for some brands, and it may be impossible to use anything but close-up lenses or lens stacking with others.

If you haven't bought a camera yet, it might be a good idea to do some research. Think about exactly what kind of close-up work you want to do, how often you will do it, and how critical you are about the results, and then see what cameras are most suitable based on these factors.

Determine what accessories you want (or may eventually want) and *make sure they are available for the camera selected*. It may be best to contact the manufacturers themselves for detailed information, as many times the stores do not seem to have it readily available. I have found that often all the store has are price lists, which only have part numbers and vague or ambiguous descriptions of the items without any references regarding which cameras they would or would not fit.

Unless scientific precision is a necessity—or money is no object—it is not necessary to have the top-of-the-line equipment. All major brands are pretty comparable in terms of the image quality produced (at least as far as most photographers' requirements go). The only *real* advantage some makes have is that they offer special lenses and gadgets that make some things easier to do. For the occasional user,

the extra convenience of these items is generally not worth the additional investment.

There are a few things to look for when choosing a camera aside from the availability of accessories and equipment. Nowadays, it is hard to find a camera that isn't fully automated. This presents no problem as long as it has manual overrides of the aperture, shutter speed, and focusing controls. *In close-up work, you must have absolute control over exposure and focusing.* If the camera does *not* have these overrides, don't even consider it.

A depth of field preview button on the camera is *essential*. Creativity is severely impaired without one, as a lot of potentially good shots are ruined by too much or too little depth of field. Things you didn't see in the background suddenly become very clear and distracting when you stop down too much. Things you wished were sharp are unrecognizable blurs because you didn't stop down enough. Many world-class photographers in close-up and nature work consider cameras without the preview button to be worthless junk for these purposes.

A light meter is also a necessity. A built-in through-the-lens (TTL) meter is the easiest to use, and most cameras nowadays are equipped with them. There are many instances in close-up work where determining exposure is more guesswork than anything else. If you are buying a new (or used) camera, be sure it has TTL metering (it doesn't necessarily have to have auto exposure modes).

If it has an auto-exposure system, there must also be an override control that allows you to reset the ASA setting or offset the exposure (exposure compensation) if desired. The system should also have a *stopped-down metering* capability, which allows you to meter the scene with the aperture closed down. You set the aperture desired, stop down the lens, and it will determine the correct shutter speed for that aperture. If your camera has a digital readout, it will display the speed. On many older cameras that have the needle display, you adjust the shutter speed until the needle is within a small square or other indicator on the screen.

Stopped-down metering saves a lot of fooling around, and it allows you to use lenses with fixed or manual apertures. When using extensions for magnification, many cameras lose the meter coupling with the lens, and stopped-down metering is the *only* way the internal meter can be used.

Interchangeable lens capability is imperative unless you only plan to use close-up lenses or lens stacking, which severely limits what you will be able to do both technically and creatively. Another feature that can be quite useful is a self-timer. In some situations it can be

used in place of a cable release to minimize camera shake.

A built-in motorized film advance or the ability to attach a power winder or motor drive can be very useful at times, but these features aren't required. They are most useful if multiple exposures of a shot are needed, as manually advancing the film can easily upset the framing or focus, especially in high-magnification work.

If you want to use flash, TTL Autoflash capability is highly advantageous. It is one of the few auto exposure systems that really works well in close-up work, and it will save endless hours and enough film that it pays for itself in no time.

Some camera systems allow the user to change focusing screens, or the operation is simple enough that a technician can show you how to do it yourself in minutes. This option is advantageous for the serious close-up photographer, as some of the standard screens don't work and become an obstruction rather than an aid. The uses of many of these options and features will be dealt with in detail later.

Automatic Cameras

With the current auto-everything camera revolution making photography less and less complicated, the photographer is further removed from the photographic process and leaves more and more of the decision making to the programming in the camera. As a result, people begin to rely on the automation too heavily and ignore (or never bother to learn) the basics.

Without an understanding of the basic principles of photography one cannot have complete control over the process, nor can one use the equipment effectively or assess and evaluate problems that inevitably arise.

One of the biggest fallacies about electronic metering and automatic exposure systems is that they are always accurate (or more accurate than people). Nothing could be further from the truth. Auto systems do lie and they can be fooled very easily.

Nor can the auto system look at a scene and decide what f-stop is required for the best depth of field, or whether blur from using a slow shutter speed would look better than freezing the subject with a fast one. It can't decide that the scene would look more dramatic if underexposed a stop or two, or that it should ignore the shadow details and expose for the highlights. It lacks the creative element—*this can only be supplied by the photographer.*

In some instances the auto systems are very helpful. If lighting conditions are pretty much even across the

scene or when using TTL flash, you can use the auto system for quick "grab shots" or "action" shots. Such shots are found in sports or photojournalism type photography where one wants to capture the event itself as it looked, and there is little or no time to be fiddling with light meters, f-stops, shutter speeds and flash computers, let alone trying to be creative.

Through The Lens (TTL) Autoflash is, however, one auto system that really works well in close-up work. It saves endless hours of setup and exposure calculations as well as piles of film. It also allows one to get many shots practically unattainable before with little effort. I feel these benefits far outweigh the loss of some creativity. You must still know how to use flash properly: where to position it and what aperture you want. The auto system just takes care of a lot of the time-consuming calculations.

The autofocus features are quite nice and very useful for people who have difficulty focusing because of vision problems or for general shooting, because it can often focus more quickly and accurately than many of us can. Autofocus is often of little or no use in real close work at around half life size or greater—just try to take a close-up photograph of a bee on a flower using autofocus and you will find it simply can't keep up to the bee's rapid movements (there's a trick to doing this which will be revealed later).

Most cameras with autofocus require the subject to be in a box or zone in a particular part of the frame to focus. Even if there are several focusing zones to choose from, you are still restricted as to where you must have the point to be focused on in the frame, limiting creativity severely at times. You will often end up framing to suit the focusing system rather than to get the most desirable picture.

Auto cameras do have their place even amongst many professionals. The difference is that the pros know the strengths and weaknesses of their auto systems and know when they will help or hinder them.

CONTROLS—FUNCTIONS AND USES

There are three primary operating controls on a camera: the aperture ring, the shutter speed dial, and the focus ring. The appearance of these controls may have changed (they are most likely pushbuttons and displays on an LCD screen nowadays), but the function and operation remains the same. *To be successful in close-up photography, you will have to learn what they do and how to use them.*

APERTURE

The aperture and speed controls are used together to provide the correct amount of light needed to expose the film *and* control how the image will appear on film. The aperture ring or buttons control the size of the lens opening (often referred to as the "f-stop" and less frequently as the iris or diaphragm). The aperture is a series of thin overlapping metal leaves within the lens. By using the aperture control to vary the size of the lens opening, the photographer controls both how much light will be allowed into the camera *and* how much depth of field the picture will have.

The aperture is probably the most important (as well as the most misunderstood and misused) creative control on the camera. In close-up and macro work it is undoubtedly the primary control used in determining how the image will appear.

Depth of field is the amount of foreground and background in the picture that appears to be in focus. We control this depth by adjusting the aperture. The smaller the physical aperture size used, the deeper the depth of field; conversely, the larger the aperture, the shallower the depth of field.

Practically, this means that if we want a lot of foreground and background in sharp focus, then we want a very small f-stop. If we want to isolate a subject from the background and make it stand out, we would use a large f-stop so only the subject appears sharp and the background and foreground blurry.

Depth of field extends from roughly 1/3 in front of the plane of focus (an imaginary plane parallel to the film plane at the point the lens is focused on) to 2/3 behind. (At magnifications exceeding 1X, some texts say it is closer to 1/2 and 1/2.) For example, if the total depth of field at a given aperture were six feet, everything from two feet in front of the plane of focus to four feet behind it would appear in focus in the print.

The actual depth for different lenses at different focusing distances can be calculated, read from charts, or even off the lens itself, but it is much easier to use the depth-of-field preview button and *actually see* what the depth of field will be. In close-up work, the depth-of-field preview is the *only* practical way to know what it will be.

Another very important fact of life about depth of field is that it not only varies with the size of the lens opening, but it also varies with focusing distance. At any given f-stop, the closer you get to the subject, the shallower the total depth gets. This can be very troublesome at times.

DEPTH OF FIELD

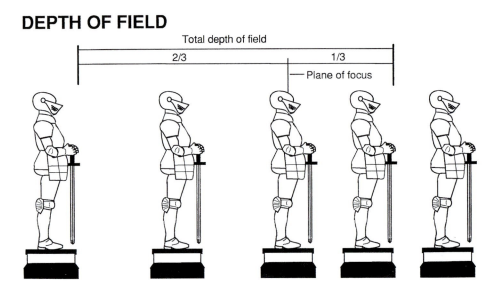

FIGURE 2.1 The photographer is standing to the right and focuses on the third suit of armor. A plane drawn parallel to the film through this point is the plane of focus. At the particular stop selected, the depth of field would extend from approximately 1/3 the total depth in front of the subject to 2/3 the total depth behind. Everything between the two end bars denoting the total depth of field would be in focus in the shot. The first and last knight are both outside the range and would appear out of focus.

There are no rules that tell us when we should use shallow or deep depth of field. It is entirely up to the photographer to choose (although at times shooting conditions may have a considerable influence on this decision).

Some photographers insist that you must *always* stop the lens down as small as possible when doing close-up work "because you need maximum depth of field." This is a ridiculous generalization. There are many reasons why you might not wish to, or can't, use the smallest aperture possible.

Common full f-stop settings, from the largest to smallest physical opening are: f1.4, f2, f2.8, f4, f5.6, f8, f11, f16, f22, and f32. Sometimes you might see f45 and even f64, but they are very rare and are not as useful as one might think, because a phenomenon called diffraction occurs that can turn a picture to visual mush.

The difference between any two adjacent aperture settings is often referred to as a "stop." Thus, when you hear, "Open (or close) the lens two stops," it means to change the aperture setting in the appropriate direction by two full-stop positions.

There are also "half stops" and "third stops." Third stops are very uncommon and nobody bothers numbering them—they say "f8 and a third" (or perhaps 2/3). Half-stop values are good to know later when it comes to how to use the aperture numbers to position lights. The half-stop values are: f1.2, f1.7, f2.4, f3.5, f4.8, f6.7, f9.5, f13, f19, f27, f38, and f54. Most photographers don't bother using numbers but will say "half way between f5.6 and f8."

You can only select specific fixed shutter speeds. If you need just a little bit extra or less exposure you select one of these partial stops. If your camera has an aperture ring, you can usually get close enough by setting the ring between the marked stops approximately where you want it. Electronic cameras may or may not have selectable half stops.

The numbering system seems backwards and is sometimes confusing because the numerically larger number is the smallest opening. There is a very good reason for the numbers being the way they are. They are ratios that relate the physical diameter of the opening to the focal length of the lens rather than a physical measurement. Because they are ratios and not measurements, f8 on a 20mm lens and f8 on a 1,000mm lens will both allow in exactly the same amount of light even though they are very different sizes physically.

Each full stop is related to its adjacent stops by a factor of 2. It will allow in exactly half as much light as the next larger opening and exactly twice as much as the next smallest opening. Thus, f8 allows in exactly half as much light as f5.6 and exactly twice as much

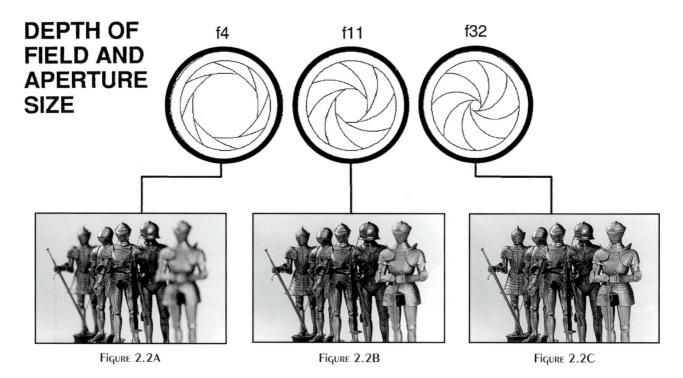

DEPTH OF FIELD AND APERTURE SIZE

f4 f11 f32

FIGURE 2.2A FIGURE 2.2B FIGURE 2.2C

FIGURE 2.2 At large apertures (f4), the depth of field is shallow. Very little outside the plane of focus (the middle suit of armor) is sharp. The depth of field increases as we stop down (f11) until finally they are almost all in focus (f32).

light as f11; f11 allows in half as much light as f8 and twice as much light as f16; and so on. We will use this knowledge of the relationship between adjacent stops in Chapter 6, "Exposure."

SHUTTER

The shutter controls how long the light coming through the lens is allowed to reach the film. It can be a series of overlapping leaves within the lens itself, much like the aperture (appropriately called a "leaf shutter"), or it can be very thin foil curtains that travel either vertically or horizontally in front of the film (called a "focal plane shutter").

Most SLR cameras are equipped with the focal plane shutter, although the type you have really doesn't make a lot of difference except when using electronic flash. These problems will be discussed in Chapter 10, "Flash."

Shutter speeds are measured in seconds or fractions of seconds. The most common shutter speeds are 1, 1/2, 1/4, 1/8, 1/15, 1/30, 1/60, 1/125, 1/250, 1/500, and 1/1000 second. In most cases, the speeds are written as whole numbers and the "1/" is just assumed. Speeds of and exceeding 1 second are usually marked in different colors on dials, or with a symbol like a quotation mark (") following the speed on cameras with digital readouts.

There are also "B" and "T" settings for "Bulb" and "Time." On "Bulb," the shutter remains open as long as the release is held down. On "Time," one push of the release opens the shutter and another push closes it. One or the other (and sometimes both) are usually found on all shutters. They are for long duration exposures. On view cameras they are also used to hold the shutter open while focusing and framing.

Some cameras extend the speed ranges to 30 seconds on one end of the scale to 1/4000 second or faster on the other end. Speeds much above 1/250 are almost never used in close-up work, except outdoors in sun with high-speed film, large apertures, and low-power magnification.

With the exception of the bulb or time settings, the relationship between each adjacent shutter speed on the dial is, like the aperture, a factor of 2: that is, 1/60 second is twice as fast as 1/30 second and half as fast as 1/125 second (or pretty close anyway), and so on.

Another way to say it would be 1/15 second allows the light in twice as long as 1/30 second and half as long as 1/8 second.

Unlike aperture settings, fractional shutter speeds (speeds between two fixed speeds such as 1/90, which is between 1/60 and 1/125) cannot be set. Some electronic cameras will give "intermediate" shutter speeds, but they may not be "user selectable" and may only be available in the auto exposure modes.

In Chapter 6, "Exposure," we will see that when it comes to the effects on exposure of the film, changing either aperture or shutter speed by the same number of steps in the same direction will produce the same change in exposure. Because they have an equal effect on exposure, many photographers will refer to the distance between adjacent shutter speeds and/or adjacent aperture settings as a "stop."

By controlling how long the light is allowed into the camera, we have the ability to control how motion will appear. With slow shutter speeds, motion will appear as blur; with fast shutter speeds it may be frozen.

The degree of blur or freezing depends upon the amount of movement over the amount of time the shutter is open. It doesn't matter whether the motion is caused by the subject moving or the camera moving, both will induce blur.

While we may, in most cases, want to eliminate blur, there are times when it can be used creatively (very rarely in close-up work, however). Unfortunately, we do not have the luxury of a "shutter speed preview," which would show us how a photo would look at different shutter speeds, as we do for apertures. We just have to use our experience, or guess and hope for the best. If possible, take several shots at different shutter speeds and select the best after processing.

Lenses

The lenses you will need depend entirely on what you want to photograph and how you want it to look. They come in a variety of lengths and sizes. Most conventional lenses can be used for close-up work in one way or another.

There are also lenses that will work within the macro range without any accessories, and some that work *only* within the macro range. The latter usually require the use of a bellows to focus.

All lenses have two characteristics that are very important when selecting which to use in close-up

work. They are "Angle of View" and "Working Distance."

Angle of view is a measure of the angle of an arc the lens "sees." It can vary from over 180 degrees (where the lens literally sees behind the camera) on the super-wide-angle lenses, to only a degree or two with a super-telephoto. The greater the focal length, the smaller the angle of view.

Working distance is the distance between the subject and the front of the lens. If we keep the size of the subject in our viewfinder the same, the longer the focal length of the lens used the greater the working distance. Thus, a long lens allows you to maintain a discrete distance from the subject and still allows a nice sized image on film.

In the conventional lens category we have three main groups: normal, wide angle, and telephoto lenses.

Normal or "standard" lenses are so called because they produce an image close to that produced by a human eye. Their focal length is approximately 50mm, and they are what 35mm cameras are usually equipped with when purchased.

Wide angle lenses, ranging from 6mm to about 35mm, take in an angle of view greater than that of a normal lens and in doing so tend to appear to create a lot more distortion. Depth seems to be much greater or exaggerated, and there is sometimes a great deal of curvature of objects appearing near the edges of the frame. The shorter the lens focal length, the greater the angle of view and the more pronounced these other effects.

These lenses are used for three main reasons: to fit a subject into the frame that wouldn't fit normally (usually because the photographer cannot get back far enough); for unusual effects caused by the large view angle and/or distortion; or if more background is desired in the picture. They are frequently used for landscapes.

Telephoto lenses, ranging from 65 to 2000mm, have an angle of view smaller than a normal lens and thus less background appears in the picture. Depth appears to be compressed or flattened, and the longer the focal length, the greater the compression. This compression can be unsightly, causing bizarre distortion of some subjects.

Some telephoto lenses, usually in focal lengths of 250, 500, 1000, and 2000mm, are "mirror lenses." They are actually small reflector telescopes and are much smaller than conventional glass lenses, a 500 mm f8 reflector being about 4" diameter and 4" long. Their biggest advantage is their compact size, being easier to carry and use, but they also have a couple of drawbacks—the first being that they have no aperture

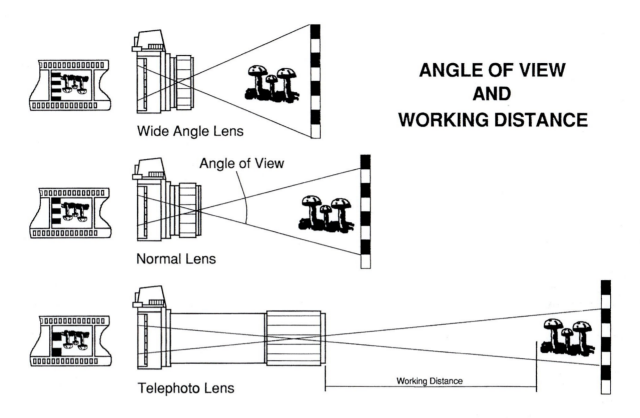

**ANGLE OF VIEW
AND
WORKING DISTANCE**

Wide Angle Lens

Angle of View

Normal Lens

Telephoto Lens

Working Distance

FIGURE 2.3 As the length of the lens increases, the angle of view decreases. If the image size on film (magnification) remains constant, the working distance (lens-to-subject distance) also increases. Note how, because of the narrower angle of view, the amount of background seen also decreases as the lens length increases. We can use this to help isolate the subject from the background and get rid of distractions.

control. The apertures are fixed so all shooting is done with the lens wide open (neutral density filters are used in lieu of stopping down). Without aperture control, there is no control of depth of field either, so focusing is critical. Also, specular highlights appear as donuts rather than circles, and the images aren't as crisp as those from regular lenses. There is really no place for these lenses in close-up work because of their lack of aperture control.

Long lenses are used when you either cannot or do not wish to get too close to the subject or to isolate the subject from a busy background. The distortion caused by these lenses is only rarely used for creative purposes and is generally limited to background compression effects.

Zoom lenses are lenses in which the focal length can be varied over a fixed range. In the past, they were considered worthless by serious photographers because the image quality was not as good as that of fixed lenses. Although they are still heavier and slower than

equivalent sized fixed lenses, nowadays the image quality is for all practical purposes just as good as their fixed counterparts. It would take side-by-side image comparisons to see any significant differences, and many professional nature photographers now use them.

The zoom lens is great for all types of photography, primarily because it has several focal lengths in a single lens allowing photographers to crop their picture precisely in the viewfinder without having to change lenses or move around a lot. They are especially handy for travel or times where you don't want to carry a lot of equipment around.

Lenses having focal lengths less than 24mm or greater than 300mm are rarely, if ever, used in close-up work.

Macro lenses are lenses designed specifically to work in the close-up range. They are usually slower than conventional lenses of the same focal length, available in sizes of about 50, 100, and 200mm focal

Figure 2.4A 24mm wide angle. Working distance = 1-3/4".

Figure 2.4B 50mm standard lens. Working distance = 5-1/2".

Figure 2.4C 200mm telephoto. Working distance = 29".

FIGURE 2.4 In these three photos, the image size remains constant at approximately .4X. Three different lenses were used to illustrate how the angle of view and working distance change with lens focal length. All photos were shot using f16 at 1/8 sec. Note how the amount of background in the photos decreases and working distances increase as focal length increases. The background was deliberately bad to illustrate how a long lens can be used to crop unwanted background and isolate the subject from annoying distractions.

lengths, and cost big bucks (about three to four times that of an ordinary lens of similar focal length).

The advantages of macro lenses are that they are able to focus from infinity to 1/2 life size or even life size without any accessories. They are also "flat-field" lenses—the image is sharp from edge to edge (conventional lenses usually show some degree of deterioration and distortion near the frame edges). They are especially suited to copy work, where edge-

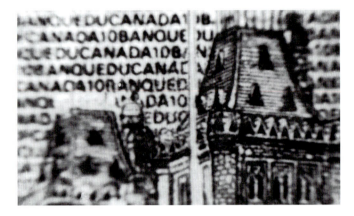

FIGURE 2.5 This close-up of the detail of a Canadian $10 bill was shot with an ordinary 50mm lens. These lenses are not designed to work where the lens-to-subject distance is short and the result is fuzziness and distortion, notably towards the edges of the frame.

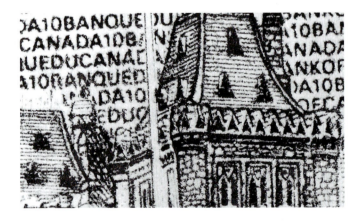

FIGURE 2.6 A flat-field macro lens produces images that are sharp from edge to edge. Notice the difference in image quality between this picture taken with a 35mm short-mount macro lens and Figure 2.5, taken with an ordinary lens. Both were shot at f8 and are approximately 5X magnification.

to-edge sharpness is required, and for nature work where one may want to do a lot of close-up work without having to carry around a cumbersome bellows.

Some lenses advertised as "Macro Lenses" are not true macro lenses. They are "Macro Focusing" lenses; that is, they are conventional lenses that focus closer than normal and may allow image sizes of 1/4 to 1/2 life size without additional devices. These, however, are not "flat-field" lenses and do not provide the same edge-to-edge sharpness that true macro lenses give, although some are close.

Unless one is going to be doing work requiring a flat field lens, many of these are every bit as good and considerably cheaper than a real macro lens.

Short-mount macro lenses are designed specifically for high-magnification work only (life size to about 10 or 20 times life size). They usually have no internal focusing capability, many have manual apertures (a nuisance—get auto if you can), and they *must* be used on extension. They are specially designed to correct for distortion and other errors within very limited magnification ranges, and they will only focus within very short distances (often just a couple of inches), thus making their usefulness extremely limited. "Pound for pound," they are probably the most expensive lenses available. But, if you do plan to do a lot of work in magnification ranges much greater than 2X, they are almost essential if you want good image quality.

CHAPTER 3

OTHER EQUIPMENT

Tripod

Unquestionably, the most essential accessory is a good tripod. Exposures ranging from 1/30 second to 30 seconds are the rule rather than the exception when working in the close-up and macro ranges, which makes handheld shots without flash out of the question.

Even if it is possible to handhold, getting the best possible shot becomes difficult. A camera with extension can be heavy and awkward to hold at times. The tripod frees your hands and allows you the ability to analyze the image thoroughly and make all sorts of minor changes that would be impossible during handholding. It also allows you to take multiple exposures of the same setup.

The biggest problem you will face is vibration and camera shake. While an inexpensive tripod is sturdy enough to hold the equipment, it probably isn't rigid enough to dampen out small vibrations and shakes. A camera with a long lens or bellows is quite heavy and needs firm support, especially if it is windy out or when doing high-magnification work. Any vibration or movement of the camera is greatly pronounced in close-up photography

There are two parts to a tripod: the legs and the head. One is just as important as the other, and both must be good to be of any use. In the better tripod lines these two parts are sold as separate units so you can "mix and match."

You needn't buy something designed to hold a TV studio camera, and you don't have to spend a small fortune either, but the legs must be sturdy and the tripod must be rigid. The fewer the extensions and the lower the rise, the better. Long or small diameter legs and those made of "U-shaped" aluminum channel are usually too flimsy to dampen any vibration when extended. Put on a camera with a 200mm lens and bellows and it shakes like jelly.

Watch the weight too. If the tripod is to be used in the field, remember that you have to carry it, and even light tripods get heavy after walking for a while. There are good relatively lightweight tripods available that are suitable.

If you plan to do a lot of fieldwork such as nature photography, then you will want a tripod that will lie nearly flat on the ground. Some will, but others need slight modifications, including replacing or sawing off part of the center post.

Many good tripods allow inverting of the center post so you can get right near ground level. I've used this method often, but I must admit it is awkward and at

times very uncomfortable. It does work, however. Sometimes it is the only way of getting the camera low enough.

For outdoor work, avoid the tripods with braces on the legs. They restrict how low the tripod can go and tend to get tangled up in plants and weeds.

The two head styles are multi-axis hinged type and ball type. I have never used a ball head for macro because if you try to make a very fine adjustment in one axis, once you loosen the ball the camera wants to move everywhere on all axes.

The multi-axis heads come in two types—those hinged on all three axes and those hinged on two. Get the three-axes type, otherwise you will regret it the first time you try to do a vertical shot.

The head must be sturdy and all adjustments lock tight and firm. There should be no looseness in any of the joints and adjustments. If there is, it will cause endless problems because they will only get worse with wear. If the adjustments are not smooth, then you will have difficulty making very fine adjustments. A good guideline is that if the head and tripod are built for a large-format studio camera, it should be good enough for most close-up work.

My experience has been that cheap tripods break easily. Invest in a good one right from the start and it will last for many years.

LIGHT METER

Lighting presents many unique or unusual problems in close-up work, and therefore it is imperative that you have some means to measure it to determine exposure accurately. That means you must have a light meter either built into the camera or a separate handheld unit. You must also know how to use one. *It is surprising how many people don't.*

There are two types of light meter: the incidence meter and the reflectance meter. All meters fall into one category or the other, and some can be used both ways.

Incidence meters are normally held at the subject and pointed towards the camera. They measure the light that is actually falling on the subject and give the most accurate light reading. But many times when working close it may be impractical or physically impossible to get the meter in a position to take an accurate reading.

Reflectance meters can be handheld or built-in. All TTL meters (Through The Lens meters) are reflectance type. They measure the light being reflected off of the subject. Handheld versions are generally unsuitable for

real close work because they measure an angle far too wide to be accurate.

Light loss from extension and filters must be accounted for with both incidence and reflectance meters. These light losses, however, do not need to be compensated for in a TTL meter. The TTL meter does it automatically and it is a great deal more accurate too, because it is only reading the part of the scene that the lens sees and not everything in front of you. They are more reliable and very accurate if used correctly, but they can still be fooled very easily if you aren't careful.

If you do require a hand meter, by far the best type to get is a spot meter. They are reflectance meters that only read a one-degree arc, which allows you to single out and select a very minute spot on the subject to take a reading from. Even if the scene is mostly dark or light, you can almost always find an 18 percent reflectance area to meter somewhere. (There are also ways to meter areas that aren't 18 percent, which will be discussed in Chapter 6, "Exposure.") It is also excellent for macro work as it is possible to take readings off of a subject the size of a ladybug. Although you must compensate for light loss from extension and filters, it is still far more accurate than any other handheld meter when used properly.

CABLE RELEASE

One wants to eliminate as many sources of vibration as possible, and that includes eliminating any physical contact with the camera during exposure. Some photographers prefer to use the camera's self-timer to trip the shutter because there is no chance of vibration being transferred through a release cable. This is the ideal solution, but it will not work if there is any possibility of subject movement. If there is, there is absolutely no way to guarantee that the subject will even be in the frame let alone in focus, so for these subjects one needs a remote release so the shutter can be tripped at the precise instant all motion ceases.

Barring radio control releases, which are rather expensive for our purposes, the best are the real long "squeeze bulb" air type releases or, if your equipment is electronic, the remote switches with long wires because they transmit no movement whatsoever.

Wire releases should be about a foot or so long and held so there is a gentle curve that will flex and take up movement as they are pressed. If they are held too straight or are too short, they can jerk the camera. If they are too long, they can sway and vibrate the

camera. They should be pressed with a smooth, even motion, not a sudden "jolt."

If you are photographing something that moves, and you may have to shoot quick, hold the release and press until you feel back pressure from the release button while viewing, then you only have to press a bit when you are ready. With this method you can shoot faster and with less vibration.

Lens Hoods or Shades

Stray light striking the front surface of the lens or filters results in washed-out photos, hot spots, poor color, specular highlights, and even light streaks. There are occasions where these may be desirable and done deliberately, but it is not something you want on a regular basis. To minimize the problem of flare, lens hoods and shades should be used whenever possible—although they may not be practical if the lens-to-subject distance is only a few inches or less, for they may interfere with subject lighting, making it difficult or even impossible.

Lens hoods and shades can be solid plastic, metal, or bellows type. The most popular are made of collapsible rubber and are threaded to screw into the front of the lens like a filter. They are sold in various filter sizes and for specific focal lengths of lenses.

For a zoom lens, get a hood that is suitable for the *shortest* focal length of the lens. Be sure you have the correct one for the focal length of lens you are using—one that is too small will cause vignetting. Vignetting may also occur if the hood is used in front of a filter, particularly polarizing filters, which are thicker than ordinary filters.

Angle Finder

The angle finders just slip on or screw in over the viewfinder and can be rotated through 360 degrees, allowing viewing from a number of positions. They are extremely useful for nature work where the camera will often be very near the ground looking up, or in some other awkward position where it may be otherwise impossible to look through the viewfinder. They are also good for copy work where the camera is on a stand looking straight down.

My angle finder also has diopter compensation for vision correction built right in. This can be helpful because glasses can sometimes make viewing difficult.

Filters and Rings

You can use any type of filters you like, but the only ones I use are a polarizer and occasionally either a blue (80A) or orange (85B) filter to correct film for the light source used (I prefer to use film matched to the source whenever I can).

It is best not to use any filters if at all possible. Each time you put a piece of glass in front of the lens, you not only reduce image quality, you add two more surfaces that can reflect and refract the light and gather dirt (some of those plastic filters will pick up a static charge and become dust magnets). If you can, it is better to filter the light falling on the subject by putting the filter between the light source and subject—that way a little dirt or oil won't affect the image.

Some experimentation with filters may be necessary to achieve the proper color balance. I have found that similar named filters by different manufacturers may be considerably different in color. One night in a photography class, three of us compared our 80A filters and we had three distinctly different shades of blue.

You cannot get filters for short-mount macro lenses, but there is a little trick I use. I managed to find a collection of very small filters about an inch or so in diameter in a "junk bin" at a camera store. There was an 80A, 85B, polarizer, and a couple of others in the set. If I need one when using one of my short-mount lenses, I simply tape it to the *inside* of the mounting plate over the rear of the lens.

One annoying nuisance concerning filters and rings is that they often stick together or to the lens and are almost impossible to unscrew. To reduce the difficulty of separating rings and filters (or removing filters), use a flat piece of neoprene, a latex "jar opener" disc, or a rubber glove. Holding the lens or filters in one hand, place the rubber on top, press lightly and rotate with the palm of the other hand, and they come loose instantly!

Whenever you put any filter in front of a lens, you are affecting the light entering the camera. You may be bending it with some special effect filters, polarizing it, coloring it, or simply reducing the amount with neutral density filters.

All filters reduce the amount of light to a different degree and thusly affect the exposure. Therefore, if you are going to use one, it is very important to know how much it will reduce the amount of light and how much you must increase exposure to compensate. The increase can range from zero to over three stops

depending upon the filter. Polarizers are tricky because their factor varies depending upon how much you polarize the light.

If you are using a TTL meter, you don't have to worry about this, as it will automatically compensate for them. If you don't, you will need to know about filter factors.

Every filter has a filter factor. It is a number that you multiply the exposure time by to compensate for the light lost. For example, if your metered exposure is f11 at 1/125 and you have a filter with a factor of 2, the new exposure is $2 \times 1/125 = 2/125$ second (or 1/60 second). That's not too difficult, until you end up with an answer that says you should use 1/84 second! I prefer knowing how many stops I have to open up so I can make the change in either shutter speed or aperture.

The manufacturers usually include a list of their filters and factors for each of their filters. Some go one better and simply tell you how many stops you must increase the exposure by.

Table 3.1 lists the corrections for various common filter factors.

To correct exposure, determine the correction in number of stops for the filter, and *increase* exposure by that amount using either shutter speed or aperture. When stacking filters (using more than one), you must add the filter factors together. Doing so can result in a very high light loss of many stops—something you cannot afford in close-up photography, so it is best to avoid filters whenever possible.

TABLE 3.1 Filter factor conversion table.

Factor	Stops
1	0
1.5	1/2
2	1
2.5	1 1/3
3	1 2/3
4	2
5	2 1/3
6	2 2/3
8	3
10	3 1/3

MOTOR DRIVES AND WINDERS

Since you are not likely to be trying to do quick action sequences, why is a power film winder a good idea? Simple. The action of winding the film by hand can move the camera enough that the picture is no longer framed properly or even thrown out of focus.

This potential problem can be most important if you want to take several exposures of the same shot, such as when bracketing, or taking photo sequences to use in dissolves in an audio visual show. If the picture is rare or exciting, I will take several shots just in case one might get scratched or damaged and want them all identical.

There are also times where you have just shot a picture and a terrific shot presents itself right in front of your camera—you click the shutter and realize you didn't wind the film after the last shot or didn't have the time and miss it.

FLASHES

Electronic flash can be used almost anywhere but is principally used in close-up work to stop motion or where a very high-power light is required. Typical electronic flashes have speeds ranging from about 1/1000 to 1/10,000 second or more. Flashes come in three varieties: manual, auto, and TTL auto.

Manual flashes have one or more fixed-output power settings and require the photographer to specify two of three parameters to be used (flash output power, flash to subject distance, and desired aperture) then determine the third for proper exposure.

Auto flashes allow the photographer to select the desired aperture. When the flash is fired, photocells in the unit measure the light reflected off of the subject and shut it off when the circuitry determines the subject has been exposed properly for the film speed and aperture set.

Ordinary auto flash exposure systems will not work properly when you start getting very close.

TTL (Through The Lens) Autoflash works very reliably in the macro range because it is controlled by the camera's internal metering system. It is, in fact, the only auto flash system that will work up close. (Flash units and their use are covered in more detail in Chapter 10, "Flash.")

Whatever type of flash you get, choose a very powerful one with multiple power settings and manual overrides. You can never have a flash that is too powerful in this field!

VIEWFINDER MAGNIFIER

Depth of field is absolutely terrible when you get really close, so how and where you focus is critical. Light losses also make the job more difficult because the viewfinder becomes very dark, so anything that helps you see and focus is welcome. Viewfinder magnifiers clip over the viewfinder of the camera and magnify the center of the image several times making life a little easier.

FOCUSING SCREENS

Conventional split-image and microprism screens are terrific for normal photography, but they have one major problem: they "black out" and don't work if the light levels are low. All they do is obstruct a good portion of the center of your image, making focusing all the more difficult.

Many cameras have interchangeable viewing screens that can be changed by the owner or a serviceperson. All-matte or all-matte screens with grid lines are the recommended types. They will not black out in low light levels or with small-aperture lenses; focusing is possible anywhere on the screen; and many are actually brighter than the other screens they replace—which

may mean you have to adjust your light meter settings to compensate if the sensors are in the prism head. (The manufacturer's instructions will list the compensation required.) I use the matte screen with grid lines for most of my shooting, close-up and normal. The lines are also a great help in "squaring up" or positioning the subject.

FOCUSING RAIL

When working up close, it is often necessary to make very fine adjustments of a fraction of an inch. It is almost impossible to move the camera and tripod that little bit without completely upsetting everything. A focusing rail is ideal for just such occasions. Mount the camera on the rail, which mounts on top of the tripod, and its rack and pinion allows you to move the camera back and forth about five or six inches.

Some manufacturers sell them separately, and most sets of bellows come equipped with a set. A few bellows allow you to take the rail off and use it separately, or you might even build yourself one—they're fairly simple to make. I built two for about $6. You can find plans for a focusing rail, copy stand, and many more pieces of equipment in a book titled *How to Build Your Own Photographic Equipment* by Dan Lewis. If you

FOCUSING SCREENS FOR CLOSEUP WORK

FIGURE 3.1 Focusing aids like split image and microprism rings (left) "black out" at low light levels and obstruct the view, making focusing more difficult. The all-matte screen with gridlines (right) is brighter than other screens. There is also nothing to interfere with viewing or focusing and the finely etched lines are helpful for framing.

intend to do a lot of close-up work using extension tubes or methods other than a bellows, one of these is highly recommended.

RUBBER EYECUP

An eyecup, attached to the viewfinder, prevents stray light from entering your eye, making it easier to see through the viewfinder, especially when lighting conditions are low, and it prevents stray light from entering the viewfinder when your are taking light readings (stray light through the viewfinder can alter TTL meter readings drastically).

Viewfinders also tend to be very hard on plastic eyeglass lenses and scratch them up quite badly. An eyecup will help prevent this.

COPY STAND

Anyone who has tried doing copy work with a tripod knows that tripods make lousy copy stands.

Not only do copy stands make copy work easier, they are ideal working bases for almost any very small subject photography. They usually have an adjustable lighting system built right onto them, which is much easier to work with up close than light stands or table lamps.

The one I have has two lights that are attached by "goosenecks" to the center post. The base of my copy stand is a nice matte neutral gray that makes taking light readings very easy.

An angle finder is highly recommended if you do a lot of copy work. You can use the stand on a table and look through the viewfinder without having to bend your neck or stand on something to get high enough.

NEUTRAL (18 PERCENT) GREY CARD

One of these is almost imperative. They are used for metering the light and can be bought in camera stores singly or in packs of mixed sizes. I *always* carry a small one in my bag because I never know when I will need it.

CHAPTER 4

FILM

The film you use determines *everything* relating to exposure. This includes what lighting conditions or type of light source you can shoot under, what aperture or shutter speeds you may or may not use, and how the scene will be reproduced. Ultimately, whether you can take the photo the way you want under the conditions that exist depends primarily upon the film.

Next to the electronic cameras and light metering systems, the greatest improvements in photography over the past twenty years have been in films.

Today there are almost as many different films available as there are things to photograph, so choosing one can be difficult. The only way to tell what the different films are like is to actually use them: that is, by shooting the same subjects under the same conditions, processing them at the same time by the same processor, and then comparing the results side-by-side. Pick the films and the lab that give the results that *you* like the looks of best. If you are after accurate color reproduction, compare the results to the subject and see which film produces the nearest color. If you prefer a film that has real punchy vibrant, though slightly inaccurate colors, choose it. Unless you require accurate color reproduction or are shooting under very unusual conditions, there are no right or wrong films.

Some photographers like to try every film on the market, and others buy whatever happens to be on sale at the time. They choose processors similarly—whoever happens to be the most convenient or has the best deal at the moment. *Don't do it!* Pick one or two types of film and one reputable processor and stick with them, otherwise things will get very confusing because of the many inconsistencies and differences in films and labs.

The best type of film to learn exposure control with is slide film. There is no printing stage involved, so there is no possibility for the processor to correct your exposure errors. Slide film also has a narrower exposure latitude than print film and is much less tolerant of exposure errors. If you make a mistake it will be obvious and, unfortunately, uncorrectable. The modern printing machines can correct for exposure errors of a stop or two, so you can't really tell a lot from a print. It is also very difficult for the inexperienced to judge exposure errors looking at color negatives. Once you can get fairly consistent good results with slide film, then consider switching to print film.

Something that I have read and heard repeated a number of times is that "*you should always underexpose slide film by 1 stop.*" Don't believe it!

Generally, slides that are a little underexposed look nicer because the colors are deeper and richer, and many people like them that way, which is fine. But if you

underexpose, you will not get accurate color or tonal reproduction. With some slide films, in fact, more than a half stop exposure error will produce entirely unacceptable results. Why the manufacturers would rate the speed inaccurately (and only with slide film), as this "rule" implies, makes no sense.

FILM SPEED

Every film made, regardless of type, has an ASA or ISO number, which is also known as the film speed. This rating is a measure of the film's sensitivity to light. The higher the number, the "faster" or more light-sensitive it is and, therefore, less light is needed to record an image. The ISO system has replaced the ASA system, but the values are numerically the same. The ISO rating of ASA 100 film is 100. (I have used ASA throughout simply because I am used to it.)

Exactly how the speed of a film is determined by the manufacturer or just what the number means is not really important to a photographer. It is primarily *a reference point* to work from when determining exposure settings.

Because idiosyncrasies in individual pieces of equipment, the ASA you set on each lightmeter you use may not be that on the film roll (see Chapter 6, "Exposure").

In general, as film speed increases, the image quality deteriorates. Grain gets larger and color quality diminishes. The degradation is not nearly as bad as it used to be—in the mid-1970s, ASA 400 color films had horrible color rendition and grain was the size of golf balls. The grain and color of some of the recent ultra-high-speed print films of today give results that are so good that, for most purposes, the degradation seen in even an 8 × 10 print from ASA 1000 isn't worth worrying about. Slide film, on the other hand, has not progressed nearly as much—grain is noticeable on speeds of ASA 200. Nature photographers tend to do most of their work with ASA 100 or slower because of finer grain and better color.

There is a relationship between the film speed ratings of different films that allows you to determine the difference in the number of exposure stops between any two speeds. Doubling or halving the ASA alternately increases or decreases the exposure difference by one stop.

Thus, ASA 200 film is said to be "one stop faster" than ASA 100, which is "one stop faster" than ASA 50. Conversely, ASA 50 is "one stop slower" than ASA 100, etc. In practical terms, when using ASA 200 film you can either close down one more f-stop or use the next fastest shutter speed than you would for ASA 100 film

under the same lighting conditions. When using ASA 50, you would have to open one f-stop or use the next slowest shutter speed than you would with ASA 100.

To find out how many stops there are between any two films, figure out the number of times that the lower speed is doubled to get the higher speed. For example, if you want to know how much faster (in terms of stops) ASA 400 is than ASA 50, first double 50 to get 100, then double that number to get 200, and finally double that number to get 400. You have doubled the speed *three* times; therefore, the difference in speed is *three* stops.

You can also divide the higher speed by the lower speed, but what you get here is NOT the difference in the number of stops, but a factor that is essentially the same as a filter factor—a number you must multiply or divide your exposure time by. If we divide 400 by 50, we get 8, and if you look up "8" on the filter factor chart (Table 3.1), you will see it corresponds to three stops, which is correct.

Confusing? You bet! Especially if you are shooting Kodachrome 25 (ASA 25) and want to switch to Tri-X Professional (ASA 320).

I have read and heard about even more complicated methods that some photographers use to figure out in their heads just how much faster one film is than another so they can "switch back and forth between different film types in the field." Isn't it much easier to use your light meter? If you've already metered the scene, just reset the ASA to that of the new film, and you can read the new exposure for it, or simply take another reading at the new ASA.

If you want to know how much faster ASA 320 is than ASA 25, set 25 on your light meter, take a light reading and pick any shutter speed, then set ASA 320 on the meter and see what the new aperture setting is for that shutter speed. Then count the difference in stops between the two readings.

To determine what speed film will give you an additional two stops more or a stop less than the film you are using, take a light reading, pick a shutter speed, and just turn the ASA dial until the aperture for that speed has changed by the desired amount and read the ASA. It's a heck of a lot easier than trying to do the mental gymnastics.

MORE CHARACTERISTICS OF FILM

There are many factors involved in picking the film to use. They include what the lighting conditions of the subject will be, the motion of the subject or camera, and the desired grain and color characteristics.

If fine grain and the best color are desired, then you will want to choose a slow film. However, you will have problems taking pictures in low light levels if you are holding the camera by hand, or if you or the subject is moving. If you want to stop subject motion or hand-hold the camera when the light levels are not good, you may need to trade off some image quality and use a faster film. If you are photographing subjects that don't move, then you may select any film speed.

The type of lighting you wish to shoot under makes a big difference with color film. Natural sunlight, electronic flash, or bulbs such as tungsten, fluorescent, mercury vapor, arc floodlight, heat lamps, or sodium vapor to name a few, all present problems of their own because they all produce different colored light. You might not notice the differences while shooting, but the film will, and you'll end up with images that have all kinds of crazy tints.

Color films, print and slide, come in two types: Daylight and Tungsten. These are the types of light the films are designed to be exposed under to get proper color rendition. Daylight film is also used when exposing film with electronic flash units.

Shooting in sunlight with daylight film still presents problems even though the film is designed to be shot in sunlight, because the color changes throughout the day; colors are much warmer (more orange) at sunrise and sunset. Daylight films are said to be balanced to give the best color results in the time span ranging from about two hours after sunrise to two hours before sunset. This doesn't mean that you shouldn't shoot outside these times—sunrise and sunset offer some of the best photo opportunities—just don't expect the colors to be accurate then.

Compared to sunlight, tungsten bulbs are very orange, so tungsten film has a "blue filter" built in that adds enough blue to compensate so that colors look normal. If you try to shoot photos using daylight film and tungsten lighting, they will turn out with a very deep orange cast.

Shooting tungsten film in daylight or with electronic flash results in a very deep blue cast. In both cases, the cast is so heavy that little other color is apparent—they look like monochrome photos.

If necessary, you can shoot daylight film under tungsten light and tungsten film in daylight. To do so, you must use correction filters to get the proper color balance. You have to add blue (80A filter) to daylight film when shooting it under tungsten, and you have to add orange (85B filter) to tungsten film if shooting it under daylight or with electronic flash.

Color correction filters should only be used as a last resort, because you must compensate for the light loss with additional exposure. If the subject is brightly lit, you may not miss that stop or two, but the difference may mean getting the picture or nothing at all in close-up work, where you may have already lost several stops due to the magnification method used.

Other types of lighting present real challenges, especially fluorescent bulbs. They usually give off a greenish color. You can buy a pink filter to use with daylight film under fluorescent lighting, but there are so many types of fluorescent bulbs and each give off a different spectrum of light. You would have to run many experiments with filters if you plan on doing a lot of shooting under such lights. Unless you have an expensive color meter that analyzes the light and tells you the appropriate corrective filtration, experimentation is likely to be the only way to find what works best for the many other types of lighting mentioned.

Mixed light sources are another headache. Besides offices with different colored fluorescent bulbs, there are many places where lighting is mixed, such as fluorescent and tungsten, or artificial and natural as one might encounter near windows or if there are skylights. There isn't much you can do here but experiment. I usually try to determine which type of light is dominant, select my film and filters for it, and hope for the best. The *only* mixed sources you don't have to worry about are sunlight and electronic flash, because the flash units are daylight balanced.

Reciprocity and Reciprocity Failure

All film needs a certain amount of light to "activate" it—that is, the chemicals need to be "kicked" into action. If they don't get this minimum amount of energy, they will react, but not exactly as desired. This can happen if the light is very dim and requires long exposures, or if the exposure is very fast (usually when using high-speed flashes having a duration of 1/25,000 second or faster). The results may be an effective decrease in film speed or color shifting. This speed and color shift, when it occurs, is called "reciprocity failure."

You may have seen the small chart or table like the one illustrated in Table 4.1. It comes in many film packages and gives you information such as, if you are shooting at a shutter speed of 1 second, you must increase exposure by 1 stop and use .1M (magenta) filter, or 10-second exposures are "NR" (not recommended). The latter doesn't mean that you can't take a

TABLE 4.1 Typical film reciprocity correction chart gives exposure increases and filters required for various exposure times.

SUPERCHROME X-700 ASA 100				
Exposure Time	1/10,000 to 1/10 second	1 second	5 seconds	10 seconds
Exposure Increase	NONE	1/2 STOP	1 STOP	NR
Correction Filter	NONE	.5Y	.5Y, .5M	NR

shot at that speed, just that the results are not likely to be very accurate or predictable.

When you are ready to shoot, check the chart, but first make sure you have done any necessary exposure correction calculations for filters and magnification that may be required (not necessary if using TTL metering). Look up the shutter speed nearest the one you are using on the reciprocity chart for the film you are using, and take the recommended action.

If you are using an average electronic flash, then you probably won't have to worry about reciprocity failure because the flash duration won't be terribly fast. Check the manufacturer's information sheet to be sure, however. Some give the flash duration at various power settings; the lower the power output the shorter the duration.

If an exposure increase is required, you may either open the aperture or choose a slower shutter speed—the choice is yours and will depend on shooting conditions and how you want the finished image to look. Whenever possible, I use a set of 5 × 5 color-printing filters for color correction, putting them between the light path and the subject rather than over the lens. This way, I avoid degrading the image. A set of printing filters is also considerably cheaper than lens filters.

For most routine photography where shutter speeds are between 1/15 and 1/2000 second, reciprocity failure is of no concern. But it is very important when getting into close-up and macro ranges, because it is not uncommon to have exposures that are several seconds long—well into the reciprocity failure zone of many films. A two-second exposure may have to become a four-second exposure, greatly multiplying the chances of camera or subject movement and ruined images. If you are using tungsten lighting, you might want to move the lights closer or use more powerful lamps so that your shutter speed will not land in the reciprocity failure range.

When selecting a film, you should consider reciprocity failure if you know you will be using very long exposures. Presently, there is one ASA 64 Tungsten-balanced slide film that I use; it requires no correction for reciprocity failure at exposures up to 32 seconds, whereas another I've used is not recommended for exposures over 1 second.

Exposure Latitude

Films cannot see the range of contrasts and brightness that the human eye can see. Their range is actually very limited, and we call the tolerances on these limitations the exposure latitude.

Exposure latitude is the degree of under- or overexposure (in stops) that the film will allow before it will not record anything on the underexposure side, or is saturated ("burned out") on the overexposure side.

This range between minimum (no image registers) and maximum (solid black) is about nine stops for black and white film, about seven stops for color print film, and about five stops for color slide film, the narrowest of all.

Ideally, proper exposure falls right in the middle of this range (18% or neutral gray). We can only over or underexpose by half this range (the latitude) before we are into one of the end limits. In the case of slide film, which has a range of five stops, overexposing by only half this range (2-1/2 stops) will render the subject pure white. Underexposing by 2-1/2 stops renders the subject pure black. Therefore, the exposure latitude of slide film can be said to be +/− 2-1/2 stops.

Compare this situation to that of color print film, with a latitude of about 3-1/2 stops, and black and white film, with a latitude of 4-1/2 stops! This narrow latitude for slide film means exposure is far more critical. You can quickly spot if you have an exposure problem and if it is towards the under or overexposure side, then determine whether it's your equipment or technique and take corrective action.

CHAPTER 5

LIGHT

INTENSITY AND DISTANCE

Time for a little lesson in math and physics.

To a photographer, light is a tool used in the creation of his or her art and is just as important as the camera, lens, and film. In order to use light effectively, we must be able to control it, direct it, and measure it. To do this, we must understand something about its properties and characteristics.

What is most important from a photographer's standpoint is how light behaves when it travels from one point to another, and how to measure its intensity.

The intensity (or brightness) of light falling on a subject depends upon two things:

1. The strength of the light source.
2. The distance between the source and the subject.

The intensity of light on a subject increases as we move it closer to the light source and diminishes as we move it further away.

Outside during the day, we do not observe this change. It still happens, but because our distance from the sun is so great, the difference in the intensity of light is imperceptible even with movements of many miles. In fact, to see a lighting change of one stop in sunlight we would have to move nearer or further from the sun a distance of about thirty million miles! The time of day and the atmospheric conditions like clouds and haze have far more to do with differences in exposure than distance.

With artificial illumination, however, we can easily see this drop-off. Observe a streetlight and you will see that the light is very intense right around the bulb and considerably less intense down at street level. We can also see this drop-off in photos taken with floodlamps or flash. Our subjects, we hope, are well lit and well exposed, but things in the background are very dark and possibly even black—this is especially apparent when electronic flash is used.

We know that when we took those pictures we could see the wall twenty feet in the background being lit up brightly, so how come it's black? It is *not* because the shutter closed before the light got there and back!

One reason is that film is considerably less sensitive to light than our eyes; we can see things in low light levels that it can't. The other reason has to do

with the rapidity with which light intensity drops off over distance.

Light intensity does not drop off linearly: that is, if you move twice the distance from the source, it is not half the intensity, or 1/3 the intensity at three times the distance. Instead, the decrease is exponential.

When light travels away from a source, it obeys the inverse square law of propagation (remember that from your high school physics class?). This law states that the intensity of a force (light) acting on an object (our subject) is inversely proportional to the *square* of its distance from the source.

The basic formula of the inverse square law for calculating light intensity at any given distance from the source is:

$$I = \frac{1}{D^2}$$

where

I = light intensity
D = distance from source

We are not interested in actual units of light intensity, only the relationship between the intensity and distance, therefore no specific units of measure are required.

Table 5.1 shows a series of intensity calculations starting with a distance of 1 unit.

Note how rapidly the intensity drops off in only a short distance!

If our light-to-subject distance is 1 unit, the intensity is 1. At 2 units it is 1/4, at 10 units it is 1/100.

TABLE 5.1 Light intensity decrease at various distances from the source.

Distance	Intensity
1 unit	$I = 1/1^2 = 1$
2 units	$I = 1/2^2 = 1/4$
3 units	$I = 1/3^2 = 1/9$
4 units	$I = 1/4^2 = 16$
5 units	$I = 1/5^2 = 1/25$
10 units	$I = 1/10^2 = 1/100$
20 units	$I = 1/20^2 = 1/400$

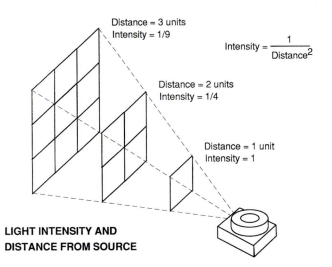

LIGHT INTENSITY AND DISTANCE FROM SOURCE

FIGURE 5.1 Light rays spread evenly as they are emitted from a source. Because they spread, their intensity (the amount falling on a given area) decreases with distance.

In Figure 5.1, our light source, the projector, is projecting a slide on a screen at a distance that equals 1 unit. If the distance is doubled to 2 units, the light now covers an area equal to four times the size of the first screen, and when the distance is tripled to three units, the light now covers an area equal to nine times the size. In each case, the total amount of light reaching the screen is the same, only it is spread out over a larger area.

Knowing how much light intensity diminishes with distance is not really of much practical use. It would be much more practical to know at what distances light intensity is halved, that is, when its intensity diminishes by a factor of 2. To solve for distances at half the intensity, we rearrange the inverse square formula (Table 5.2). The new formula is:

$$D = \frac{1}{\sqrt{I}}$$

Looking at the distances in Table 5.2, you should recognize that series of numbers—it is exactly the same as the f-stop numbering sequence! As it should be, since we know each adjacent f-stop allows in exactly half the amount of light as the previous larger stop.

We have already learned that changing the amount of light by a factor of two is equal to a stop, and now we can take things a little further.

If our subject is at a distance of one unit from the light source, and we move it back so that it is 1.4 units

TABLE 5.2 Distance from light source at which light intensity decreases by factor of two.

Intensity	Distance(units)
1	1
1/2	1.4
1/4	2
1/8	2.8
1/16	4
1/32	5.6
1/64	8
1/128	11
1/256	16
1/512	22
1/1024	32

away, we have decreased the light intensity on it by half (equivalent to closing the lens a full stop). Move it to two units and the light intensity has halved once again, equivalent to having closed the lens another stop. Moving it in the opposite direction doubles the intensity with each step, equivalent to opening the lens a full stop. (If you aren't convinced, set up a light in a darkened room and take measurements at 1 foot, 1.4 feet, 2 feet, 2.8 feet, and so on, and compare. They should drop a full stop between each distance.)

This works no matter what the distance or units of measure. If you have a light 8 feet from the subject, then moving it to 11 feet will halve the intensity. Similarly, if the light is 8 inches, moving it to 11 inches reduces the intensity to half.

This can be a great help when it comes to positioning lights, as we shall see later. It can also be a great problem when the light is very close to the subject, for a very small positioning error can mean a serious exposure error.

Because of this rapid drop-off of light intensity with distance and the film's exposure latitude, there may not be enough light reaching the film for it to record an image of anything more than a short distance behind the subject. If the object in the background is the same distance behind the subject as the light source is in front of the subject, it will be receiving two full stops less light than the subject.

We can prove this simply from the information in Table 5.2. If our light-to-subject distance is 1 unit, and the background is 1 unit behind the subject, then the distance from the light to the background is 2 units. The light intensity at 1 unit is 1 and at 2 units, as we have already shown, it is 1/4 that at 1 unit. We should know by now that to reduce light intensity to 1/4 would be an exposure change of 2 full stops.

Since we know that slide film's exposure latitude is only +/− 2-1/2 stops, the objects in the background at the flash-to-subject distance will be just within the film's range and may just register. Anything much further behind that, however, will not have enough light falling on it to register on film, and the result is the familiar black background.

The rule applies to print films as well, but because of their greater exposure latitude, items a little further away will register (at about one and a half times the light-to-subject distance behind the subject with color print film, and at twice the distance with black and white print film).

It does not matter how powerful the flash or floodlight you use is, what aperture you shoot at, or even if it is a white wall in behind—it is the distance between the light source and the subject that matters. With slide film, if your light-to-subject distance is 8 feet, then anything much beyond 8 feet behind it will be black. If your flash-to-subject distance is 2 inches, anything much more than 2 inches behind the subject will be black.

If you try to open the aperture to lighten the background, then you overexpose the subject. The only solutions to this dilemma are either to move the light source further back or illuminate the background separately.

This drop-off can create lots of headaches, but there are solutions to some of the problems. They will be discussed in more detail as they occur.

POINT SOURCES AND DIFFUSED LIGHT

Light sources can also be broken down into two types: point source and diffused. Any kind of lighting source can be one or the other.

A point source of light is simply that—light emanating from a single point (or a very small area). It can be a light bulb, electronic flash, or the sun. It is very directional in nature, and produces hard shadows and "contrasty" images. It is particularly unflattering to subjects such as delicate flowers or things with soft, subtle colors. It also creates "hot spots" on shiny surfaces.

A diffused source of light scatters the light rays so that they are coming from many directions. It can be a light or flash with a diffuser, a piece of drafting paper, a thin white cloth, and so forth, between the light and subject, or sunlight through thin overcast clouds. The effect is a much more even and gentler light, which emphasizes subtle detail and colors that point source lighting obliterates. Diffused light is the best light for most close-up work, *especially nature photography*. There will still be shadows, but they range from much softer to almost nonexistent.

Shade is not the same as, nor as nice as, diffused light from a thin overcast. Shade is diffused too much, with no shadows, and is thus very flat and lifeless in comparison. Although shade is much better than direct sunlight for close-up work, reflectors or a touch of flash may be needed to add highlights and shadows.

To work properly, a diffuser must be larger than the subject being photographed. When used to photograph insects and other very small subjects, an electronic flash is large enough to behave as a diffused light source.

POINT SOURCE AND DIFFUSED LIGHTING

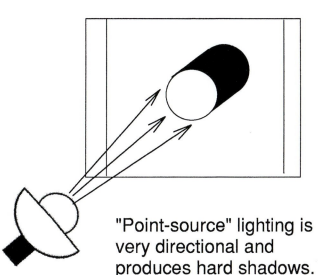

"Point-source" lighting is very directional and produces hard shadows.

Diffused lighting is non-directional. The light rays are scattered, striking the subject from many directions. Shadows are softer or almost non-existant.

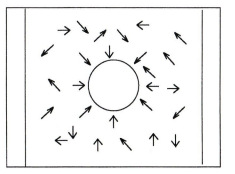

FIGURE 5.2

CHAPTER 6

EXPOSURE

To record an image, the film must be exposed to light. It then must be processed to make this recorded image permanent. Exactly how much light film must be exposed to is difficult to say, because it depends upon the film speed and how you want the subject to appear on film. In this chapter, we will deal with what I call a "technically correct" exposure. That is, an exposure setting that results in an image that renders the tonality of the subject as accurately as the film will allow.

An exposure setting is a combination of f-stop and shutter speed, which is determined by the speed of the film and the amount of light falling on the subject. You can pick either the aperture or shutter speed you wish to use, and a light meter will determine the value of the other. You cannot arbitrarily pick both. That is, you cannot just decide you want to use 1/500 second to stop motion *and* f32 for maximum depth of field unless film speed and lighting conditions permit that combination.

To demonstrate exposure settings, I will use an "old-fashioned" handheld light meter with a dial for explanation purposes. The principles are the same no matter what type of meter you use, whether it's handheld or built-in. I prefer the dial meters over the purely digital, because you can get a lot more information from the dial at a glance without needing to push any buttons.

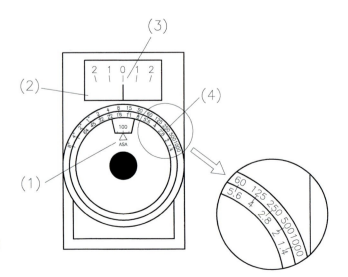

FIGURE 6.1 A simple handheld light meter.

Referring to the drawing of a simple light meter (Figure 6.1), first we set the ASA of the film we are using into the meter (1). Next, we meter our subject. (Check how your particular meter works.) In most, a needle (2) will move, and we must turn the dial until the needle lies over the "0" (3) or another reference point. Some meters require you to match two needles. Digital meters will give a direct readout without this step.

Now, look at the shutter speed and the aperture scales (4) in the drawing. If you have metered properly and the needle is zeroed, any one of the combinations of aperture and shutter speeds shown will result in a properly exposed image.

All of these exposure settings are *"equivalent exposure"* settings. Any one of them, provided your equipment is functioning correctly, will result in images that are the same contrast and density on film. They will not, however, look exactly the same; the depth of field and freezing of motion will be different in each. (If you are using a digital meter, changing the selected aperture or shutter speed should display an equivalent exposure combination.)

Notice that both the speed and aperture combinations vary by the same amount. If you change the shutter speed by a full step, the aperture changes by a full stop also, only it changes in the opposite direction.

For example, if you choose an exposure reading of f16 at 1/125 second and decide to increase the shutter speed one step to 1/250, *you must open the aperture an equivalent amount*—in this case, by one f-stop to f11. Because of this inverse relationship, an increase in shutter speed means a decrease in depth of field and vice-versa. You trade off between motion-stopping ability and depth of field: as one goes up, the other goes down. The *only* ways to increase both simultaneously are either to add light or use faster film.

Photographically, *in terms of exposure*, the effect on the image of a change in shutter speed or aperture by the same number of stops (or steps) is exactly the same. Therefore, if you must make an exposure correction of a full number of stops, you may change either the shutter speed or the aperture by that number. If the change is to be more than one stop, you can divide the change between the aperture and shutter speed if you wish. Changing shutter speed or the aperture by two steps, or changing each by one step, creates an exposure change of two stops. You can only accomplish a half-stop change with the aperture, unless your camera allows you to set intermediate shutter speeds.

By understanding this principle, you can make quick exposure changes without having to meter or think too

hard. You move the shutter speed one direction and the aperture the other the same number of stops.

I have to admit that here is one time I prefer the old-fashioned shutter speed dial and aperture ring to the new pushbuttons. It is very easy to quickly change either and know by the feel of the clicks how many stops you've changed, or to do a very rapid change of many stops. With the pushbuttons you have to be watching a digital reading change and step through each stop or shutter speed, which takes time and can cause the loss of plenty of good photo opportunities.

MEASURING THE LIGHT

To measure the light accurately, the first thing to do is to calibrate the light meter(s) you will be using. The simplest method is to use what is called the *"Sunny f16 Rule,"* which essentially says that the proper "sunny day" exposure for any film is f16 at the shutter speed equal to (or nearest) the film speed. Thus, when using ASA 125 film, the correct sunny day exposure would be f16 at 1/125 second. We will then calibrate the meter over a range of film speeds to see if there is any reading error.

On a bright cloudless afternoon, set your exposure meter to ASA 32 and point it skyward away from the sun. (If you are using an incidence meter, stand in a well-lit open area facing the sun, then point the meter in the direction of the sun and slightly downwards toward the ground). If the meter is reading accurately, the corresponding aperture for the shutter speed equal to the ASA setting (1/30 being the nearest to 32 in this case) should be f16. If it isn't, then adjust the ASA setting dial until it is. This is the "Adjusted ASA." Record this in a chart like the one illustrated in Table 6.1 and then repeat this process for the other speeds listed.

If the adjusted ASA is greater than the ASA set, then the meter is overexposing. If it is less than the ASA set, it is underexposing. To correct for this error for a given film speed, set the light meter to the adjusted ASA value for that speed.

In Table 6.1 we can see my Canon A1 consistently overexposing by one-third stop. To compensate, I just set the meter to a film speed 1/3 greater than the film's rated speed. I can also compensate by setting the exposure compensation dial to underexpose by 1/2 stop, since both have the same effect. I prefer to adjust the ASA dial, however, because exposure compensation controls tend to be forgotten until after you've shot (and incorrectly exposed) a roll or two.

TABLE 6.1 Exposure correction chart for my Canon A1.

ASA Set	Shutter Speed	Adjusted ASA
32	1/30	40
64	1/60	80
125	1/125	160
250	1/250	320
500	1/500	640
1000	1/1000	1200

If the pattern is very erratic, there may be something wrong with the meter, in which case it may be advisable to run the test a few times. If it continues to be erratic, have it serviced.

Remember, calibration must be done for every meter used and the corrections apply only to the meter tested. Don't be surprised if they all require different compensation. One photographer said that at his workshops he has everyone do the "Sunny f16" test and compare their readings—there can be a spread of as much as two full stops!

You might occasionally want to compare readings between various meters as well. They should all give the same exposure readings for the same ASA (corrected) and lighting conditions. With experience, you will get to know if your meter is acting strange.

Once your meters have been calibrated, I recommend including at least one shot of an 18-percent-gray card in a couple of films. Fill as much of the frame with the card as you can, meter off the card, and then compare the results to the actual card. If everything is working properly, they should match pretty closely. If the exposures seem to be out consistently, there may be problems with the camera's shutter speeds. If they seem to be out only when a particular lens is used, suspect problems with the aperture.

USING A LIGHT METER

There is a lot more to using a light meter than simply pointing it in the direction of the subject and blindly using whatever reading it says.

A light meter is not an absolutely precise instrument (even if it is computerized), and it will only give

an accurate reading under very limited circumstances. It can be fooled very easily if it is not used properly. In fact, some can even be fooled by the color of the light as their sensitivity to different colors of the spectrum may vary.

It has been determined that the "average" scene, whatever that may be, reflects 18 percent of the light falling on it, so light meters are calibrated to give a proper exposure reading under these conditions. If, however, the scene does not have average brightness, the readings may be quite inaccurate.

An incidence meter is held *at the subject* and the white globe is *aimed towards the camera* with a very slight downward tilt to prevent excess light from above affecting the reading. This reading may still have to be corrected to compensate for filters and other factors such as light loss due to extension.

In really close work you won't be able to get the meter in a position to take an accurate reading. Even if you could, when working closely at magnifications above 2X, being off by an inch or two could mean major exposure errors.

Handheld reflectance meters are pointed towards the subject. Standing where you are going to take the picture from and taking the reading only works with very large subjects such as landscapes, buildings, and such. Ideally, you should get as close to the subject as you can and meter something with known reflectance, such as an area that is about 18 percent gray or a neutral gray card. Hold the card near the subject (or in a similarly lit area) with a slight backward tilt and take your reading off of the card. Hold the meter close enough that it will only see the card. With TTL metering, fill as much of the frame with the card as possible.

Reflectance meters also require exposure corrections to their readings for light loss and filters. In addition, they require exposure correction for the brightness of the subject. Spot meters excepted, they do not work well in really close either, because they read an angle that is much too wide to be of any value.

A spot meter solves the reading angle problem. Reading a one-degree angle, you can almost always find an area of known reflectance in every shot big enough to take a reading off of.

For close-up work, TTL metering is best for two reasons. First of all, it automatically compensates for light losses due to extensions, filters, and so on (calculating these can be a time-consuming headache at times). Secondly, it reads a very narrow portion of the scene—only what you see through the lens. If your TTL meter has a spot meter option, so much the better, as you can read smaller areas and be much more precise.

Since the light reflectance meters are measuring is that which is reflected from the subject, they will always be prone to errors. No matter what the true reflectance (or "brightness") of the subject, these meters will always assume that they are looking at an average 18 percent scene, and the readings they give will result in the scene being reproduced on film as though it were 18 percent.

We can test this out experimentally by photographing a white card, an 18-percent-gray card, and a black card, metering each and using the settings given directly. Instead of getting white, 18 percent gray, and black prints, *all three will be 18 percent gray!* The meter, thinking that all cards were 18 percent gray, gave readings that would render them 18 percent gray in the final prints. The light card was underexposed and the dark card was overexposed. The same thing happens if the overall scene is predominantly lighter or darker than 18 percent gray.

It is possible to compensate for this in one of several ways. One method is to use a chart like Table 6.2. You simply meter the subject itself and compensate by adjusting the reading by the amount shown based upon the brightness of the subject. It is a rather simple one. I have seen some where the author has expanded it from +2 to −2 stops in one-third-stop increments.

To use the charts, for example, suppose we meter a bright yellow butterfly, then we look at the chart and see that for a subject of similar brightness (dandelion yellow) the exposure has to be increased by one stop.

TABLE 6.2 TO USE A "SUBJECT BRIGHTNESS CHART," METER THE SUBJECT ITSELF. DETERMINE ITS APPROXIMATE BRIGHTNESS COMPARED TO AN OBJECT OF "KNOWN" BRIGHTNESS, THEN COMPENSATE THE EXPOSURE ACCORDINGLY.

Subject Brightness Chart

Subject Brightness	Exposure Compensation
White	Open 2 stops
Soft Pink	Open 1-1/2 stops
Dandelion Yellow	Open 1 stop
Sand	Open 1/2 stop
18 Percent Gray	None
Cedar Bark	Close 1/2 stop
Dark Green	Close 1 stop
Wet Cedar Bark	Close 1-1/2 stops
Dark Shadow	Close 2 stops

These charts are only approximate and take a lot of work to refine. You should make your own if you want to use this approach, because what someone else defines as "light yellow," "dark foliage," or "medium dark" may be entirely different than what you define it as.

You can make a chart by defining your own subjects of varying brightness, then metering them and a neutral gray card under the same lighting. The difference in the readings is the number of stops you must compensate your exposure by. If the subject is 18 percent, the reading will be the same as the gray card reading. If it is lighter, you open the lens by that number of stops, and if it is darker, close the lens.

Be sure to pick things that are likely to be accessible when shooting. Nature photographers, for example, pick different types of foliage, tree bark, or colors that they're likely to find in the flowers, animals, and birds they photograph.

You must also make up charts for each type of film you use (black and white, color print, or color slide) because of the films' different exposure latitudes. The only charts I've seen published are all made up for slide film. Frankly, I think they're another one of the ways some photographers use to complicate their life. They take too much time and fooling around.

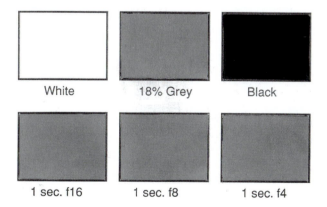

FIGURE 6.2 A LIGHT METER ASSUMES THAT WHATEVER IT IS AIMED AT IS AN AVERAGE 18-PERCENT-GRAY SCENE AND WILL GIVE A READING THAT WILL REPRODUCE IT AS SUCH IN THE FINISHED PRINT. HERE, A WHITE, 18 PERCENT GRAY, AND BLACK CARD (TOP ROW) WERE METERED AND THE SUGGESTED EXPOSURES WERE USED. THE RESULT IS THAT ALL THREE CARDS ARE REPRODUCED AT 18 PERCENT GRAY (BOTTOM ROW).

FIGURE 6.3 Using a "mini" gray card to take a close-up reading.

I often use a gray card. I have several sizes and a few tiny strips (as small as a quarter of an inch wide) which I use when doing high magnification work.

Ideally, you should hold the card up near the subject, but if you can't, loosen the tripod head a bit and point the meter at a gray card or an 18 percent area that is lit the same as your subject to take your reading. Be sure to pick an area that is large enough to fill most or all of the metering area of the screen. If you have built-in spot metering capabilities, use it. Be sure to frame and focus on your subject first, or the reading could be very inaccurate.

There is usually something in every scene that approximates 18 percent gray or for which you know the compensation. For example, nature photographers know that green grass or some gray tree barks (like cedar) are approximately 18 percent and thus meter one of them (provided, of course, that they are in similar lighting conditions as their subject). The most unusual known object I've heard of are the faded blue jeans of one photographer, who knows they are approximately 18 percent and takes his readings off of them.

Nature photographer Rod Planck says that if he is photographing gulls with slide film, he only has to meter their white feathers and open two stops and the exposure is correct. Knowing this, he also says he never has to bracket. It's simple, it saves time—and it works!

METERING A SUBJECT THAT ISN'T 18% GREY

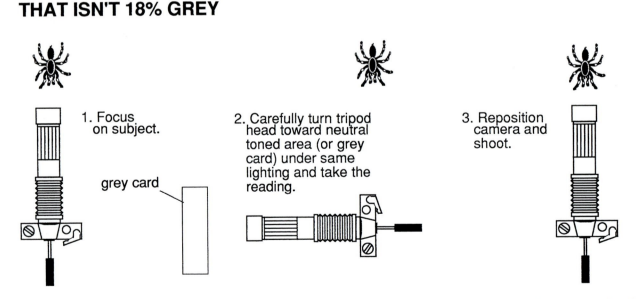

1. Focus on subject.

grey card

2. Carefully turn tripod head toward neutral toned area (or grey card) under same lighting and take the reading.

3. Reposition camera and shoot.

FIGURE 6.4 This metering technique can also be used when working with a ratio ruler if you cannot position the ruler near the subject (see Chapter 8, "Magnification and Magnification Methods"). It works best at magnifications up to about 2X.

For black and white film, which has double the exposure latitude, opening only two stops would reproduce the white feathers about midway between neutral gray and white. So you would have to open four stops to get correct exposure. For color print film, you would have to open about three stops.

The key to proper exposure is to meter the light on the subject itself and *expose for the subject,* not the entire scene. Sometimes this will mean that the backgrounds may burn out or go black, but it's the subject that is important.

If you will be dealing with a subject where there is a predominantly dark or light background, you may also want to bracket your shots because of a visual illusion. Although the subject is perfectly exposed, if the background is very bright it may "appear" to be overexposed, or underexposed if the background is very dark. By bracketing (discussed in the next section), you should have one image that "looks about right" even though it may not be the exposure your meter said to use.

Bracketing is also a useful troubleshooting tool. If you are finding that the image that has one stop more exposure is consistently the best, then you may have a problem with underexposure. Conversely, if the image with one stop less is consistently the best, overexposure. It could be your meter, technique, or camera causing the problem.

I know from experience that most of my exposure errors are underexposure, so when I bracket, I will emphasize that end by taking more on the overexposure side than the underexposure side. I might do one stop under and up to two stops over.

Something else to keep in mind when metering with TTL meters is that if your eye is not right up to the eyepiece, stray light can enter and have a devastating effect on the exposure if the metering system is in the prism head. In high magnification work I have seen as much as four stops difference between what the meter reads when you block out the light and what it reads if you move your eye back a bit and allow light into the viewfinder.

I recommend using a rubber eyecup and removing any glasses when taking the meter reading. I also *always* set the exposure manually once I have my reading, because this is where auto exposure systems can really create serious problems for you. You can be very careful when you take the reading, making sure that no stray light gets in, then back away from the camera so you won't cause any vibration, and shoot. If you didn't set the aperture and shutter to manual, the auto system will read the light coming in the viewfinder and reset

that exposure as soon as you move your eye away, and all your pictures will be underexposed.

Sometimes closing the viewfinder window (if equipped) will work, but I prefer setting the exposure manually because of what can happen with a Canon A1 and possibly others with similar auto exposure systems. The stopped down metering auto exposure mode is activated when the depth-of-field preview switch is locked on. In this mode, you stop down the lens, the meter will read, and the auto system will select and set the corresponding shutter speed.

Many times I have set up my shot, picked my f-stop, read the shutter speed, set it on the speed dial, taken the shot, and bracketed by changing the shutter speed setting. After shooting about five or six shots, I have discovered that I had forgotten to disengage the preview switch. This meant that my camera was still in auto mode, thus overriding whatever I set on the shutter speed dial, so I ended up with a string of slides all taken with the same exposure!

The effects of magnification on exposure, as you will find, are different with each method used. The various methods of determining proper exposure will be covered under each of the different methods, discussed in Chapter 8, "Magnification and Magnification Methods."

At times, you may find when you are using stopped-down metering that the viewfinder gets very dark, and it is either difficult or impossible to read the internal light meter display. A way around this is to note the aperture you wish to use, then open the lens until there is enough light to read the meter. Take a meter reading at this aperture, then simply count the number of stops from that aperture to the one you wish to use, and lengthen the exposure time by that number of steps.

For example, you may need to use f22 for a picture, but you can't even see the meter in the finder. You open the aperture and find you can read the meter when it has been opened three stops to f8. Take a reading at f8 and suppose the meter says 1/4 second at f8. Now close the lens to f22 and increase the shutter speed from 1/4 second by three steps, which would be 2 seconds. Therefore, 2 seconds at f22 is the new exposure.

BRACKETING

You may have heard the term "bracketing" before. It is a method of exposing that, in most cases, ensures that you will get at least one good exposure of a shot.

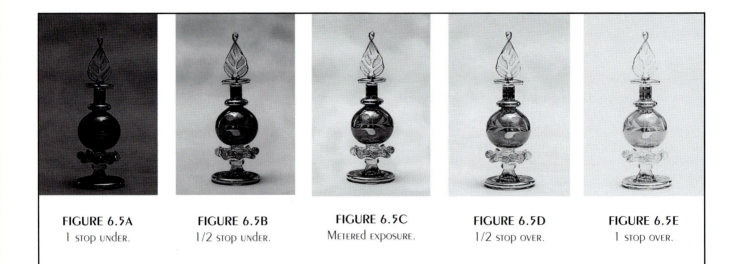

FIGURE 6.5A
1 stop under.

FIGURE 6.5B
1/2 stop under.

FIGURE 6.5C
Metered exposure.

FIGURE 6.5D
1/2 stop over.

FIGURE 6.5E
1 stop over.

FIGURE 6.5 To insure at least one good exposure, many photographers will bracket the shot. For color slide film, the bracketing will usually only be in half-stop increments. For print film, bracketing may be done using full-stop increments because of its wider exposure latitude.

To bracket, you must first determine what the correct exposure should be. The aperture is then set one stop larger than metered and a series of five shots are taken; the aperture being closed by a half stop each shot. The results are a series with exposures that are one stop and a half stop over the correct exposure, the correct exposure, and a half stop and one stop under the correct exposure.

Some photographers may vary this process by using full stops for print film, or by skewing their bracketing in favor of the over- or underexposure side if necessary. They also may take many more than five shots or bracket in third-stop increments, depending on how important it is to have the perfect exposure.

Some of the data backs for cameras allow for the programming of bracketing, so that the camera automatically performs the operation every time you take a shot.

Bracketing is usually used in circumstances where getting an accurate exposure is difficult or where you will never have the opportunity to get the shot again and want to be sure you have one good one. Some photographers use it, however, in lieu of learning proper metering technique. If you make enough exposures, you're bound to get *one* right.

CHAPTER 7

SPECIAL PROBLEMS AND SOME SOLUTIONS

There are many problems encountered in close-up photography. Some you may encounter in any field of photography, but not to the extent you do in close-up work, and others are almost exclusive to the close-up world. As a general rule, *the more you magnify the subject, the more you magnify the problems.*

Many times the problems are interconnected—solving one aggravates another and solving the other just creates yet another, so you must make many compromises. Often you will come to a satisfactory solution, but there are times it may be absolutely impossible to get a worthwhile picture because a balance cannot be had under the existing circumstances.

DEPTH OF FIELD

The depth of field becomes extremely critical in close-up and macro work. The closer you get, the shallower the depth of field gets and the faster the rate of decline of the depth of field. At magnifications around life-size you might have a depth of field of a centimeter or two at a particular aperture setting, and at 10X you may only have a fraction of a millimeter at the same aperture.

Focusing is critical. You cannot compensate for bad focus by stopping down the way you might be able to ordinarily, because you simply may not have the depth of field available or the necessary shutter speed may be far too slow to be acceptable because of subject movement or reciprocity failure of the film.

Many pictures are ruined by failure to adequately check the depth of field before shooting. With too much depth of field, objects in the foreground and background may appear as annoying distractions; with too little, important features of the subject may be out of focus and blurry.

Whenever the conditions permit, use the depth of field preview button prior to shooting. Study the image through the viewfinder and see how it looks at various aperture settings before you shoot. The viewfinder will darken as you stop down— sometimes to the point where you think you cannot see anything at all. The usual mistake is to just glance through the viewfinder quickly and hope for the best because it's too dark to see any details.

The trick here is that you must allow your eye to adjust to the lower levels of light just as you must if you walk indoors on a bright sunny day. It may take a few minutes, and it helps to use a rubber eyecup, to cup your hand around the viewfinder, or even to use a black cape like the old-fashioned photographers. In all but extreme conditions, you will be able to see well enough to evaluate the image.

If you are indoors or using a flash, bring in additional light on the subject for focusing and checking the depth of field, then shut it off before shooting. A quartz halogen auto headlight is great for this, as it is very bright and does not throw as much heat on the subject as a tungsten light.

As the depth of field diminishes, the tendency is to compensate by stopping right down. This, of course, means longer exposures, more chances of vibration, and loss of sharpness due to something called diffraction (which I will discuss later in this chapter)—all of which cause a reduction in image quality.

When photographing under ordinary conditions, some photographers use the depth-of-field scales on the lenses to set the focus. This does not work in close-up work because the scales on the lenses are only accurate when no extension or supplementary lenses are used.

Others may try to "guesstimate" about where they should focus, expecting the depth of field to correct for slight errors; but again, you can't do this in close-up work. Using the preview button eliminates the guesswork, reduces waste, and saves time and disappointment in the long run.

VIBRATION AND SUBJECT MOVEMENT

Because of light losses, exposure times increase as you magnify your subjects. Outdoors, exposure times of 1/8 second or longer are not unusual, nor are times exceeding 8 seconds indoors.

All movement, whether of camera or subject, is magnified by the same factor as the image. If, for example, the subject moves 1mm, at 1/8 life-size it will appear to have traveled 1/8mm across the film, which might not even be noticeable. At life-size, it has moved 1mm, and at 8 times life size, 8mm. It may not sound like a lot, but looking at it another way, your 35mm frame is 36mm wide, and at 1/8 life-size the subject will have covered 1/288 of the screen. At life-size, it will have covered 1/36 of the frame, and at 8 times life-size it will have covered almost 1/4 of the screen—and that will be very noticeable!

The easiest movement to eliminate is camera movement. Our primary tools are the tripod, copy stand, clamps, and other various means of support.

A tripod is only as solid as the ground it is standing upon. If the ground is soft, like a sphagnum bog or thick carpet, you have to stay absolutely still while shooting—on a bog, merely moving your head back from the eyepiece can cause enough movement of the system to throw everything out of focus.

There is vibration caused by movement of the mirror and shutter. Whether it is enough to actually cause any observable effect is another question. All you can really do about it is make sure the camera is secured firmly to a tripod, copy stand, or clamp.

When using extension and/or long lenses, the effects of any vibration will be pronounced. If lots of extension tubes are being used, mount the camera on the tripod by the tubes or lens barrel using a ring clamp. It is more stable and puts less strain on the lens mount on the camera body.

Whenever you use a bellows, always try to keep the center of the system as near to being directly over the center post of the tripod as possible. If you rack the focusing rail right out, the weight is on the end of a long lever and will not only vibrate very easily, but will magnify any vibrations.

If you can obtain the required degree of magnification in one of several ways and the end results are exactly the same, choose the method that requires the shortest setup. For life-size magnification, for example, instead of using a 100mm lens on 100mm of bellows extension, use a 50mm lens on 50mm tubes, reverse a 50mm lens with just a touch of extension, or use a macro lens. (These methods will be discussed in Chapter 8, "Magnification and Magnification Methods.") Smaller setups are lighter and less prone to vibration and shake.

Avoid all physical contact with the camera during exposure. If you can, use a cable release or timer to trip the shutter rather than pressing the button by hand, and don't have your eye pressing against the viewfinder when shooting.

If it is possible, brace or support the front of the lens by putting something under it to take the weight off of the lens mount. I've used film boxes, pillows, sticks, rocks, clamps, camera bags, and even lenses or other equipment. Some photographers carry beanbags for this purpose.

Many times when I am in the field without my tripod, or when I am trying to shoot from near ground level, I will sit my camera on the ground, frame the

KEEP THE WEIGHT EVENLY DISTRIBUTED OVER THE CENTER OF THE TRIPOD

FIGURE 7.1 The system on the left has the mass centered over the tripod head. This is much more stable than the setup on the right where most of the weight is hanging out over the front. Such a setup is much more susceptible to vibration and will magnify movement rather than diminish it.

shot, then stick whatever I can wherever I need to under the body and lens so that I can let go of the camera and use the timer or cable release.

If you have to raise or lower the camera on a tripod, it is better to extend the tripod legs than the center post. One engineer told me that when you extend the center post, your tripod has become a monopod, and monopods are not very steady—the longer you extend the post, the shakier everything gets.

Subject movement is another matter. Because we may not be able to control, we just have to work around it.

Wind is very likely to create a problem with subject movement. Even when the wind appears to be a dead calm, if you zoom in on a spider in its web, it may look as though it is bouncing around like a cork in the Atlantic during a gale. Fortunately, it has been my experience that light winds do not usually blow steadily. If you wait long enough, it will break—perhaps only for a few seconds, but long enough to take a shot. Keep your eye to the viewfinder for a while, watch for the subject to stop, and shoot quickly (providing it is still in focus, of course). With experience, you will be able to judge just when to shoot.

Live subjects such as small animals and insects present the greatest problems with movement. Some, like a female praying mantis or a tarantula, will sit motionless for hours. Others will stop now and then, while many will not sit still for a split second. For these active subjects, electronic flash is the *only* solution.

Lens Faults

Edge-to-edge sharpness—or rather the lack of it—is the most common lens fault (see Figures 2.6 and 2.7). You won't likely notice it unless you photograph flat objects such as stamps, or do other copy work involving fine text or drawings. Straight lines or lines of type near the corners of the frame will take on a bent or curved appearance, and there may be a slightly softer focus with less contrast. The degree of such distortion varies with the lens—I have seen some with little or no noticeable distortion, and one that was like a fun house mirror. Stopping the lens down may help reduce this problem somewhat, but if you need edge-to-edge sharpness, you need a flat field lens.

There are other lens faults such as astigmatism, coma, and spherical aberrations, to name a few. But unless you have a really bad lens you will not likely be troubled by these, or even notice there is a problem, unless you are doing side-by side comparisons of shots taken under laboratory conditions with corrected lenses. If you do need critical results, then you will likely be using precision macro lenses that have been corrected for most of these faults.

DIFFRACTION

Many photographers suggest, or have heard, that when doing close-up work you must *always* use the smallest aperture you can set because you need maximum depth of field. They not only don't understand creative photography (where there are no hard rules), they don't understand diffraction!

Diffraction affects all photographers who like to stop their lenses down a lot. In high magnification it can be a very serious problem and utterly ruin a good photograph.

Whenever light passes through any opening, diffraction occurs along the edges of the opening—that is, the light waves are bent slightly. As it bends, each wavelength of light is bent a different amount, and the light begins to separate out into its component colors (this is how light passing through diffraction gratings, as in filters that create rainbow effects, work). The smaller the hole or width of the slits, the greater the bending and separation.

The result is that sharp edges begin to soften, and the colors along these edges start to bleed into one another giving a soft appearance to the photograph overall. Often the effects of diffraction are incorrectly attributed to camera shake or bad focus, because they can appear similar at first glance.

If you know anyone interested in model train photography, you may have heard about "pinhole photography" where pinhole apertures are used "for realistic depth of field" in their photos of their train layouts (some of these layouts are huge and require tremendous depth of field).

Some go as far as replacing the aperture in the lens with a thin piece of copper or brass sheet with a micro-tiny hole drilled through it by a jeweler, and exposing the picture for many minutes at a time. They do get terrific depth of field, but the diffraction is so bad that the photos are *never* razor sharp! They look like very old photos done with an ancient box camera. In these cases,

the diffraction may be acceptable as it may add to the realism of the picture—particularly if they are old-style locomotives.

An aperture setting marked on the lens is only that value *when the lens is focused at infinity*. As we increase magnification by extending the lens (the most popular way), the effective aperture gets smaller. The smaller it gets, the greater the problem diffraction becomes.

The following formula can be used to figure out what the effective aperture we are using is:

$$FE = FM \times (M + 1)$$

where

FE = Effective f-stop
FM = f-stop (marked on lens)
M = Magnification

At life size (1X), using f16, we get

$$FE = 16 \times (1+1) = f32$$

At five times life size (5X), using f16, we get

$$FE = 16 \times (5+1) = f96$$

Thus, the smaller the marked aperture and the greater the magnification, the smaller the effective aperture and the greater the effects of diffraction.

I attended one photo club meeting where the guest, an insect photographer, routinely used f45 for maximum depth of field and used magnifications up to 18X life-size. Using the formula, his effective f-stop would be $45 \times (18+1) = f855$! No wonder some of his photos looked soft like watercolor paintings rather than photographs; the diffraction was so severe.

The effects of diffraction are primarily noticed on flat subjects with very sharp dividing lines between colors. You can minimize the problem by not stopping down more than necessary. Don't use f16 or f22 if you only need f5.6 or f8 to give you enough depth of field. Using the larger aperture also allows you to use a faster shutter speed.

LIGHT LOSS

Undoubtedly, this is one of the biggest problems in close-up photography. There is a price to pay for magnification, and it is light loss.

There are only three ways to compensate for light losses:

1. increase film speed,
2. increase exposure, or
3. add more light.

All have their problems.

Increasing film speed increases grain and reduces color quality. I generally never use films faster than ASA 200. Increasing exposure means slower shutter speeds or larger apertures, which may mean you can't get the picture the way you hoped.

If the subject moves, or if you are in the reciprocity failure region, you may be restricted to a minimum shutter speed—which means that you must open the aperture and the resulting depth of field may be inadequate.

Adding more light may mean more or increased wattage lamps, more powerful flashes, or moving the lights closer to the subject—which can be a problem if space is limited or you're already in as tight as you can get. Increasing the power of floodlights or moving them closer increases heat—which may be uncomfortable for the photographer and destructive to the subject.

LIGHTING THE SUBJECT

Light loss isn't the only lighting problem faced by the close-up photographer. Often you may be working very close to the subject. With the lens literally only a fraction of an inch away, it may be almost impossible to get a flash or lamp into position to give the best possible lighting.

Equipment (and the photographer) often gets in the way of the light source and casts shadows. In some instances almost direct side-lighting may be the only way to light things—and it is rarely appealing. For these situations, there are mirrors and light housings, special spot lamps, and even fiber-optic lights available. In their absence, ingenuity often prevails, and reflectors made from tinfoil and cardboard may save the day.

Outdoors, you may have to use reflectors, shades, diffusers, and fill flash to obtain the effects you want because you can't move the sun. If not controlled carefully, backlighting can play havoc, causing specular highlights or flare and totally washing out or otherwise ruining many good shots.

In addition, the heat generated by lamps is dangerous to both subject and photographer. It can kill plants, animals, and insects, melt plastics, and make metal objects screaming hot. In really close quarters, they can get in the way, and it is very easy to get badly burned from accidental contact with a bulb or its reflector. If it happens to be shining on the camera, it won't do the film much good either.

VIGNETTING

There are two types of vignetting in photography: one is desirable for producing creative images, and one is undesirable, caused by the interference of filters, adapter rings, lens hoods, or poorly designed equipment.

If the edges of these devices protrude such that they fall within the lens' angle of view, the result will be underexposure around the corners of the frame in a "circular" pattern. The amount depends upon how much they interfere. It can be so little that you do not see it through the viewfinder, even though it will show up on film or, in severe cases, produce circular pictures surrounded by black as though you're looking through a microscope.

A way to check for vignetting is to stop the lens all the way down to its smallest aperture and, using the depth-of-field preview, look at a bright light source such as a brightly-lit sky. You should be able to see any

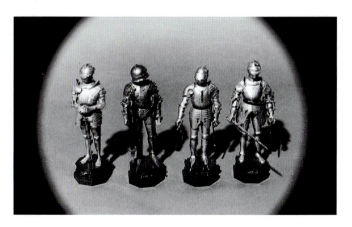

FIGURE 7.2 Vignetting is caused by something in the way of the lens, usually too many filters or a wrong-sized lens shade. A rather severe case is shown.

vignetting easily: it will appear as noticeable darkening around the corners of the screen. Reducing the number of filters or using a larger lens hood can usually eliminate vignetting.

Lens Flare

This problem is not unique to close-up photography. It is basically caused by stray light hitting the front surface of the lens, which results in hot spots, streaks, specular highlights (those round aperture-shaped hot spots), and washed-out images. Sometimes the effect is easily seen through the viewfinder, or it may be so subtle it isn't noticed until the film is processed.

For general shooting, lens hoods (or shades) are used. These cut down a lot of flare problems, but they don't always eliminate it—especially if you are using backlighting or there are highly reflective surfaces nearby.

Lens flare can be a bigger problem with close-up photography, because many times, as when using short-mount macros or reversed lenses, the lenses are right out front in the open. Lens shades or hoods cannot be used with them because they will interfere with the lighting of the subject.

If it is possible to shade the side of the lens where the stray light is coming from without affecting the subject lighting, then do it. (An example of how to do this is shown in Figure 9.5.) The shading device can be a hand, piece of card, or anything that will block the light. It can be positioned anywhere between the lens and the light source. If that doesn't work, try repositioning the light. You may only have to move it a bit.

Polarizing filters can also be used to cut down problems with stray light, but you will lose up to two stops.

CHAPTER 8

MAGNIFICATION AND MAGNIFICATION METHODS

"To magnify" means "to enlarge," although technically, any image produced by a lens is magnified whether it is enlarged, reduced, or life size.

If you are using TTL exposure systems, you really don't have to know anything about magnification, although it is nice to know if an image is 1/2 life size, life size, or 7.5 times life size. If you don't have TTL exposure, or if you plan to use non-TTL flashes or some methods that disconnect the TTL mode, then you will have to know about magnification and how to calculate it or you will never get a properly exposed image except, perhaps, by chance.

Photographically, magnification deals with comparing the size of the image produced on film to the size of the object being photographed. The term is often incorrectly used interchangeably with "Magnification Ratio." They are not the same. "*Magnification Ratio*" refers to a mathematical relationship of the size of the image on film compared to the actual size of the object. Mathematically, it is written as

$$R = I:O$$

where

R = the magnification Ratio
I = the size of the Image on film
O = the size of the Object

Example 1
The size of the image on film (I) is 1" in length. The size of the object (O) is 1/4".
Therefore the Ratio (R) = 1:1/4
(dividing both sides by 1/4 to eliminate the fraction, we have a ratio of 4:1).

Example 2
The size of the image on film (I) is 1" in length. The size of the object (O) is 6".
Therefore the Ratio (R) = 1:6.

The magnification ratio can be any number compared to any other number (e.g., 1:2, 47:123, 1/2:7/9, etc.). In Example 2, the image on film is smaller than the

object. It is still correct to refer to it as a "magnified image," even though it is really a reduction.

"Magnification" is a very specific magnification ratio. It is *always* the ratio of the image size to "1" (life size). It can be expressed as a lone number, fraction, or decimal, such as: magnification of 4, 1/2, or perhaps .25 life size. More often it is written in terms of "X," where the X represents life size—that is, 4X, 1/2X, .25X.

Magnifications less than one (fractions or decimals) are actually reductions (the image is smaller than life size). There are no such things as magnifications of "0" or negative values. They cannot exist.

The simplest formula for magnification is

$$M = \frac{I}{O}$$

where

M = the Magnification
I = the image size
O = the object size

Example 3

The size of the image on film (**I**) is 0.5" in length. The size of the object (**O**) is 1".

The magnification (**M**) is 0.5/1 life size. It can also be written as 0.5X or 1/2X.

Example 4

The size of the image on film (**I**) is 1/2" in length. The size of the object (**O**) is 1/8".

The magnification (**M**) is .5"/.125" = 4 times life size, or 4X.

If we know the magnification ratio, then obtaining the magnification is simple. Just substitute a division bar for the colon and divide!

Be very careful when dealing with magnifications and magnification ratios. If you write the ratio backwards, your magnification will be wrong. If you happen to be calculating exposure correction factors, it can mean an error of many stops.

Problems determining magnification may arise when using macro lenses. Some show the actual magnification on the barrel (i.e., .25, .5, etc.), some show the ratios (1:4, 1:2), and others show the reciprocals like shutter speeds (4 instead of 1/4, 2 instead of 1/2). Check the instruction sheets so you know which way they are written on your lenses.

There are a number of ways to determine the magnification being used in almost any situation. For each

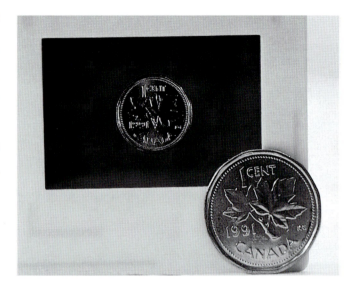

FIGURE 8.1 The image of the coin on film is approximately 5/8 life size. Its magnification ratio would be 5:8, and its magnification would be approximately .62X.

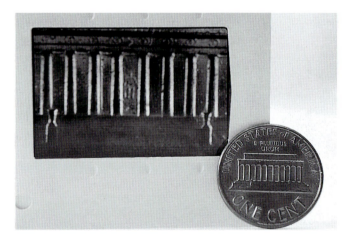

FIGURE 8.2 The image of the coin is approximately 3 times life size. The magnification ratio would be 3:1, and its magnification would be 3X.

method of achieving magnification detailed, there will be some fairly simple methods to calculate it. It is not always necessary to know what the precise magnification being used is, but if you do not have stopped-down TTL metering or TTL autoflash, you will have to be pretty close or exposures can be way off.

Instruction sheets that come with most bellows, extension tubes, and macro lenses have charts you can

look at to determine what your magnification is depending upon the lens being used and the extension of the bellows or tubes being used. These charts for tubes and bellows frequently list various lenses (usually a standard 50mm or 55mm lens and similar macro lens, and possibly the same lenses if reversed) and the resulting magnification with various lengths of extension. The charts with lenses are similar. In addition, some will have a small exposure correction chart that you reference once you've determined your magnification. One of the charts I have for extension tubes lists a 50mm lens and gives the resultant magnifications for it with extensions ranging from 5 to 65mm in increments of 5mm.

The difficulty with these charts is that they usually only list a small number of lens focal lengths and, invariably, you will want to try almost every lens you have and will find that many are not on the chart. When I first tried close-up work I assumed that if a lens wasn't listed on the instruction sheet for the tubes, you couldn't use it. You can use any focal length lens on extension, although some wide angles will vignette so severely that they cannot be used.

MAGNIFICATION RULERS

Magnification or Ratio rulers are another method of determining magnification. One of them is reproduced here life-size (Figure 8.3). Just photocopy it and glue it to a piece of light cardboard.

Hold the magnification ruler up to the subject and, while looking through the viewfinder, line up the left edge with the left side of the viewfinder and read the magnification off of the ruler where it touches the right side of the frame. On some, including the example, you can also read the number of stops exposure correction.

Example 5

Looking through the viewfinder, the left edge of the ruler is lined up with the left edge of the frame. At the right, we read .7X in the magnification row; below it, in the exposure correction row, we read 1.5 stops. Remember that exposure correction for magnification is always an exposure increase, so you would have to increase exposure by 1.5 stops to compensate for the light loss.

Magnification rulers work pretty well up to about 3X or 4X, but there are a few drawbacks. If the subject is more than a foot away and you can't sit the ruler in place, it can be very awkward (if not impossible) to hold it in place and look through the viewfinder at the

same time. It must also be held close to the subject. At high magnifications this may not be possible because of space limitations.

There are times you cannot use a magnification ruler. Most insects will not allow you to hold it near them, and there are times when only a fool would attempt to use one (photographing snapping turtles or hornets, for example).

There *is* a method of determining magnification with the ruler if you can't place it near the subject. This method is very similar to the method for taking light

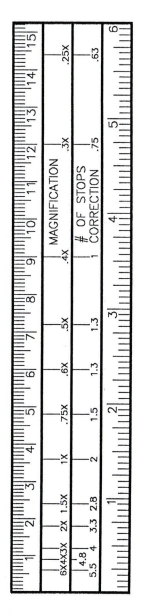

FIGURE 8.3 MAGNIFICATION RULER FOR 35MM FORMAT (FULL SCALE).

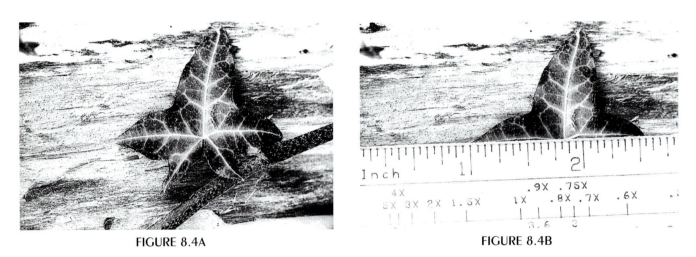

FIGURE 8.4A FIGURE 8.4B

FIGURE 8.4 We want to know the magnification being used to calculate exposure for the subject (Figure 8.4a). To use a ratio ruler, hold the ruler up to the subject and align the left edge of the ruler with the left edge of the viewfinder frame (Figure 8.4b). Read the magnification on the right edge of the frame (in this example, magnification is about .5X), or calculate it by dividing the width of the frame (1-1/2" for 35mm format) by the measurement on the ruler.

readings illustrated earlier (Figure 6.5). Focus on the subject, then swivel the camera so it is pointed in another direction that is well away from the subject. Hold the ruler so the left edge lines up with the left edge of the frame as usual, then carefully move the *ruler* in and out until it is in focus (do not readjust the focus!). When it comes into focus, just read the ruler as you would normally.

Make sure your ruler is made for your film format. I have never run across anything mentioning this before, but I quickly realized it was very important when I tried to use the ruler for 35mm format with my 4 × 5" camera and it read .3X at what should have been 1X.

Be careful when you read exposure corrections off of rulers and charts (like the ones included here). These exposure corrections are valid *only* when the lenses are extended out from the camera body! If you have used optical methods such as close-up lenses, lens stacking, or mixed these methods to achieve the magnification, they are useless and will result in overexposure if followed.

For example, if you extend a lens and the magnification is 2X, the charts will tell you to open the lens 3-1/4 stops to allow for light loss. If you reverse-mount a 24mm lens, you will get a magnification of about 2X, but if you open 3-1/4 stops, you may have just overexposed by about 3 stops because there may be little or no light loss with that method of magnification.

Most of the time, I prefer to calculate my magnification using the simple formula that I will provide later in this chapter. Ratio rulers and multiple pages of charts and tables are just more things to carry and keep track of, and it usually takes me longer to find the right ones than to do the calculations.

Ratio rulers are quick and easy to use, but their use is limited—although I once made a ratio ruler on the back of a piece of gray card so it served two purposes. With it I could read magnification off the front then flip it and meter off the back.

Magnification Methods

There are three methods of achieving magnification: optically with magnifying lenses, by extending a lens away from the film, or with a combination of both.

Extending the lens is by far the most inexpensive and popular method, but it does have its drawbacks. If we move the lens further from the film, the intensity of the light striking the film diminishes according to the inverse-square law, as mentioned in Chapter 5, "Light." This is often referred to as "light loss"—though we really haven't lost any light, just spread it out a bit. We can compensate for this loss to a point by increasing exposure, film speed, and/or lighting.

Optical magnification, with the exception of multipliers, has an advantage with little or no light lost. Its disadvantages are that it requires good optics, which are usually expensive, and it usually involves inserting additional glass in the light path, which can diffuse, soften, or distort the image as well.

Diopters

The simplest method of gaining magnification is by using diopters. These are low-power magnifying lenses, also called "close-up lenses" or "supplementary lenses," which screw into the filter threads of a regular lens and allow one to focus a little closer than normal. They are usually sold in sets of +1, +2, and +3 values, though I have heard you can get higher values. The higher the number, the greater the amount of magnification.

Diopters can be stacked, and the resulting power is the sum of their individual values: using a +2 and +3 = +5, for example. However, it is preferable to use only one at a time, such as a +3 instead of a combination of a +1 and +2.

The advantages of diopters are that they are relatively inexpensive and provide that little bit of extra magnification you need to photograph a single rose or even a large butterfly or moth. They are also easy to carry and use, and require no exposure compensation.

Diopters do have many disadvantages, however. The most noticeable downfall is that they are really not very good optically unless you buy the two-element variety such as those put out by Canon and Nikon. They are expensive, but they perform well.

Some of the really cheap ones are terrible—suffering from serious edge distortion. The greater the power, the worse the distortion.

You can reduce these effects by stopping the lens down and/or keeping critical items away from the frame edges. Stopping the lens down may limit what we can do creatively, result in background and foreground

FIGURE 8.6 Some of the really cheap diopters produce terrible edge distortion. Here is a photo of the edge of a dime. Three diopters, total power +6, were stacked onto a 200mm lens giving a magnification of 1.2X. The photo was shot at a wide open aperture (f4) to demonstrate just how bad the distortion near the edge of the frame can be.

distractions we don't want, and won't entirely eliminate the problem. But what I have found is that when I am doing something like close-up nature work, it really doesn't matter that much if the edges are a bit soft because you rarely need edge-to-edge sharpness anyway.

Diopters are of little value with short focal length lenses if you want to get in the 1:1 range or greater—they simply do not have the power. They are not normally color corrected and don't have antiflare coatings, so lens flare can be a problem in some lighting conditions.

To keep image degradation to a minimum, it is recommended that diopters up to +3 be used with regular or telephoto lenses, and that +4 to +6 be used with wide-angle lenses. When stacking, no more than two should be used, and the highest power diopter should be closest to the lens.

The formula for determining magnification when using a diopter is:

$$M = \frac{FL(p)}{1000/P}$$

where

M= Magnification
FL(p) = Focal length of the Primary Lens (camera lens)
P = Power of the Diopter

FIGURE 8.5 Diopters screw onto a lens just like a filter. When stacking diopters, always put the highest power diopter nearest the lens.

Solving this for a 100mm lens with a +1 diopter, the magnification would be 100/(1000/1), or .1X. For a +3 diopter, it would be 100/(1000/3) or .333X.

By rearranging this formula to solve for the diopter power required for a specific magnification, we get

$$P = \frac{1000 \times M}{FL(p)}$$

Using this formula, we can see that to achieve a magnification of 1X with a 50mm lens would require a +20 diopter, a 100mm lens would require a diopter power of +10, but a 200mm lens would only require +5. Therefore, the greatest magnification results can be obtained using diopters on longer lenses, because you do not need nearly the power and, therefore, lose less image quality for the same magnification.

EXTENSION

The use of extension is the most common method of reaching magnifications up to about 10X. Essentially, the lens is moved out (or extended) from the camera body using either a bellows, solid extension tubes, or a combination of each. The main difference between the two, aside from price and convenience, is that a bellows allows any increment of extension between its minimum and maximum travel, and tubes only allow extension in fixed increments (although some camera systems offer "variable length" extension tubes).

I recommend tubes as your first purchase as they cost considerably less than a bellows. Even if you do get

a bellows later on, the minimum extension on the bellows may be too much for many applications. For example, my Canon Autobellows has a minimum extension of 39mm. My extension rings come in a set of 5, 10, and two 20mm rings, which covers the extension range my bellows doesn't cover. I can also use them with the bellows when I need a little more than the maximum 175mm it allows.

Tubes and bellows may be available in both automatic or manual aperture versions. The autobellows uses a dual-cable release to achieve an auto-like aperture (one cable closes the aperture before the other releases the shutter). Some manufacturers make an "auto ring," which lets you use the dual-cable release to activate the lens aperture in a similar fashion when using non-auto-extension tubes or non-auto bellows.

Manual rings and bellows and auto bellows do not couple the TTL metering system or automatic exposure system to the aperture. Therefore, it is imperative that the camera have a stopped-down metering mode or else the internal meter is useless.

When you are purchasing these items, it is best to buy the original manufacturer's parts if they are available. I once purchased a "third party" set of auto tubes for the Canon A camera series that were so poorly designed that they vignetted badly no matter what focal length lens I used. I returned them because they were useless. Before purchasing tubes, it would be a good idea to try them out or do the test mentioned in the section on vignetting in Chapter 7, "Special Problems and Some Solutions," using a range of lenses.

You can use extension with almost any focal length lens. With short wide-angle lenses, extension can cause "retrofocus"—the plane of focus is actually somewhere behind the front element of the lens! Obviously, you can't focus on anything if this happens.

Determining your magnification when using extension is quite easy—much easier than fooling around with ratio rulers, so I don't understand why some insist upon using them under these circumstances. Simply divide the length of the extension by the focal length of the lens:

$$M = \frac{E}{FL}$$

where

M = Magnification
E = Extension Used
FL = Focal Length of Lens

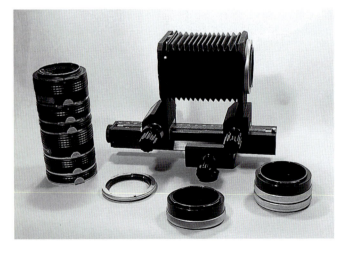

FIGURE 8.7 EXTENSION TUBES (OR RINGS) AND bellows.

Example 6

A 200 mm lens is being used with 50mm of extension. The magnification would then be 50/200 = .25X, or 1/4X if you prefer fractions.

Example 7

A 50 mm lens is being used with 50mm of extension. The magnification would then be 50/50 = 1X.

If we continue with the 50mm lens, adding another 50mm would give us 100mm extension and our magnification would be 100/50 = 2X. Adding another 50mm of extension on the 50mm lens would give us 150/50 = 3X, and so on. From this we can conclude that to increase magnification by a factor of 1X we must add an amount of extension equal to the focal length of the lens.

If we want a specific magnification and need to know how much extension is required, we just rewrite the formula:

E = M × FL

Example 8

We want a magnification of 1.5X and we are using a 70mm lens. 1.5 x 70 = 105mm extension required.

There are obvious limitations to using extension with ordinary lenses—particularly if you want high power. Lots of extension is required, and it becomes difficult to handle as well as very prone to vibration. Magnification of 3X with a 50mm lens would require a 150mm extension, but with a 200mm lens it would require an impractical 600mm extension!

Why, one may ask, if 1X can be achieved with a 50mm lens and 50mm of extension, would someone use a 200mm lens and 200mm of extension? The answer is because the 200mm lens has a narrower angle of view, so you can better isolate the subject from the background. It also allows a greater working distance so you don't have to crowd in on your subject.

For various reasons, you cannot always get up close enough to your subject. With some distance between you and the subject, it may also be easier to light it. If the working distance and angle of view are not important, then go with the shortest setup that gives the required magnification, because it is usually easier to work with and more stable.

There are other difficulties involving extension. It can be awkward to use in the field, and bellows are particularly cumbersome to carry and prone to damage if

you're not careful. (Whenever you are carrying one in the field, always remove the shutter release cables and collapse the bellows so they don't get caught and damaged.) You *cannot* hand hold a camera with a bellows attached—don't even try it. You must use a tripod.

Although they may be used for higher magnifications, the image quality of ordinary lenses begins to deteriorate above magnifications of about 2X.

Exposure Correction for Extension

Light loss is the primary disadvantage with extension. The amount of light lost and the resultant required correction are dependent upon the magnification. It does not matter if you are using a 35mm extension and a 35mm lens to get 1X, or if you get it using a 500mm lens and 500mm extension—the light loss is the same because the magnification is the same.

A TTL metering system automatically compensates for these losses, so if you have it you can ignore this section. If, however, you want to use a hand meter, an electronic flash that doesn't have TTL metering, or multiple flash units, you will need to know the following information.

Like everything else, there is an easy way to do exposure correction for extension and a difficult way. Many of the manufacturers' instruction sheets and some books like to give you all the mathematical formulae to calculate an exposure correction factor that you then multiply your exposure time by to get a corrected exposure.

Method A (The Hard Way)

Mathematically, if you are so inclined and have a scientific calculator, exposure correction can be determined by the following formula:

$$EC = \frac{\log\left(1 + \frac{E}{FL}\right)^2}{\log 2}$$

where

EC = Exposure Correction in stops
E = Extension
FL = lens Focal Length
log2 = .301030

Example 9

A 100mm lens with 65mm of extension is being used.

$$EC = \frac{\log\left(1 + \frac{65}{100}\right)^2}{.301030} = 1.444$$

Rounded off to the nearest half-stop, that's 1.5 stops. Go to step 4 in Method B.

Since magnification $(M) = \dfrac{E}{FL}$, this formula can also be written as:

$$EC = \frac{\log(1+M)^2}{\log 2}$$

Method B (The Easy Way)

For those of you not so mathematically inclined, this is the easy way:

1. Once you have composed your picture, meter it normally using your handheld reflectance meter and determine the uncorrected exposure setting you wish to use (the aperture and shutter speed combination you would use ordinarily).
2. Determine the magnification you are using.
3. Having determined the magnification, turn to the Exposure Correction Table (Table 8.1) and locate the magnification in one of the columns labeled "M." Read across. In the adjacent column labeled "STOPS" you will find the exposure correction required in number of stops. Once

TABLE 8.1 Exposure Correction Table.

Exposure Correction for Magnification Using Extension

M	STOPS	M	STOPS	M	STOPS
0.1	1/4	3.0	4	6.8	6
0.2	1/2	3.2	4 1/4	7.0	6
0.3	3/4	3.4	4 1/4	7.2	6
0.4	1	3.6	4 1/2	7.4	6 1/4
0.5	1 1/4	3.8	4 1/2	7.6	6 1/4
0.6	1 1/4	4.0	4 3/4	7.8	6 1/4
0.7	1 1/2	4.2	4 3/4	8.0	6 1/4
0.8	1 3/4	4.4	4 3/4	8.2	6 1/2
0.9	1 3/4	4.6	5	8.4	6 1/2
1.0	2	4.8	5	8.6	6 1/2
1.2	2 1/4	5.0	5 1/4	8.8	6 1/2
1.4	2 1/2	5.2	5 1/4	9.0	6 3/4
1.6	2 3/4	5.4	5 1/4	9.2	6 3/4
1.8	3	5.6	5 1/2	9.4	6 3/4
2.0	3 1/4	5.8	5 1/2	9.6	6 3/4
2.2	3 1/4	6.0	5 1/2	9.8	6 3/4
2.4	3 1/2	6.2	5 3/4	10.0	7
2.6	3 3/4	6.4	5 3/4		
2.8	3 3/4	6.6	5 3/4		

Note: The corrections on this table are only valid when using extension alone for magnification.
To use the table, simply look up the magnification you are using in column (M) and read across.

you've determined your correction for extension (by whichever method), you can continue.

4. Increase the exposure time and/or open the aperture by the number of stops determined.
5. Determine and add correction for any filters and subject brightness.
6. Check the film reciprocity chart, and make any corrections required.
7. Shoot when ready.

Example 10

The subject is a flat postage stamp, so a great deal of depth of field is not necessary. The light meter reads f8 at 1/60 second, and we have calculated the magnification as 1.2X.

Locating 1.2 under the "M" and reading across to the column labeled "STOPS," we see the exposure compensation is 2-1/4 stops.

First, let's take care of the 1/4 stop. Either round it up to a 1/2 stop or down to 0 (or use 1/3 stop if you've got it)—it's not really going to make a lot of difference.

Now the 2 stops can be in the aperture, resulting in a corrected reading of f4 at 1/60 second, in the shutter speed giving f8 at 1/15 second, or divided between them giving f5.6 at 1/30 second. The choice is yours and depends on whether depth of field or motion stopping is most important.

If any filters are used, or compensation for subject brightness needed, you must also add the corrections for them now, and you must check the film manufacturer's data sheet and see if there is any further correction required for reciprocity failure and make them too. You *must* make this last check for reciprocity failure whether you have TTL metering or not.

Now you are ready to shoot.

Using Extension and Bellows

Extension tubes are really quite easy to use. You just place them between the lens and body, focus, and shoot.

If you have auto tubes, that's about it. If not, you will have to open and close the lens manually.

Using tubes takes a little bit of experimentation. Look through your viewfinder and start adding or subtracting rings of various sizes until the image is about the size you want it. You aren't restricted to how many rings you can use. Use two or three sets if you like.

The biggest difficulty I've found in using rings is that frequently you can't get precisely the image size you want. I remember trying to photograph something

with my Maxxum where inserting a 25mm ring was just a bit too much, and the subject overran the edges of the frame. With the 15mm ring, the image was just a bit too small, and there were some annoying things in the background. I needed 20mm, but there was no 5mm or 20mm ring, so I settled on the 15mm and put up with the unwanted extra background.

When using extension, you have to move the camera within a small distance range from the subject because the focusing range of the lens has been considerably reduced. When framing the shot, you will need to make lots of small movements of the tripod to get the camera within range. This is where you should really have a focusing rail. You move your tripod until you're almost in position, then you can roll the camera back and forth for fine-tuning. It really makes a big difference when you are working very close, where moving the tripod a few millimeters is impractical.

A bellows (Figure 8.8) is really nothing more than a fancy variable extension tube with built-in focusing rail. There is a base that sits on a tripod. The base has a rack and pinion system controlled by knobs that cause a larger rail on top (to which the lens, body, and bellows itself are attached) to roll back and forth.

The big rail has two vertical mounting plates with a paper bellows between them. The camera body mounts on the one at the rear, and the one at the front has the

TYPICAL BELLOWS ARRANGEMENT

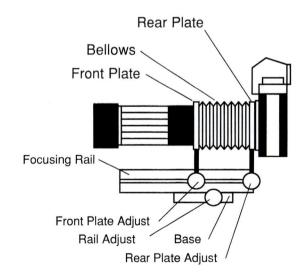

FIGURE 8.8 Typical bellows arrangement.

lens mounted on it. This front plate can be removed and reversed on some units so you can use a lens in reverse.

Each of these plates has knobs that allow you to run them back and forth on the big rail.

Moving the front and rear mounting plates back and forth can change magnification. I usually set the rear one with the body to the rear limit and, while viewing the subject through the lens, move the front plate until the image is close to the desired size. As you focus, you will notice the image size change slightly so you may have to do some fine-tuning—move the lens in or out a bit until it's just the right size, and adjust the focus until you get what you want. (Alternately, you can fix the front plate and move the rear plate, or you can move both.) You figure out your extension amount using the little measuring scale on the rail (the instructions will tell you how to read them).

If you need to do a bit of "fine-tuning" with the focus (i.e., you're at the end of the focus travel and it still isn't quite sharp), you can use the knob on the focusing rail and move the whole unit in and out a bit. If the bellows and camera are hanging too far out over the tripod, then move the tripod a bit so that the bellows will be located closer to the center of the tripod where it will be more stable. You will be especially thankful for the focusing rail if you are working at 5X with a short-mount macro—there's no way you can move a tripod 2 or 3mm easily.

Personally, I like my bellows better than my macro lens, because to change magnification with the bellows, I can just move either the lens or body (or both) back and forth on the rail. With the macro lens, changing magnification means moving the whole tripod, unless it's only a small change and you have a focusing rail.

Macro Lenses

A true macro lens is a special lens with its own built-in extension that can focus from infinity to close enough to produce a magnification of 1:2 or 1:1 without any additional extension. It is also a "flat field" lens that gives an image that is sharp from edge to edge and is ideal for flat copy work. Macro lens images are always very sharp and crisp.

Many close-up photographers favor macro lenses because of these features, and because they are very compact and much easier to carry than extension tubes or a bellows. They are ideal "traveling lenses."

Once again, if you have TTL metering, it will compensate for any light losses.

Lens Reversing

Normal lenses are designed to work best when the subject-to-lens distance is greater than the lens-to-film distance. If we exceed magnifications of 1X, the lens is closer to the subject than it is to the film, so the image quality suffers. Reverse-mounting the lens can reduce this problem.

Reverse-mounting a lens immediately increases magnification, and it does so without light loss. An unextended 50mm lens, when reversed, will produce a magnification of almost 1X, and the image is flat field, reducing distortion and increasing edge-to-edge sharpness. Good quality images can be expected up to 2X with an ordinary lens and up to about 6X if a macro lens is reversed. Reversing a 28mm or 24mm wide-angle lens will give a very large magnification of about 2X with little or no extension required.

To do this requires a reverse-mounting ring or adapter in which one side screws into the filter threads on the lens and the other side attaches to the camera body, bellows, or extension tubes. Because the lens is attached to the adapter by the filter threads, you can use almost any make of lens, as long as you can open and close the aperture when reversed.

There are several disadvantages to reverse mounting. The biggest is the loss of automatic aperture control. With some lenses you can open and close the aperture manually, while others may require "auto rings" or other adapters to operate the aperture. On

FIGURE 8.9 Reverse mounting a lens requires a special attaching ring. Reversing a lens gives instant high magnification and edge-to-edge image sharpness. (A special shade is attached to the rear of the lens in the photo.)

some of the newer cameras that operate the aperture electronically, it may not be possible to control the aperture at all if the lens is reversed. Light-meter coupling is also lost, so if you don't have stopped-down metering capability, the internal meter will be useless.

Loss of built-in focus also occurs. Turning the focus ring has no effect whatsoever. This means that it is essentially a fixed-focus lens and you must focus by moving the entire camera or subject back and forth—unless you are using it on a bellows or with a focusing rail.

Reversing a lens also exposes the rear elements and mechanisms, making them susceptible to damage as well as flare from lighting, since the rear elements do not have corrective coatings.

The calculation of magnification with a reversed lens is not too difficult. Instruction sheets that come with a bellows often have tables for standard and macro lenses mounted in reverse, giving the exposure corrections.

If you don't have them, then you have to first determine what I call the "Zero Extension Magnification" factor (or ZEM): the magnification of the lens itself when reversed with only the reversing adapter and no other extension. To determine ZEM, mount the lens on the camera in reverse with only the adapter, then determine what the magnification is with a magnification ruler. Line up the left edge of the ruler with the left edge of the viewfinder and move in and out until it is in focus. When it is sharp, read the magnification. (It is easiest to mount the ruler on the edge of a table or wall and move the camera in and out until it is in focus.)

Since most viewfinders only show about 95% of the scene, there will be a small error—probably not significant enough to worry about in most cases. If you want to be more precise, an alternate way is simply to photograph a metric ruler placed horizontally across the frame and count the number of millimeter divisions across the width of the image on film. Divide 36 (the width of the frame in mm) by the count, and this will give you the magnification. This can be done to determine magnification by any method fairly accurately.

Once you know what the ZEM is for the lens, to determine magnification:

$$M = ZEM + \frac{E}{FL}$$

where

ZEM = Zero Extension Magnification

E = Extension used
FL = Focal Length of lens

Example 11

A 50mm lens reversed with no extension has a **ZEM** of .9X. 50mm of extension is to be used.

$$M = .9 + (50/50) = 1.9X$$

The total magnification is simply a calculation of what the magnification of the lens used in normal position would be with the extension used, with the addition of the zero extension magnification.

Macro Lenses with Extension

Macro lenses can be used with extension like any other lens, except determining magnification can be a little more difficult. The magnification markings on the barrel will no longer be accurate.

To calculate the approximate magnification, first determine the "equivalent extension" of the lens. This is done by reading the magnification off the lens, then multiplying it by the focal length of the lens. Add this to the amount of additional extension being used.

$$EE = (ML \times FL) + E$$

where

EE = Equivalent Extension
ML = Magnification read off the Lens
FL = Lens Focal Length
E = Extension used

Now calculate the magnification for the macro lens with extension:

$$M = \frac{EE}{FL}$$

where

M = Magnification
EE = Equivalent Extension
FL = Lens Focal Length

Example 12

A 100mm macro lens is used. It reads 1:2 (.5X) and a 40mm additional extension is used.

The equivalent extension (**EE**) = (.5 × 100) + 40 = 90mm.

Magnification (**M**) = 90/100 = .9X.

STACKING LENSES

Lenses can be "stacked." That is, another lens is mounted in reverse on the front of the camera lens. Essentially, this other camera lens is being used as a supplementary lens like a diopter, only much higher magnification is achieved with much better quality. (You may recall from the section about reversing a lens that a reversed lens acts like a flat-field lens providing edge-to-edge sharpness.)

Stacking is accomplished with a stacking ring (not to be confused with a "reversing" or reverse-mounting ring). It looks like an ordinary filter-adapting ring except it has male threads on both sides. You can also add other filter-adapter rings to reverse-mount lenses with different sized filter threads.

The resulting magnification is simply the focal length of the primary lens (the lens attached to the camera) divided by the focal length of the reverse-mounted lens.

$$M = \frac{FL(p)}{FL(r)}$$

where

FIGURE 8.10 LENS STACKING IS BASICALLY REVERSE-MOUNTING ONE LENS ON THE FRONT OF ANOTHER LENS. VERY HIGH MAGNIFICATIONS CAN BE ACHIEVED THIS WAY.

M = Magnification
FL(p) = Focal length primary lens
FL(r) = Focal length reversed lens

Example 13

You are using a 100mm lens on the camera and have reverse-mounted a 50mm lens.

$$M = 100/50 = 2X$$

On a 200mm lens, a 50mm lens reversed would have a resultant magnification of:

$$M = 200/50 = 4X$$

It is very easy to get quite high magnifications by this method.

The front lens should have an equal or larger maximum aperture than the primary lens, and it is set with the aperture fully open for shooting. Sometimes a small amount of extension may be required behind the primary lens to prevent vignetting. Use the test in the section on vignetting in Chapter 7, "Special Problems and Some Solutions," to determine if it is occurring. If it is, it should only take about 5 to 20mm extension to eliminate it. To determine if there is any effect on exposure with this extension, meter a plain area with and without the extension and determine what the loss is, if any.

A zoom lens may be used as a primary lens, but will not work as the reversed lens. Vignetting from a reversed zoom lens is so severe that all you will see through the viewfinder is a round circular image surrounded by black.

Once again, as in reversing, you can reverse any manufacturer's lens on any other—provided, of course, that you can open the aperture of the reversed lens.

The disadvantages of stacking are primarily the same as with reversing—the rear elements and mechanisms are exposed and susceptible to damage, and the lenses aren't coated and thus susceptible to flare. The system also becomes long and awkward to handle because of the weight of two lenses, and that makes it easier to damage the mount on the body if you aren't careful.

Some people use tape in place of a reverse coupling ring. I don't recommend this because the lens can fall off, and the tape may leave a sticky mess on the lenses. The ring itself is rather inexpensive.

Magnification is available only in fixed increments, depending upon the focal lengths of the lenses being used, and it is usually quite high. It is, however, one of

the most economic methods of achieving high magnification and is also the most portable.

Zooms with Extension

Anyone who has tried putting a zoom lens on extension quickly discovers that the zoom control no longer varies the size of the image, but acts as a focus control. The normal focus control still works but it now works more like a "fine-focus" control. I have heard that if you attach a close-up lens in front, the zoom control will return to normal, but this hasn't worked with any of my zoom lenses.

Zoom lenses work just as well on extension, however there are a few minor disadvantages. They are generally heavier than an equivalent non-zoom lens, and they are usually a stop or two slower. Without a ratio ruler, it is difficult to determine the precise magnification for exposure calculations.

Multipliers

A multiplier does exactly what its name suggests. It multiplies the focal length of the lens. They are also known as "converters" and "tele-extenders." The most common are 2X and 3X, and some lines include a smaller 1.4X multiplier.

Placed between the lens and the body, they multiply the focal length of the lens by the power of the multiplier. A 100mm lens with a 2X multiplier effectively turns the lens into a 200mm lens—both the image size and working distance are increased.

When used with extension, the positioning of the multiplier is important. Placed between the lens and extension, it multiplies the focal length of the lens and increases the working distance. Placed between the extension and the camera body, it multiplies the image size but focal length and working distance are unaffected.

The advantage of a multiplier is that it is a simple and quick way to increase magnification. They have many drawbacks though.

Some multipliers on the market are cheap and degrade the image severely. Good ones may be matched to specific lenses or groups of lenses. The latter are flat-field and very expensive.

The disadvantages include vignetting, which occurs with short lenses (under 50mm), lens flaws and faults are magnified, and high light loss. A 2X multiplier cuts light by two stops and a 3X by 3 stops, so you should only use them as a last resort.

MULTIPLIERS AND EXTENSION

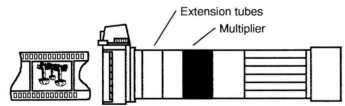

A multiplier placed between extension and lens multiplies focal length. Both image size and working distance increase.

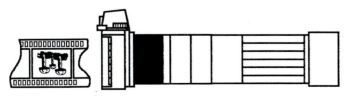

A multiplier placed between extension and camera body multiplies image size only. Focal length and working distance remain the same..

FIGURE 8.11

Short-Mount Macro Lenses

These lenses are designed especially for work in the macro range. They have no built-in focusing ability, and therefore a bellows must be used. Many do not have automatic aperture controls either—they must be operated manually (which can be awkward when very close to the subject).

The construction of short-mount macro lenses is very simple with few elements, and they give optimum performance within a very narrow magnification and focusing range—often only focusing at distances no greater than a couple of inches. The lens barrels are tapered to allow easier lighting of the subject, although lens flare is much more of a problem when lighting is placed in front of the lens. The elements are exposed and vulnerable to damage; it is very easy to inadvertently wind it right into the subject while setting up the shot.

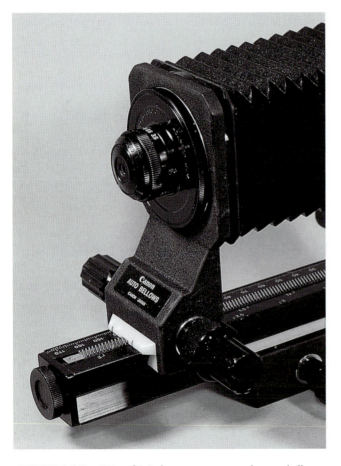

FIGURE 8.12 35mm f3.5 short-mount macro lens on bellows for magnifications between 1X and 5X.

Magnification can be determined most easily from the manufacturer's charts supplied with the lens. You just look down the column for the amount of extension being used and read off the corresponding value. To calculate the value, it is first necessary to determine what the magnification of the lens without any extension is (Zero Extension Magnification, or ZEM). If the magnification for zero extension is not given in the chart, it can be determined by mounting the lens on the camera with no extension and viewing (or photographing) a metric ruler as mentioned earlier.

Ratio rulers usually won't work with these lenses. You are working either at magnifications too high for the ruler to be of any use, or you will be so close to the subject that it is impractical if not impossible to get the ruler in any position to be useful without wrecking the entire setup.

Once you know the ZEM, the magnification can be calculated as follows.

$$M = ZEM + \frac{E}{FL}$$

where

ZEM = Zero Extension Magnification
E = Extension used
FL = Focal Length of lens

Example 14

Using the magnification at 0mm extension (**ZEM**) = 2X, a lens with a focal length of 20 and 30mm extension, we get:

$$M = 2 + (30/20) = 3.5X$$

This formula is exactly the same as the one for reverse-mounting a lens.

Many times when you are doing real close work with these lenses, you will find that you simply cannot get close enough to the subject because the equipment itself interferes with something (usually the front of the bellows or the focusing rail). One method of getting by this problem is to reposition the subject itself—shim it, raise it, tilt it, or whatever you have to do to get it in a position where the camera lens can get closer.

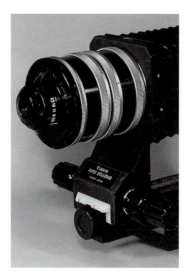

FIGURE 8.13 If the front of the bellows unit prevents you from getting the lens close enough to the subject, make up some of the required extension with extension tubes placed between the lens and the bellows.

Another method is to put some of the extension in front of the bellows front plate using extension rings. For example, if you need 150mm total extension, use 50mm of rings and 100mm of bellows. This method puts the lens out in front of the rail and closer to the subject.

CHAPTER 9

LIGHTING

Many potentially good photographs are ruined by poor lighting. For a successful photograph, the photographer must be able to use and control the lighting effectively.

SUNLIGHT

The most obvious source of light is sunlight. Everyone loves to take pictures on bright sunny days with deep blue skies and maybe some of those nice puffy cumulus clouds using a polarizing filter. Under these conditions, you can use a high shutter speed and small aperture as well. For scenic and travel pictures you can't find anything better.

For close-up photography, however, direct sunlight is probably the *worst* lighting imaginable. It is a point source of light, and on small subjects it produces very hard contrasty shadows that are not very appealing. Fine details and subtle colors all but disappear, light shades turn into washed-out hot spots, and the shadows are hard black. What is on film is always worse than what you saw through the viewfinder because the film (particularly slide film) already has a narrow contrast range to begin with.

Sunlight is very directional lighting, and, unfortunately, you cannot reposition it to suit your subject. You can only diffuse it, reflect it, or block it out.

If the subject is in bright sun, you can create your own shade—have someone hold a coat or garbage bag, or in some cases you can stand in the way yourself to shade the subject with your own shadow. You must be sure that everything in the shot is shaded, including the background, otherwise things in the sun will be burned right out. You may also need reflectors or flash to add a bit of highlighting to the subject, for lighting in shade, unlike the diffused light from a light overcast, is very flat and lifeless.

Photos taken in shade may have a bluish tinge from the reflection of the blue in the sky, but they are a major improvement over direct sun. Some photographers use an 81A warming filter to enhance photos taken in shade—it's mostly a matter of personal preference.

The ideal outdoor lighting for close-up work is a light overcast. The lighting is bright and even, and there are only light shadows. You can create such light "artificially" by using a diffuser. You can buy one, or make your own: it can be something

as simple as a piece of drafting paper, sheer cloth, or translucent plastic. I have seen people use ordinary white or light-gray umbrellas, or special white photo umbrellas, and I have used a small tent made of light gray fabric as well as shot in greenhouses made of translucent plastic. Plastic from white kitchen trash bags also makes good diffuser material.

Diffused lighting is always better than shade. Indoors, indirect sunlight coming through a window is excellent. Taping a piece of drafting paper to the window will help diffuse it further. Besides better lighting, working indoors or in a tent or greenhouse also shelters you from the wind, which makes some things much easier. Live subjects can't get away from you either.

ARTIFICIAL LIGHTING

What makes artificial light so appealing is that you have it available whenever you want it, and you can position it almost any way you want. With sunlight, you are extremely limited in both of these capacities.

The two primary sources of artificial lighting used in close-up photography are tungsten lighting and electronic flash. There are others, such as fluorescent and quartz, but they are either of limited use or present big problems when it comes to filtration for correct color rendition.

Which lighting is the best depends upon what you are photographing. Lamps are the easiest to work with and position, but if the subject is moving, like a mechanical device or an insect, you may have no choice but to use flash to stop the motion.

Lamps have the advantage over flash because it is extremely difficult to aim and position flashes accurately. In most cases, you can only aim flash and hope the results will be acceptable. Frequently you will spot many glaring errors when you get your film back, which you couldn't see when shooting because the flash duration was so short.

The primary problem with tungsten lamps is that they get very hot. Working in close proximity, it can be uncomfortable for the photographer and detrimental to the subject.

One nice thing about close-up work is that much of it can be done with ordinary 60 watt light bulbs—they still get hot, but not like those 500- or 1000-watt monsters you need for portraiture. They're cheaper, last a lot longer, and are a lot easier on the electricity bill, too.

When using tungsten bulbs, I always use tungsten-balanced film—because of the two stops lost when using daylight film and an 80A filter.

POSITIONING LIGHTS AND SUBJECT

With sunlight, the only positioning that can be done is with the subject itself. The light can be reflected, but only to a limited degree.

I have seen some examples of setups with six or more separate lighting units, but I will only discuss a maximum of three units. The more units you have the bigger the working space you need, even for tabletop setups. Up close, it may be very difficult working with even a single light.

Although many books say there are "right and wrong" ways to position lights, like everything else in photography, there are no right or wrong ways. Lighting is determined by the subject and purpose of the photo.

In portraiture, certain lighting setups are very unflattering to the subject and may be considered "wrong" for that reason. In nature photography, a photo taken using artificial light in which it is obvious that more than one source is used is "wrong" because our planet only has one sun. The only exceptions to this that are considered acceptable in nature photography are photos of nocturnal animals or birds where two flashes are used to give good lighting, which often results in two catchlights in the eyes.

For most technical work, "wrong" lighting means that the subject is not evenly lit, is lit in such a way that what the photo is trying to illustrate is not clearly discernible, or the colors are all off because of the type of light source and incorrect film or filtration. I am not going to explain how you should light any given subject in this chapter, but I will provide a description of the various methods and some shortcuts that will help when it comes to getting proper exposure of the image. I'll leave the creative part for later.

SINGLE-SOURCE LIGHTING

Single-source lighting is very directional in nature. It is a point source resulting in lots of hard, contrasty shadows. It can be skimmed low across the subject or high above for very dramatic effects or used with reflectors to fill in shadows, highlight specific areas, or add subtle tinting if colored materials are used. Diffusers can also be used to soften the light.

A single light can be positioned anywhere around the subject, limited only by the ability to physically put it there. In some areas, specifically those opposite the camera lens, it may cause flare and exposure problems

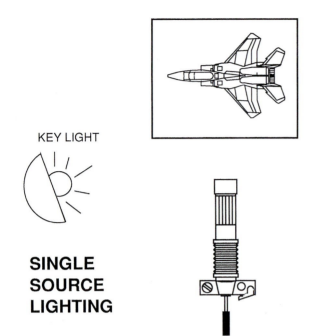

KEY LIGHT

SINGLE SOURCE LIGHTING

FIGURE 9.1 Single-source lighting is the simplest method of lighting.

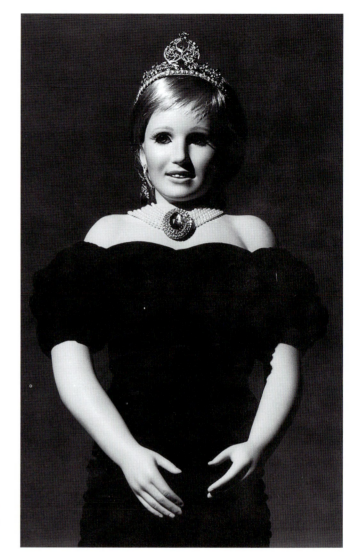

FIGURE 9.2 Single-source lighting on a three-dimensional subject produces very directional lighting with hard shadows.

unless one aims or blocks them carefully. Shots that are almost entirely backlit usually result in very flat low-contrast images that are rarely pleasing.

Metering is straightforward, just as if you were outside—although backlit subjects are more difficult to meter. A spot meter is excellent in these cases, because it won't be affected by stray light around the edges of the subject.

One problem with single-source lighting is that if the subject and background are large, the light must be a fair distance back or it will not be possible to light it all evenly. The further back you put the light, the more exposure is required.

If the light is too close, you should be able to actually see the drop-off. The center of the scene will be bright, and it darkens further out. It will be even more noticeable on film.

What I am about to describe is a method of repositioning light sources without having to take additional light readings or make calculations. It works for all types of lights, including floods, flashes, and multiple sources.

As I discussed earlier, the distances at which light intensity on a subject decreases by half follows the iden-

tical numeric sequence that our f-stops follow. We know that since these are ratios, it does not matter what unit of measurement we use. The light intensity at 8 feet from the subject will be exactly half the intensity as the light 5.6 feet away, and the light 8 inches away will be exactly half the intensity of the light 5.6 inches away.

We are now going to put this information to a practical use. Let's say that we have a tabletop setup with our subject in the middle. We set up our light, position it where it looks good, and take a light reading.

The light meter says f8 at 1/30 second, and we decide we'd rather use f11. We know that we can use f11 if we slow the shutter to 1/15 second, but what if we don't want to use that speed? The only answer is to move the light source closer to the subject. Increasing the light on the subject will allow you to close the aperture down.

How much should you move it? Well, you can move it a bit at a time and take readings until you get the exposure you want, or you can do the following:

Example 1

1. Measure the distance of the light source to the subject. Let's say it's 32".
2. Referring to the series of f-stop and half-stop values, find the value nearest to the distance measured (f32).
3. Now, we want to move the light closer to the subject enough to increase the illumination by one full stop, so we just look on the scale and see what aperture would allow one full stop more light in. It would, of course be f22.
4. Your new light-to-subject distance is 22".

If, instead, you wanted to decrease exposure by one stop, we know a one stop decrease from f32 is f45, so placing the lamp at 45" will decrease the amount of light by one stop. This works with half-stop values as well. Simply count the number of stops and half-stops in the desired direction from the known distance value. An easy way to remember which direction to go is this: if you want to increase the light intensity, you count values towards f1 on the scale.

Example 2

What if the subject distance isn't on the chart?
The light is 25cm away and we want to open up two stops.

1. Looking at the aperture scale, approximate where 25 would fall (a little less than 1/3 of the distance between 22 and 32).
2. Count over two stops from the nearest stop value (in this case f22). This would be f45.
3. Since we started about 1/3 the distance between 22 and 32, go up approximately 1/3 the way between the full stop you ended at (f45), and approximate what the value would be 1/3 the way between it and the next full stop (f64). It is approximately 51.
4. Place the lamp at 51cm, and the subject will receive two full stops less light.

Since we are again dealing with ratios here, it makes no difference what unit of measure is used.

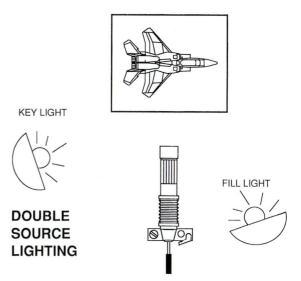

FIGURE 9.3 The addition of a "fill light," usually placed near the camera, helps soften the hard shadows of the key light.

DOUBLE-SOURCE LIGHTING

With double-source lighting, one can soften the shadows by adding fill, or even out the "hot spots" and balance the light over a large area as for copy work.

Generally, one light is the "key" light providing the main subject lighting, and the second light is a "fill" light to (as the name implies) fill in shadows. The key light is positioned wherever it is desired to have the main light source coming from. The fill light is then positioned to reduce or eliminate shadows. Normally, it is positioned at a distance to give 1/2 to 1 stop less exposure than the key light. Some say it should be as near to the camera as possible, but again that is entirely dependent upon the results desired.

All lamps should be the same output to make positioning calculations easier, then you need only determine the light-to-subject distance for one. Positioning the second becomes easy—use the same distance from the subject for the same exposure, or use the aperture number sequence to determine placement if one is to give more or less light.

Work with the key light first. Position it then take your light reading. Determine the distance your fill light should be, and position it at that distance where you want it coming from.

Dual-source lighting is also popular for copy work, although for larger items, four lights may be used to ensure even lighting. All lights should be the same output, and are placed the same distance away from the

FIGURE 9.4 A fill light positioned to give 1 stop less was added for this shot. It softens some of the shadow and adds detail to the shadow areas. Compare this photo to Figure 9.2

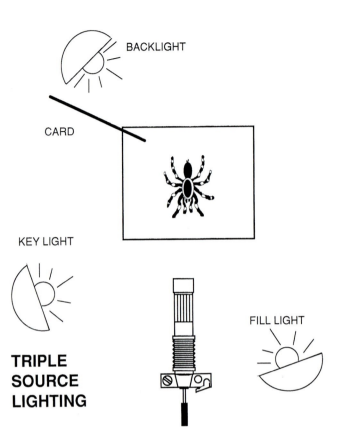

TRIPLE SOURCE LIGHTING

FIGURE 9.5 The backlight provides separation from the background. Exposure for it should be the same as, or 1/2 stop less than, the key light. The piece of card is used to prevent lens flare from the backlight. It is important to hold it at an angle, as shown. If it is held parallel to film, it may reflect light from the key light into the lens.

subject and aimed inwards towards it. They should be aimed so the light across the subject is even. If they are too close, hot spots will occur.

Three-Light Sources

A third light can be added to the setup. It is usually a "backlight" that is used to provide good separation between the subject and the background. This is especially effective when photographing something like a hairy tarantula because the individual hairs show up clearly and crisply.

The backlight should be placed almost directly opposite the camera, but it should be aimed at an angle so that it does not point directly into the lens, otherwise the flare will burn out the image. A card can often be positioned so that it does not interfere with the view or the subject (or appear in the frame) but prevents stray light from the backlight from causing flare.

The light should be positioned so its exposure reading is the same as or about a half stop less than the key light. Distances are determined as outlined before. You can double check the distances by metering each light separately before shooting.

FIGURE 9.6 Three-source lighting was used for this shot of a tarantula. The backlight separates the fine hairs making them stand out, and it also helps eliminate most of the shadows.

Shadowless Backgrounds with Close-Ups

Sometimes you may want a very simple, plain, uniform background. Beginners tend to place the subject directly onto the background material, light it, and take the picture. The result is a well-lit subject and background with very hard shadows outlining the subject.

A simple way to avoid shadows is to place the subject on a piece of glass plate supported a distance above the background material. The higher you can keep it, the easier it is to hide the shadows. A foot is good for small subjects a few inches in size.

Position the camera, then aim the lights so they illuminate the subject and throw the shadows outside the camera's view. You will have to check through the viewfinder to see that they don't appear in the frame.

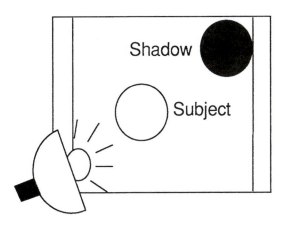

Position light(s) and subject so shadow(s) fall outside of camera view.

SHADOWLESS BACKGROUNDS FOR CLOSEUPS

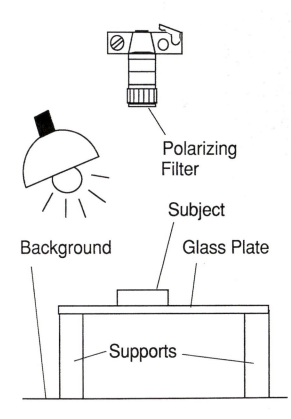

FIGURE 9.7 The shadows of the subject appear on the background below and not on the glass plate. By careful positioning of the camera, subject, and lights, the shadows can be hidden or placed out of view. The higher the glass is above the background, the easier it is to eliminate the shadows. An additional light on the background itself can be used to eliminate them altogether.

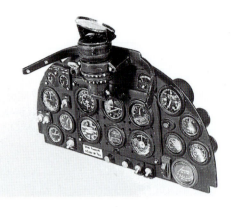

FIGURE 9.8 This close-up of a model plane instrument panel was taken using the shadowless background method.

If the lights have been positioned to eliminate the shadows, the lighting will tend to be very flat, which is ideal for copy work but may not be complimentary to a three-dimensional subject. You might consider shining a third light on the background below the glass level to obliterate any shadows. This will allow you to light the subject so it looks its best and eliminate the shadows.

If you use a third light, position the light so the exposure for the background is the same as or slightly more than for the subject. If it is too much more, the background will appear much lighter than it should. If you want a very pure white background, use a white or light-colored background and adjust the background light so it reads at least two stops more exposure than the subject exposure.

A polarizing filter will likely be required to eliminate the reflections from the glass surface. Be sure the plate is large enough so that its edges or supports don't show in your picture.

Transillumination

Until now, all lighting of the subject discussed has been reflected lighting. Transillumination is lighting a subject by passing light through it as is done with most microscopes. When you view a slide by holding it up to the light, you are viewing it by transillumination.

There are transillumination housings, macro stands, and mirror housings available. These may make things easier, but they are not necessary for the occasional photograph. A very simple system consists of a light source and a diffuser (opal glass or plastic). The subject is placed between the diffuser and the camera,

TRANSILLUMINATION LIGHTING

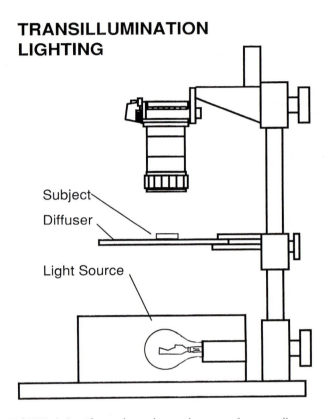

Subject

Diffuser

Light Source

FIGURE 9.9 This is about the simplest setup for transillumination lighting. There are many other ways to do it including housings and especially designed bases.

and the light is shone through it from behind. A diffuser is necessary to create even lighting across the subject. Some are made from a heat-absorbent glass to help reduce heat on the subject.

Metering can be tricky here, because we want to meter the light coming through the subject and not light that may be reflected off it or coming around it. If the scene appears to be about 18 percent, then meter it directly. Otherwise, meter it and correct the exposure for subject brightness; you might want to bracket as well.

Reflectors

Reflectors are used to redirect light onto small areas of a subject to add light, fill shadows, or add highlight. Mirrors, aluminum foil, white paper, a glass plate, or almost anything shiny may be used. There are also silver cloth reflectors available in various sizes—many fold down small so they are convenient to carry.

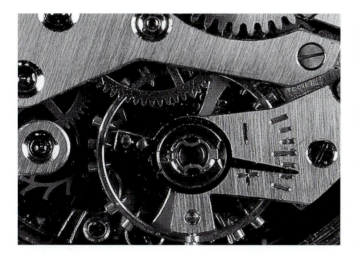

FIGURE 9.10 Only a single 60-watt light bulb was used to light this shot. No reflector was used.

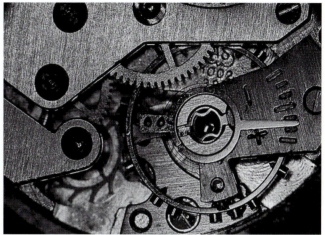

FIGURE 9.11 A reflector was used to add light to the darkened areas. Hidden details, like the numbers and the machining marks in the metal plate behind the gears, are now visible. Lighting here is very flat compared to that in Figure 9.10. The former is more appealing visually because the shadows give it dimension, but if the photo were to be used in a repair manual, for example, the latter would be desired because it shows more detail.

Mirrors should only be used when it is desired to reflect a large amount of light, such as when trying to simulate a multisource light with a single-source, or add highlighting under heavily diffused lighting conditions. Because a mirror reflects so much, the results tend to be hard and contrasty if the lighting is bright.

For highlighting a subject, the best reflector is one made of the dull side of a piece of aluminum foil. Crumple the foil into a tight ball, then open it and flatten it out. Some photographers attach it to a hard piece of board to make it easier to use.

Once the subject and lighting have been positioned and the exposure determined, the foil is used to reflect light onto the subject and add a bit of fill or highlighting so that there is some detail visible in darkened areas. The amount of light is usually so little that it will not affect exposure, but it can make considerable difference in the photograph.

Reflectors are often used when doing backlit shots where extra light is needed on the unlit side of the subject. Without it, the shot may lack any detail or texture and look rather flat. Attempting to open the lens or increase shutter speed to compensate would result in burned out backgrounds.

Reflectors are also used to throw a bit of light into the shadows or hidden areas to make details visible. An example is using a reflector to throw a bit of light under the hood of a Jack in the Pulpit flower to highlight "Jack" (pictured in Figure 18.13).

Slight tints can also be added by using different colored reflectors. Gold foil, for example, can be used to add a slight bit of warmth to the subject.

In the field, reflectors can be very awkward to use because they have to be held in place somehow, either by hand or with other types of supports, and the effect can only be properly evaluated through the viewfinder. A second person may be required to hold or aim them.

If several reflectors are used, the problems multiply. It also takes a lot of time to set up, which can mean missing the shots entirely as lighting conditions outdoors may change rapidly—especially around sunrise.

For very small subjects, particularly when doing tabletop work, "mini" reflectors can be made in various shapes and sizes to reflect the light. Many times I've used square, conic, angled, and curved reflectors made out of foil glued to light cardboard when I found that lighting with more than one lamp was very difficult or impractical.

It is impractical to try to use reflectors with flash. It would be almost impossible to direct the light or determine the effect without taking and evaluating an actual picture.

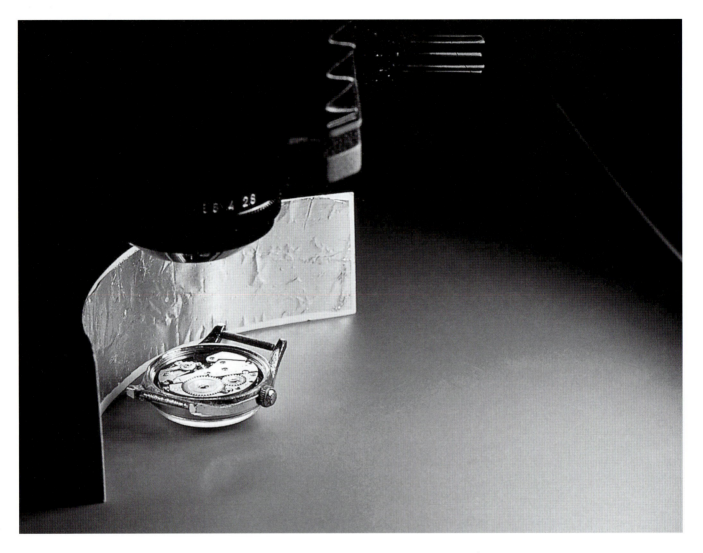

FIGURE 9.12 Small pieces of tinfoil can be used to make reflectors for close-up work. Unless you need lots of fill, use the dull side of the foil.

CHAPTER 10

FLASH

It would be quite impossible to photograph many things if it weren't for the electronic flash. Not only is it of very short duration, which will freeze many subjects mid-motion, but even a small one packs a lot of power, allowing the use of small apertures up close.

As with everything else in photography, when we have something advantageous, its advantages are balanced by disadvantages. The biggest problem with flash is trying to aim it properly.

Unless the flash has built-in modeling lights (and very few other than ring flashes and studio flashes do), much of it is guesswork. You can fire off a few test flashes while looking through the viewfinder and get a general idea of what the results will look like, but not much in detail because of the short duration. A slight misalignment can also result in hot spots in one area and pitch black areas somewhere else in the frame.

It is also a point source of light unless you are photographing objects smaller than the size of the flash's window. If not, a large diffuser of some sort must be used to prevent hard and contrasty images.

Often flash shots look worse than those made in bright sunlight, as anything with a smooth or glossy surface becomes a powerful reflector that fills the shot with many hot spots and harsh shadows. Furry critters diffuse the light and look okay, but a hard-shelled beetle or waxy orchid flower may end up looking like something made of cheap plastic.

With cameras using a focal plane shutter, there is a maximum flash synchronization speed, which will be discussed later in this chapter. This speed is listed in the camera manual and may be in a different color on the dial. In older cameras this speed was about 1/60 second, which presented many problems using fill flash outdoors.

With speeds below the sync speed, adjusting the shutter speed has virtually no effect on exposure until the speed gets close to the speed for the ambient light conditions at the selected f-stop. At that point, there is enough ambient light to also create an image, and the result is often a ghost or double image.

With close-up work using flash, you will almost always be using shutter speeds well above the ambient light speed.

Electronic flashes also have voracious appetites for batteries, which can make them quite costly to operate. I like to use nicads in mine, although nicads have one disadvantage: when they go flat, they die very suddenly without warning. Alkalines

die gradually, so you can judge their state by how long the flash takes to charge.

If your flash has an AC adapter option, it will pay for itself quickly if you use flash often. With batteries, you might be reluctant to do more than one or two "test firings" per shot while positioning flashes because of their limited life, but with the AC cord the number is almost limitless.

There are three basic types of electronic flashes available: the manual unit, the autoflash, and the TTL Autoflash.

Manual Flash

The standard manual flash is fast losing popularity to the other two types, primarily because it takes a lot of time to use. People want something they can just turn on without having to bother making adjustments or fiddle around with apertures, distance scales, or calculators.

The units come in many sizes, from pocket-sized to large handheld monsters. Some have one output power (full), while others may have several power settings. Thyristor units with several settings are more economical on batteries. They can be set low when you don't need a lot of power, such as when positioning, and higher for the actual shooting.

Autoflash and TTL Autoflash

Both of these flashes use sensors to measure the light of the flash reflected off the subject and control the exposure by varying the duration of the burst of light. The difference between the two is how they sense the light. Some people get them confused because they are both called "auto" flashes, but *they are not the same.*

Standard autoflashes have sensors built into the flash units themselves, or they may have a remote sensing unit that can be placed elsewhere. Because the sensor is a distance away from the lens, parallax error is a serious problem when we get close. The sensor may not even be looking at the subject but another point some distance away. And even if one can direct the flash and sensor independently, the sensor will still read an angle far too large to be of any value when working close.

Some units work with any camera, and others are dedicated to specific cameras. The latter may, for example, automatically set the shutter speed to the maximum sync speed or set the aperture to the one selected on the flash control unit.

PARALLAX AND STANDARD AUTOFLASH

FIGURE 10.1 Conventional autoflashes have sensors built into the unit or remote sensors that can be placed where desired. In this example, neither fields covered by the flash or the sensor include the subject. With TTL Autoflash, the camera's internal light-metering system does all the sensing—it sees exactly what the lens sees.

There are autoflashes that cannot shut off fast enough to work properly at very short distances. The results will be overexposure unless compensated for by setting the aperture smaller than what the flash is told. This requires a little experimentation to get right.

The auto units do not compensate for light loss from magnification or filters either. In both cases, this must be done for them by readjusting the ASA or exposure compensation dials on the camera or flash, or using a different aperture than the one the flash is set for.

Autoflashes may work fine when shooting objects at low magnification (1/8X or so), or with the flash well back from the subject, but for real close work these auto systems are of no use whatsoever.

TTL Autoflashes use the camera's internal metering system to control the flash duration. They are by far the best autoflash system developed. They work exceptionally well in close-up work because they work through the camera lens and see the subject exactly as the film will see it. Since they are reading through the lens, they also automatically compensate for light losses from magnification and filters, which makes them very simple

to use. As long as the flash is aimed correctly, chances are pretty good that the results with respect to exposure will be good.

Since TTL flash exposure works on the same principle as a regular light meter (trying to expose everything as though it is neutral gray), you will have to compensate for subject brightness in the same way that you do for a lightmeter (see Table 6.2). I suggest running tests on predominantly light, medium, and dark subjects to determine necessary corrections for your equipment.

TTL Autoflashes may be dedicated to specific lines of cameras and may not work with any other in the auto mode.

RING FLASH

This is a special type of flash that may come in manual, auto, or TTL versions. It mounts on the front of the lens (usually with an adapter that screws into the filter threads) and illuminates small subjects immediately in front of the lens.

Ring flashes are normally very low power units compared to regular flash units and come in three versions: complete circular ring, twin-flash tube, and four-flash tube.

Lighting with the circular ring, with both tubes of a twin-tube flash when positioned opposite one another, or all tubes of a four-tube flash, is very flat as light comes from all around the lens at once. Circular ring lighting is often used in medical and scientific photography or small-scale copy work where flat lighting is desired.

FIGURE 10.3 Ring flashes produce very odd-shaped catch-lights and reflections, as seen in this Iguana eye. They do not look natural and can be distracting.

Most units have two flash tubes that can be switched on or off independently and positioned anywhere around the lens to control lighting direction. Four-tube units are similar, only a much flatter lighting can be achieved with them than with two-tube units. Many also have built in modeling lights that are quite handy at times indoors, but useless outdoors because they are not bright enough to see.

RING FLASH ILLUMINATION

FIGURE 10.4 If the subject is located within the shaded area, it will not be lit by the flash. In reality, this area does receive some light but nowhere near the full amount, and underexposure will occur. Some photographers know that when their subject is within this distance they can get acceptable shots by allowing extra exposure; the amount is determined by experimentation.

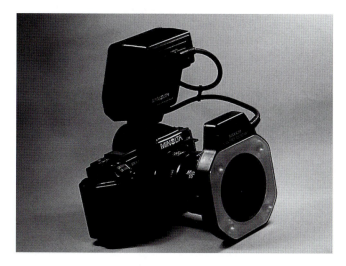

FIGURE 10.2 Four-tube auto ring flash and control unit.

Unfortunately, ring flashes produce unusually shaped catchlights in eyes and on shiny surfaces that look unnatural and may ruin a photo completely. There is also a minimum lens-to-subject distance, and the subjects will not be lit properly if they are any closer.

Ring flashes also tend to be very costly. But for things like insect photography in the field, you can't beat them.

FLASH SYNC SPEEDS

All cameras with focal plane shutters have a maximum flash synchronization speed. This is the maximum speed you can use when using electronic flash.

Focal plane shutters have two curtains that move across the film plane. There is a maximum speed at which these curtains can travel, and any shutter speed beyond it is attained "artificially" by overlapping portions of the two curtains to form a slit. The width of the slit and the speed at which it travels determines what the shutter's effective speed is. At speeds up to and including this maximum curtain speed, the shutter is fully open, exposing the entire film to light. This maximum speed is called the "sync speed."

Above the sync speed, since the shutter curtains are overlapping, only a portion of the film gets exposed to light at any given instant during exposure. If you use an electronic flash and set the shutter speed faster than the sync speed, you get only a fraction of the film exposed. This occurs because the flash is fast enough to freeze the movement of the slit and therefore exposes only the portion of the film the slit happens to be over at the time.

Exposing at twice sync speed will result in only half the frame exposed, four times sync speed, a quarter of the frame, and so on.

The sync speeds on modern cameras are as high as 1/125 or 1/250 second, but on many older cameras it is down around 1/60 or even less. Cameras with slow sync speeds present many problems when using electronic flash outdoors, as the ambient light at those shutter speeds may require apertures smaller than the flash requires or is desired, thus nullifying any effect of the flash or resulting in depths of field greater than wanted.

EXPOSURE WITH FLASH

Electronic flashes can be used alone, or several can be used simultaneously for illumination. Positioning theory is the same as for floodlights.

When you use multiple flash units, connect one to the camera (the master) and photocell slave units attached to each flash will trigger the rest. Some TTL flash systems have a controller that will handle an additional flash unit. If you don't have such a system, you will likely be using at least one flash in the manual mode and will need slave units. (When using flash slave units, direct the photocells towards the master flash unit.)

Another instance when you may have to go manual is when you are working with subjects that have very little surface area to reflect enough light, such as a needle and thread. Both are too small for even the TTL metering system to read accurately—they are more likely to read the background and expose for it, thus overexposing the subject.

In these cases, as with a straight manual flash, you must be able to determine the correct flash-to-subject distances (how far away you must place each flash) based upon the selected aperture and the flash power output. The distances can be calculated using the guide numbers or a calculator device on the flash unit. A flash meter can also be used.

With a flash meter, the subject is metered and the flashes are moved until the desired aperture is read. This is the simplest way, though the meter does not automatically compensate for light losses or subject brightness. Using a flash meter is also subject to the same problems as normal light meters when it comes to being able to position and read it.

To calculate the distance using guide numbers, you should find a reference table somewhere in the flash manual. It will usually give two guide numbers for each power level the flash has, calculated for ASA 100 film. One number is for use if measurements are in feet and the other if meters are used. Ordinarily, we frame and focus, then use the guide numbers to determine what aperture to use.

The aperture is equal to the guide number for the flash power level being used divided by the distance:

$$\text{f-stop} = \frac{\text{Guide Number}}{\text{Distance}}$$

Be sure to use the correct guide number for the units you are measuring in, as well as the flash power setting used if it has more than one.

Example 1

For ASA 100 film, a flash with a guide number (for feet) of 92 and the flash-to-subject distance of 12 feet, we

would divide 92 by 12 and get 7.7. The closest stop (or half stop) to this is f8, so that is the aperture we would use. *Note: This formula does not take any light losses into account. They must be compensated for separately.*

In close-up work, we often select the aperture we want to use and determine where to position the lighting instead. In this case, divide the guide number for the power setting being used by the aperture you want to use. Rearranging the formula to solve for distance, we get:

$$\text{Distance} = \frac{\text{Guide Number}}{\text{f-stop}}$$

Example 2

Suppose the guide number for ASA 100 film when measuring in feet is 80. The aperture you want to use is f16. Distance = 80/16 = 5. Therefore, the correct flash-to-subject distance is 5 feet.

It's fairly simple to do—provided you always use ASA 100 film (or whatever speed the instructions give you the guide number for). If you don't, you have to determine what the guide number is for the film speed you are using. You must use a rather complicated formula to determine it—and it's not one that's easy to use in your head!

$$\text{GN(New)} = \frac{\text{GN(Known)} \times \sqrt{\text{ASA(New)}}}{\sqrt{\text{ASA(Known)}}}$$

Example 3

A flash has a guide number of 92 for ASA 100 film. What is its guide number for ASA 64?

The film we have both the ASA and guide number for is the known film. In this case, it is the ASA 100 film.

$$\text{GN(ASA64)} = \frac{92 \times \sqrt{64}}{\sqrt{100}} = 73.6$$

Some manufacturers have taken all of this mathematics and converted it into tables or little calculators printed or built onto the flash. You either read the chart or just set a dial at the ASA (and perhaps another dial, if the flash has several power settings) and read off the distance opposite the aperture.

You can use these calculators to determine what the flash guide number is for any ASA a lot quicker than you can calculate it. Simply set the film ASA you want the guide number for and read the aperture across from the distance of 10 feet (or 10 meters if you are using metric measure), then multiply by 10 to get the guide number for the appropriate measuring units.

Example 4

Set ASA 64 on the dial and the 10-foot mark appears about in the middle between f8 and f11 (roughly 9.5). Multiply by 10 to get the guide number of 95. It may actually be 92 or 98, but this will be close enough for our purposes.

Those who have tried have learned that using straight guide numbers do not work for macro work—they do not account for any light losses. Nature photographers have used a system called "Calhoun's Formula for Calculating Nature Numbers" to determine flash-to-subject distance. Some photographers still use Nature Numbers, although they are extremely time-consuming and as obsolete as the slide rule.

I will go over this method and refine it—you may require it if you are using manual flash or multi-unit setups.

To use this method, you must calculate a Nature Number for the lens/flash/aperture combination being used.

$$\text{NN} = \frac{\text{GN} \times \text{FL (mm)}}{3 \times \text{f-stop}}$$

where

NN = Nature Number
GN = Flash Guide Number
FL(mm) = Lens Focal Length in mm
f-stop = Aperture selected

This Nature Number is then divided by the lens-to-film distance (lens focal length + extension) *in inches*, giving the flash-to-subject distance in inches.

You need a different Nature Number for *every* combination of flash guide number, lens, and aperture setting used! Every time you change lenses, aperture, or magnification you must recalculate.

Not liking the complexity of having to use two formulae (twice the opportunity to screw up), I combined both formulae into one, which gives the flash-to-subject distance directly. This formula can easily be programmed into a calculator or computer.

$$D = \frac{8.5 \times \text{GN} \times \text{FL}}{\text{f-stop} \times (\text{FL} + \text{E})}$$

where

D = Flash-to-Subject Distance (inches)
GN = Flash Guide Number

FL = Lens Focal Length
f-stop = Aperture selected
E = Extension used (mm)

Example 5

GN = 92, FL=200mm, E = 50mm, and f-stop = f22

$$D = \frac{8.5 \times 92 \times 200}{22 \times (200 + 50)} = 28.4"$$

Another version of the formula can be used if magnification (**M**) is known.

$$D = \frac{8.5 \times GN}{\text{f-stop} \times (1 + M)}$$

Example 6

In the previous example, using M = E/FL, we can determine that the magnification obtained is 50/200 = .25X. We will use this in the following version.

$$D = \frac{8.5 \times 92}{22 \times (1 + .25)} = 28.4"$$

The answer is the same.

Note: If you are measuring in the metric system, then substitute 21.6 for 8.5 in these formulae and the answer will be in centimeters.

You must still account for any filter factors if filters are being used, and you must also account for subject brightness, too, if you find it necessary. Unless using a very high speed flash, one with a duration of 1/10,000 second or faster, you probably will not have to compensate for film reciprocity failure.

Because guide numbers may be inaccurate for many reasons, and positioning of the flash units becomes less precise as they get closer to the subject, I usually bracket my flash shots.

Now, here is where things get really complicated and why I don't like using multiple-flash units. I advise rereading this section slowly several times as it can be very confusing.

Ideally, all of your flashes should be the same output power. If they aren't, you have to go through steps two through five for *each* flash being used, and you must do it each time you change lens focal length, aperture, or magnification!

1. Determine the guide number for each flash for the ASA of the film being used. (Calculate this once and write it down for future reference.)
2. Decide what f-stop you wish to use for the photo. Do this after you have focused and framed the shot, not beforehand, for when you preview the shot you may find that you don't like what you see and want to use a different aperture.
3. Determine the number of stops of compensation that will be required for subject brightness and any filters, and then determine the "corrected" f-stop (defined in Example 7). *Do not* include exposure corrections for magnification. The formula takes care of them. The example will explain this, I hope.
4. Calculate the flash-to-subject distances for each flash using the corrected f-stop and the flash distance formula. If all flashes are the same output, then you need only calculate this once and position fill and backlighting flashes using the aperture number method described earlier in the section on positioning lights and subjects.
5. Position the flashes directionally at the distances calculated, do a test firing or two while looking through the viewfinder to see how the lighting looks, make any changes necessary, then take your picture. Bracket if you feel it's necessary.

There is a difficulty bracketing when using flash. Since the shutter speed has virtually no effect, you must use the aperture (which affects the depth of field), change the output power of the flashes, or reposition them. With TTL flash on auto, you just have to use the exposure compensation control on the camera and set it to over- or underexpose by the right amount. Read the following example carefully. It can be very confusing.

Example 7

Two flashes are being used. The lens is 100mm with 55mm of extension. One flash with a guide number of 120 with ASA 100 film is being used for the key light, and one with a guide number of 92 for ASA 100 film is being used for fill. The fill is to be 1 stop less than the key light. ASA 100 film is being used, and a filter with a factor of 2 is being used. No correction for subject brightness is required.

1. **Determine the guide number for each flash for the ASA of the film being used.**
 This is not necessary in the example as both guide numbers given are for ASA 100 film and ASA 100 film is being used.

Whenever possible, when using a multipower output flash, use the full-power setting. It allows you to keep the flash at a good distance for moderate-sized objects, and in real close-up work you will need all the power you can get!

2. **Decide what f-stop is to be used for the photo.**
 Looking through the viewfinder, f22 looks best.

3. **Determine the number of stops of compensation that will be required for subject brightness and any filters.**
 There is a filter with a factor of 2 being used so, according to our chart in the section on filters, we need to open the lens one stop. Again, *do not* include exposure compensation for magnification.

 We must now find the "corrected" f-stop. This is the aperture we are going to tell the flash we are using. It is not necessarily the aperture we actually are setting on the lens.

 We want to use the f22 setting on the lens, and we have determined we have to add one stop compensation for the filters. This means we want the flash to "put out more light." In other words, in this instance we want it to put out the amount of light needed if we were using an aperture one stop smaller.

 From our aperture scale, the aperture that is one stop smaller than f22 is f32. Thus, our corrected aperture is f32.

4. **Calculate the flash-to-subject distance for each flash to be used using the corrected aperture and flash distance formula for each flash.**
 By substituting the corrected f-stop (32) for the f-stop in the formula, we determine the flash-to-subject distance For our key flash, guide number = 120, we have:

$$D = \frac{8.5 \times 120 \times 100}{32 \times (100 + 55)} = 20.6"$$

 For our fill flash, guide number = 92, we want a full stop less light than the key light. One stop less light than f32 is f22. Substituting f22 into the formula for f32, we arrive at 22.9 inches:

$$D = \frac{8.5 \times 92 \times 100}{22 \times (100 + 55)} = 22.9"$$

 Remember! A flash has to put out *more light* if you are using a smaller aperture and *less light* when using a larger one.

5. **Position the flashes where you want them (directionally) at the distances you have calculated.**
 It has never been made clear to me whether the flash-to-subject distance is measured from the flash tube or the window. I use the front of the window, but it really

doesn't matter as long as you use the same reference point at all times.

The key flash in our example would be placed at a distance of about 20.5 inches from the subject and the fill would be 23 inches away.

I am sure I don't have to point out how this method can be extremely confusing and tedious. Even using a calculator, it can take a half hour to figure out the positioning of three flashes, and it has to be redone every time you change magnification, aperture, or subject brightness.

It is quite possible to use a TTL Autoflash as the key light and manual flashes for fill and backlighting. You *must*, however have the exposure on aperture priority and select the aperture you will be using. You don't need to place a TTL Autoflash at a specific distance as long as you are within range (some flashes display the working range on an LCD panel or calculator on the unit when you select your aperture). Determine the positioning distances for the other flashes as described.

Like floodlamps, flashes can be positioned almost anywhere using the f-stop number sequence once you have a known distance. Light drop-off is the same for flash as it is for lamps, though it may seem more noticeable with flash. This is probably because flashes put out a much narrower "beam," and because the effect is more noticeable on film due to less area coverage.

FLASH OUTDOORS

There are three ways to use flash outdoors: as the primary source of light, as fill, and for stopping motion. Flash outdoors is usually used as the primary source for close-ups of insects or at night. In daytime, one may be limited as to what one can do with flash outdoors if using an SLR because of the limitations imposed by the maximum flash sync speed.

When using flash as the primary source, the exposure is based on the flash exposure and not the ambient light. If you have an older camera with a sync speed of 1/60 or even 1/125 second, you can have real problems in bright light. You cannot use a speed faster than the sync speed, and the ambient light exposure setting may call for an aperture smaller than what the flash requires. In that case, the film won't even see the flash.

Let's suppose your flash-to-subject distance requires you to use f8, your flash sync speed is 1/125 second, and the ambient light exposure is f16 at 1/125 second. If you expose for the flash (f8), you will overexpose by

two stops because the ambient light is two stops brighter. If you expose for the ambient light, the flash will be providing two stops less light and won't be seen. If you change the camera settings to f11 at 1/250 second, the flash exposure will be one stop less so its effects will be seen, but you will only get half of a picture because you exceeded the maximum sync speed.

When used as a fill, the flash-to-subject distance is determined for the shooting aperture. Using the aperture number method, move the flash away from the subject by the appropriate distance to give it either 1/2 or 1 stop less light. (If the flash has many power levels, then set it for 1/2 to 1 stop less than the ambient light exposure instead.)

If the subject were at 8 feet from the flash and the light reading were f11, then either move the flash back to 9.5 feet (1/2 stop) or 11 feet (1 stop), or adjust the flash power output to f9.5 or f8 (1/2 or 1 stop underexposure).

This can get confusing, because we are used to thinking that to give one stop less exposure, we close the lens (which in this case would mean f16). If we went and set the flash for f16, we would end up *overexposing* everything because we added more light instead of reducing it.

With flash you are *adding* light, so if you want to underexpose, you must add less light than required for proper exposure, which means setting the flash to expose for a larger aperture. Conversely, to increase exposure, set it for a smaller aperture.

You can also use flash to stop motion outdoors. What you do here is take an ambient light reading, then set the flash for that aperture. Set the shutter speed one speed faster than the ambient reading and shoot. The shutter speed, of course, must still be at or below the sync speed. The idea here is that you have a nice frozen picture of the subject from the flash and you get background detail from the ambient light because you are within one stop of its proper exposure.

This doesn't work well if the motion is large or the shutter speed is slow. What you get then is a frozen image of the subject from the flash and a blurry ambient-light ghost image from the movement. It doesn't look very good, so I don't bother trying it anymore. It

works fine where there is very little movement, such as insects that are almost, but not quite still.

Some of the all-electronic cameras automatically do all the calculations and set everything up for flash fill at the press of a button. I've never liked the results I get, so I never use this feature. In fact, I rarely ever use flash outdoors except when I'm doing insect photography.

When I go, I carry my camera with my TTL ring flash, and because I am usually shooting at close range at very small apertures, I do not have to worry about ambient light causing problems or any of the other problems associated with flash.

FIGURE 10.5 Electronic flash was used to expose the shot. The ambient light exposure called for 1/8 second at the aperture I selected, so the shutter speed was set for one stop underexposure (1/15 second). The insect had moved enough in that time to create the terrible looking blurry "ghost image" that looks like a shadow on the background. Also notice how flash on a shiny insect creates many unpleasant hot spots.

CHAPTER 11

MISCELLANEOUS

SUPPORTS

Quite often you will find it necessary to prop up or support your subjects and will need something to hold them. One of the most useful little gadgets I've found is a small device sold by Radio Shack and many hobby outlets called a "Helping Hand." It has a weighted metal base with a bar and several adjustable joints that allow a pair of alligator clips to be set in a variety of positions. The subject itself, background materials, twigs holding insects, and many more things can be held and moved around as you compose your picture. I have even used the clips to stabilize long lens setups by clipping onto the arm used to adjust the aperture on my short-mount macro lenses.

FIGURE 11.1 "HELPING HANDS"— AN EXCELLENT LITTLE CLAMPING DEVICE THAT CAN HOLD SMALL OBJECTS WHILE YOU PHOTOGRAPH THEM.

When photographing things like small flowers or a stick with a bug on it, small bottles or pop cans are ideal. Just put water in them to weigh them down and place the stem in the neck. Styrofoam blocks also work well—just poke the stick in wherever you want. You may have to weigh or tape the Styrofoam down if it is just a small piece.

BACKGROUNDS AND FOREGROUNDS

Too many photographers pay too little attention to what is in the foreground and background of their photos. What's in these areas can be just as important as the subject and can make or break a picture.

I will be referring to these areas frequently, especially in Part II, so rather than saying "background and foreground" repeatedly, I will in most instances simply use "background."

Hard shadows, distracting items caused by not enough or too much depth of field, unwanted objects, hot spots, uneven lighting, or inappropriate backgrounds are but a few of the things that ruin a photo. I speak from experience here—I have done just about everything that could be done wrong with backgrounds at one time or another.

Outside, doing nature close-ups, photographers usually try to position their cameras in a way that uses the existing background to advantage, often using very shallow depth of field so the background becomes a blur of color that does not distract from the sharp foreground image.

Indoors, most backgrounds are artificial. They can be anything: colored paper, a wall, fabric, or even large photographs. I've used coats, blankets, dirt, moss, leaves, and more for indoor nature photography. The background items are positioned behind or under the subject.

When using a vertical backdrop, make sure it is supported well. There is nothing worse than having your background fall on your subject in the middle of shooting. It tends to bust up things and scares little critters (if it doesn't squash them).

The biggest technical blunders made with backgrounds have to do with lighting. The first is not having enough light on the background, or having uneven lighting. This can be resolved by any of the following means: moving the background close enough that it is no more than half the light-to-subject distance (which will mean it gets one stop less light); moving the lighting farther away so the drop-off is less (which will mean a considerable loss in intensity of light and therefore

longer exposures); or adding more light or lighting the background separately.

I like to keep my lighting as far away as it can be put for the aperture being used so that I can keep my backgrounds well lit and evenly lit. If the lights are too close (particularly with single-source lighting), you can get the "spotlighting effect" mentioned earlier.

Try to use an aperture no smaller than absolutely necessary because the light can be kept further back, a lower powered light can be used, or a faster shutter speed can be used. Use the depth of field preview and stop down only until everything you want sharp is sharp. If f8 is adequate, then why use f22? You don't gain anything image-wise, and you have to provide a lot more light with its associated problems and headaches.

The second blunder is getting the shadows from the subject on the background. This can be somewhat embarrassing if you are trying to simulate a real scene such as making a model airplane look like it's flying and there is a big shadow on the blue sky! It is simply the result of carelessness. Reposition the light so the shadow is out of the frame, or use additional light on the background to obliterate it.

The third blunder is inaccurate or unnatural lighting. This is really only of concern to model photographers or nature photographers who want to make their photos look real or natural. More will be said about this in later chapters.

Always check your depth of field to make sure there are no surprises in the background. Too much depth of field can bring details in the background (and foreground) into focus and be very distracting. Too little depth of field and important details may become visual mush.

I once used a green blanket as a background for some insect photos. At the time, I didn't know the importance of the depth-of-field previewer and was still stopping the lens right down whether I needed to or not. Since the blanket appeared out of focus through the viewfinder, it looked fine—until I got the film back and the texture was razor sharp! Those images looked pretty silly.

BACKGROUND PLACEMENT

Unless there is a separate light source on the background, it will always receive less light than the subject. In most cases, there should be only about 1/2 to 1 stop less light on the background so the subject will stand out a little. If you get it back too far it will become very dark to almost black (especially when using slide film).

To calculate the background position:

1. Determine where the light source is to be positioned first. Let's say it's 22" from the subject.
2. Find the flash-to-subject distance (22) on the aperture scale.
3. We want to put one stop less light on the background, so look for the value one full stop smaller than f 22, which is 32.
4. If we place the background 32" *from the light source* (not the subject), it will receive exactly one stop less light.

Because of light drop-off, the closer the light source is to the subject, the closer the background must also be. This is most important if you want the background to be well lit, or if it is to be in sharp focus.

A good rule of thumb is to keep your lights back from the subject as far as is practical. If you can put higher power lights ten feet away and still use the aperture you want, do that rather than using a lower power light and putting it a foot away. It not only allows you more room to work, but you can put your backgrounds a lot further back, and it is easier to get the lighting more even. This goes for electronic flash too. If you have multiple power settings, then use high power further back instead of low power up close.

If the background is something other than plain or mottled colors and you want it out of focus, you may have to use a separate light source on it because you may have to put it some distance back. The smaller the aperture used the further back it must be.

In some cases you may wish to put a separate light or two on the background. If you want the same exposure on the background as on the subject, use lights of similar power as on the subject. Place them the same distance away from the background as the main light is from the subject, and use the aperture number method of moving them if you want to increase or decrease the light on the background. If they are not the same power, use a light meter to determine the initial placement.

A number of times I've heard that you should *always* photograph a light subject in front of a dark background and a dark subject in front of a light background. It simply is not true. Someone asked about this at a portraiture course I attended, and the instructor, without a word, pointed out a superb high-key photo of a white woman in a white robe against a pure white background. The best portrait I've ever done was a low-key photo of an African-American girl against a solid black background. So much for that advice.

There will be more said about backgrounds for specific areas of interest such as model photography and nature photography in Part II.

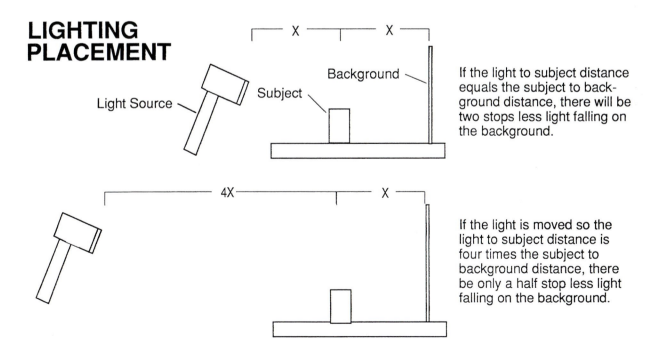

LIGHTING PLACEMENT

Light Source

Subject

Background

If the light to subject distance equals the subject to background distance, there will be two stops less light falling on the background.

If the light is moved so the light to subject distance is four times the subject to background distance, there be only a half stop less light falling on the background.

FIGURE 11.2 IT IS BETTER TO USE HIGHER POWER LIGHTING FURTHER BACK THAN LOW POWER UP CLOSE.

PART II

MAKING THE TECHNICAL PRACTICAL

CHAPTER 12

COMPOSITION

Here's where we take what was learned in Part I and make practical use of it. While almost anyone willing to take the time and expend enough film can learn to be a very good technical close-up photographer, it's the creative ability that really sets someone apart.

Some people are born creative—they can see pictures everywhere they look, and when they point a camera, they end up with spectacular images. Sometimes they don't even know how they do it. I asked one amateur I knew, who did work that would put many well-established professionals to shame, how she did it. "I just go by feel," was how she answered. "If it feels right, I take it."

Unfortunately, many of us don't have this extraordinary sense and have to work hard not only to find a subject of interest, but to make the photos of it look interesting. This sense can be developed to a degree with experience.

There are the infamous "rules of composition" that you hear much about in photo clubs and that many photographers seem to believe are hard and fast. I've seen many a clinic judge apply some of them where they don't apply, and one whom automatically rejected any photograph, no matter how good, that marginally violated any of a long string of "rules." Such narrow-mindedness can only stifle creativity and bring discouragement.

I prefer to call them "guidelines" rather than rules: bits of good advice that usually work but are not hard and fast as rules. There are a few guidelines that I do use and will mention, but I rarely consciously think about them when composing. I work with the subject and lighting until it "looks right" (or "feels right"). Don't ask me to explain it.

A few thoughts I would like to mention that are of importance are as follows.

A good photograph does *not* always have to be razor sharp with a depth of field to the horizon and all motion frozen. When I first started in photography I always tried to use the fastest shutter speed and the smallest aperture combination possible at all times. There are many occasions where blur or very shallow depth of field may add excitement, mystery, or emotion to a photograph.

A photograph of a racing car frozen on the track with a high shutter speed, for example, is static—as far as the viewer can tell, the car could have been stopped. Use a slow shutter speed and pan, and you get a picture where the car and driver are sharp but the wheels and background are a blur, giving the impression of speed.

Photograph a butterfly with maximum depth of field and you may see all kinds of leaves, grasses, and other annoying things in the background. By using a shallow

depth of field, the butterfly is sharp but the background becomes an out-of-focus softened smear of color that complements the subject.

You cannot do your best work if you are not comfortable, both physically *and* with your subject.

Think about it. If you are twisted and bent like a pretzel while trying to look through your viewfinder with a charley horse in your neck, you simply cannot concentrate on your work.

Neither can you work effectively if you are not "in the mood"—things just don't seem to work no matter how hard you try.

If you are not comfortable with your subject, it also shows. I find directing people difficult and don't feel comfortable doing it. Consequently, I am a terrible portrait photographer.

Do insects make you squeamish? Do snakes terrify you? Then you won't like working with them at all, and certainly not up close.

If you aren't interested in a particular subject, then you aren't going to put a lot of effort into photographing it. So, choose things you like to photograph, try to make working conditions as comfortable as possible, and if you can't, accept them as they are and work around them.

Make things easy for yourself whenever you can. I used to sit my subject on my workbench and move the camera and lights into all sorts of awkward positions—until I figured out it was often easier to move or tilt the subject.

In technical photography, you are trying to make an accurate record of what your subject actually looks like. In creative photography, you are trying to show how you feel about your subject and that is what you want to come through in the final image.

The most important thing a photo must have is a center of interest. A center of interest is a subject one can focus attention on. In most cases, it is what you are trying to show when you take the picture.

Usually there is only one center of interest in a photo, but there can be more. The problem with too many is that your eye tends to bounce back and forth between them and this can be discomforting.

No center of interest is a common mistake. These include shots such as landscapes or seascapes where there are no prominent features—just land (or water) and sky. There is nothing to catch the eye and hold it: you sort of keep searching and searching for it but don't find anything.

When you are taking a picture, take the time to ask yourself, "What am I trying to show or convey? What is my main center of interest?" Every picture should tell a story.

Most people tend to put their subject smack in the middle of the picture. I don't know why this is. Perhaps it's because most of the focusing aids in the viewfinder are in the middle, or perhaps it's the notion that the most important thing in the photograph should be there. Maybe they figure the "center of interest" should go in the "center" of the picture. These shots often look static and boring.

Does the main subject have to be in the middle? Can it be off to one side or a little higher or lower? There is a guideline called "the rule of thirds," which basically says that if you divide the viewfinder into thirds horizontally and vertically, then place your main subject either along one of these lines or where they intersect, it will look more pleasing than sticking it right in the middle. It usually does (see Figure 12.1).

RULE OF THIRDS

FIGURE 12.1 Most people tend to put the subject smack in the middle of the frame (left). Unless the subject is symmetrical, photos like this tend to be "static."

Don't put a horizontal line such as a horizon or a vertical line right in the middle of the frame either. There is something unsettling about dividing a frame in two. No matter how appealing the beautiful clouds and sunset over the prairies looks, if the horizon is in the middle of the picture it will not look right.

One exception to sticking the subject in the middle of the frame or dividing the frame in half is when photographing a symmetrical object. A round flower, for example, can be put right on the centerline and it will look acceptable.

Since 35mm cameras are built to be used most comfortably with the film oriented such that the wide dimension is horizontal, many seem to think it must always be held that way. I've watched countless times as someone either chops off a portion of a vertical subject, or moves back until the whole height of the subject fits within the height of the frame, rather than just turning the camera and shooting a vertical shot (their image could also be 50% larger if they did).

People tend to avoid filling the frame with their subject, settling for a tiny little image of the subject surrounded by a huge, uninteresting, or distracting background because they didn't want to move in closer or wanted to show too much.

The larger the size of the image on film, the more detailed it is, so why not make it big?

Some who do their own print processing, myself included, may often keep the image just a little smaller than they could get it so they have room to do some cropping in the darkroom (photo labs also routinely crop the image to fit their print sizes). But when you are shooting slides, all cropping has to be done within the camera. You can't remove that excess background or annoying distraction in the corner after the film is processed.

People will also chop off part of the subject rather than moving back a bit. The classic example is pictures of people with the tops of their heads cut off. It used to be easy to do it unintentionally with old box cameras, but you have to be quite inept or careless to do this with an SLR camera.

Just because the subject isn't a person doesn't mean it's okay to cut part of it off. Pictures of birds with beaks trimmed by the frame edge look just as bad. If you must crop, cut off at the rear or lower portion of the body.

With insects, don't cut off antennae unless doing a close-up of the face. What is often seen is a photo of a butterfly someone wanted to frame a particular way so they chopped off its antennae—the part that remains in the frame leads your eye right out of the picture and it looks incomplete.

As I have mentioned before, two of the most ignored things in photography are the background and foreground. I cannot overemphasize this enough. They are just as important as the main subject.

At a photo seminar, Rod Planck had this to say about composition: "If something isn't adding to the picture, then it is taking away from the picture. So, if it isn't adding, get rid of it!" (Easier said than done!)

These flaws aside, a good photo should have symmetry and balance. They are easy concepts to define, but difficult to convey. If you look at a picture and it has them, it "looks comfortable." If it doesn't, you might feel uneasy. A good photographer, however, can deliberately use lack of symmetry or balance among other things to make you feel uneasy.

Balance also means "the same on both sides" as in a balance scale—if the weights in the pans on both sides are the same, they are balanced. But they needn't be the same things on each side. A picture that is symmetrical is balanced. A picture that is balanced, however, is not necessarily symmetrical.

CHAPTER 13

CREATIVE USE OF CONTROLS

SHUTTER SPEEDS

A lot of creative work can be done playing around with shutter speeds. A very popular (and overdone) device many photographers use is to photograph waterfalls or rapidly moving water using very slow shutter speeds of a second or more and small apertures around f16. The result is a background that is razor sharp with the water as a big, nondescript, blurry white and gray foamy mass.

FIGURE 13.1 HERE ARE THREE photos of a watch ticking at different equivalent exposures. NOTE THAT although the images look identical in terms of tonality and contrast, they are very different in terms of depth of field and motion-stopping ability (note the differences in the appearance of the gears and balance wheels). As shutter speed increases, depth of field decreases. Also note how the gear left center appears to have twice the number of teeth in Figure 13.1a than in Figure 13.1b. The long exposure caught the gear when it stopped in two different positions.

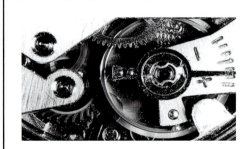
FIGURE13.1A 4 second f22

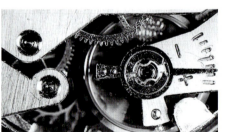
FIGURE13.1B 1/2 second f8

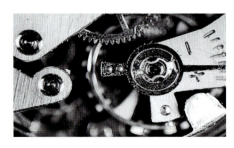
FIGURE13.1C 1/15 second f2.8

By using the fastest of shutter speeds, the motion of waves spraying as they crash on a rocky shore can be frozen, stopping the droplets of water in midair. Birds can be frozen in flight or hurdlers stopped mid-jump.

The best way to see the effects of shutter speeds is to experiment on a moving subject. Photograph moving cars at several different shutter speeds and use a tripod so the camera doesn't move. Do this on an overcast day so you can have a wider range of shutter speeds to select from. Shoot pictures using the fastest and slowest allowable speeds and one at a speed in the middle.

Compare the results with a magnifier, and notice the difference in movement each shutter speed has. Also take careful note of the effect the aperture has on these images. If your camera and meter are working properly, all of the images should appear to be the same density and contrast, *but* there will be considerable difference in the motion-stopping effect and depth of field.

APERTURE, DEPTH OF FIELD, AND ISOLATING THE SUBJECT

The aperture is *the* most important creative control on the camera when it comes to close-up photography. Misuse of it will guarantee poor results. To quote Maria Zorn, "You use only the amount of depth of field required to make the picture." The question now is "How do you know how much depth of field is required to make the picture?"

Before that can be answered, you must learn how to use the aperture, and to do that, you must have and learn to use a depth-of-field preview button. For this experiment, you won't need to take any pictures unless you want to, nor will you need any close-up equipment—just another person. If you have a short telephoto lens (about 135mm), use it because the effect will be more noticeable with a longer lens.

Go outside and set your camera horizontally on a tripod and have your friend stand somewhere where there are a lot of things off in the background (trees, houses, etc.). Set the aperture to wide open.

Position your camera so only your friend's head fills the frame from top to bottom. You are currently viewing the subject at full aperture and minimum depth of field.

Focus on the person's eyes and study the rest of the image. Their eyes are sharp, but their nose and ears may be slightly out of focus. Now look at the background. It should be terribly out of focus—perhaps nothing but an indecipherable blur of color.

Focus on something in the background and the person is a blurry blob.

Focus on the person's eyes again, and this time engage the depth-of-field preview and study the image as you stop down gradually from the largest aperture to the smallest. You will notice more and more in the foreground and background coming into focus as the depth of field increases. The image in the viewfinder gets darker as well, so allow enough time for your eye to adjust to the changes.

At some point the objects in the background will start to be recognizable shapes. Keep stopping down until you are at the smallest setting and observe how much is in focus.

Open the lens again and focus on the person's eyes. Now, still using the depth of field preview, stop down slowly until their head is in focus from the tip of the nose to as far back on their head as you can see and no more. This is what you call "isolating your subject from the background" using selective focus and selective depth of field.

This technique is used very frequently in close-up work, especially in nature photography, to reduce or get rid of annoying and distracting elements in the background and foreground. Try this with lenses of several different focal lengths and different-sized objects and notice the effect with each.

Another method for isolating the subject with depth of field is to simply look through the viewfinder with the depth-of-field preview engaged; adjust both aperture and focus until the image looks the way you want it rather than focusing on a selected spot and stopping down.

Using the Lancer illustrated in Figure 13.2 as an example, if we focus on the eyes, the depth of the face in front of the eyes is very small compared to the depth behind them. We need to stop down a fair bit so that his entire turban is in focus, but we only need to stop down slightly to bring the tip of his nose in focus. Thus, there is a lot of "wasted" depth of field available in front that is not being used.

What we can do is to start moving the point of focus a little further back and adjusting the aperture a bit at a time until we reach the point where everything we want sharp is in focus. Any further change in either results in the nearest or farthest points on the subject starting to go a bit fuzzy. At this point, we have just enough depth of field to cover the subject, although the actual point focused on may be nearer to his ear. The aperture would be a little larger than that required when focusing on the eyes, resulting in a shallower

FIGURE 13.2A This is our lovely background. Ordinarily, we would choose something better, but let's just imagine we have no choice and are stuck with it.

FIGURE 13.2B Here is our subject, a model of a Bengal Lancer. These shots were taken with a 100mm macro lens; this one using an aperture of f4. Note that the background is a "mottled blur" with no distinct objects visible and the tail of his turban is not sharp.

FIGURE 13.2C At f32 the greenhouse and trees in the background are much too clear. They distract our attention from the subject.

FIGURE 13.2D At f8, the lens was stopped down just enough so that the depth of field covers only the subject. Although objects in the background are starting to take more form, they are not clear enough to distract.

FIGURE 13.2 Depth of field and isolating the subject.

depth of field and further isolating of the subject from the background.

Whenever practical, you should use the preview button so you know exactly what your picture will look like. Because the rate of decrease of depth of field is very rapid when you get close, at some magnifications it won't even be possible to keep the entire subject in focus at the smallest of apertures.

Selective depth of field only works when you get close to your subject (i.e., the lens-to-subject distance is only a few feet or less). For example, try photographing a bus on a busy street. You will find that because you must be a fair distance away from the bus to fit it all in, even at maximum aperture buildings and objects a long distance in the background are still quite recognizable.

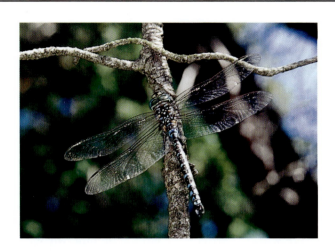

FIGURE 13.3A Too much depth of field was used in this shot. Note the numerous distractions in the background, particularly the dark diagonal and hot spots on the right.

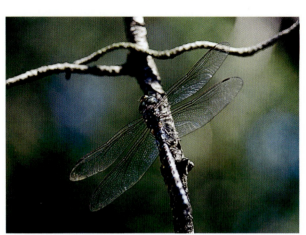

FIGURE 13.3B Here just enough depth of field to keep the subject in focus was used. Note that the distractions in the background are now blurred and less annoying.

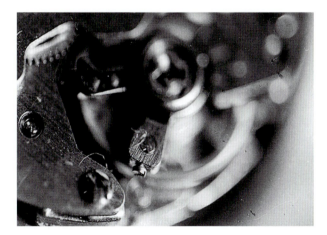

FIGURE 13.3C Far too little depth of field was used in this picture of the watch. Man-made subjects tend to look awful unless the depth of field is great.

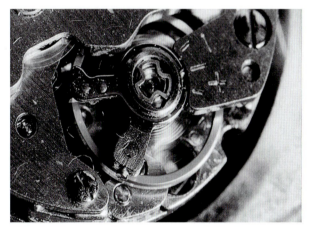

FIGURE 13.3D Here is the same picture with the lens stopped down to f22 instead of f3.5. Almost everything in the picture is sharp.

FIGURE 13.3 Depth of field and subject types.

Unless the shallow depth of field prohibits it, your subject should always be sharp and entirely in focus. There are a few times, as with some natural subjects, where softening of focus may be pleasing, but it almost never works with man-made objects unless you deliberately isolate a specific component or subcomponent amongst the works.

Flowers, for example, are soft with flowing curves and few hard edges or corners, so you don't notice it as much when the depth of field is too shallow and details of the flower in the distance start to blur.

Man-made objects, on the other hand, are filled with hard, straight lines, sharp corners and edges, and it is very obvious when they are no longer sharp. It sort of jumps right out at you.

When photographing fast-moving things like crawling insects, you really have no choice in the matter: you must stop down as much as you can and hope the depth of field is adequate, because your subject won't stay still long enough for you to check. In such cases, you will almost certainly be using flash.

EXPOSURE

Up until now, we have been concerned with getting the right exposure. I defined the right exposure as one that will render the tonality of the image as close to the original as the film is capable of producing. A judge at one photoclub competition defined the right exposure as "the exposure that produces the picture the way the photographer wants it to look." He stated, for example, that if the photographer wanted the picture to look dark and underexposing it two stops produced what he or she had in mind, then that was the correct exposure for the picture.

The example shot was of a skier on a hill slope. It was an "up sun" shot (looking into the sun). The photographer chose to expose for the sun and used the smallest aperture possible, which caused the skier to be a black silhouette and the sky to be a very dark blue with a "starlike" sun. Had he chosen the exposure for the skier, he'd have a horribly burned out image—thus the correct exposure for that print was almost two stops underexposure.

When you underexpose, everything gets darker and you lose a lot of detail in the shadows. They just go solid black.

Deliberate overexposure is a lot more difficult to make work—particularly with slide film, for when it occurs, not only is the image lighter, but the colors get washed out. The only time I use overexposure is when I want detail in the shadow areas. You end up losing detail in the highlights, though.

CHAPTER 14

POLARIZED LIGHT PHOTOGRAPHY

You've probably used polarizing filters or had Polaroid sunglasses and noticed the effect they have on glare and colors. Polarizing filters can also be used to create fascinating and colorful pictures.

Polarizers are special filters that will only allow light traveling in certain directions to pass through. Light striking at any other direction cannot penetrate. The result is the filters cut down on glare, and they also improve contrast and color saturation.

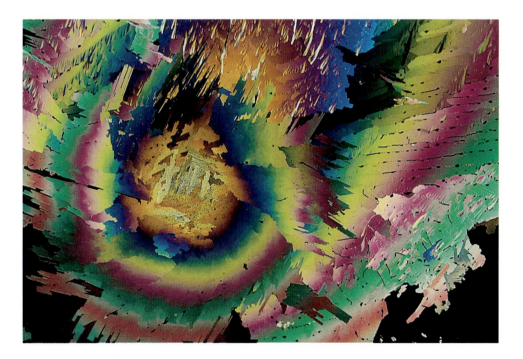

FIGURE 14.1 Napthalene crystal under polarized light (about 8X).

PHOTOGRAPHING CRYSTALS

Polarizing filters are also used to photograph crystals of chemical compounds that produce fantastic surreal photos of bright multicolored snowflakes, feathers, or jewel-like structures and frostlike patterns. To make such photographs, all you really require is a couple of polarizing filters and a light source. The crystal is placed between the polarizing filters and photographed by transillumination lighting. There are, of course, many other ways to do this besides the method illustrated. I have used a slide-viewing box, and I know one photographer who has adapted a slide copier.

The polarizer between the light source and the subject can be a sheet of polarizing plastic (sold in good photography shops) or another polarizing filter for a camera.

Sit the crystals over one polarizer and put a polarizing filter on your camera, then look through the viewfinder. If the crystals are made properly, as you rotate the polarizing filter you will notice they change color from dark gray-black outlines on a clear background to brilliant reds, oranges, yellows, blues, and greens against a black background.

Exposure when photographing crystals is a bit of a trick if you don't have TTL metering. I've never tried it

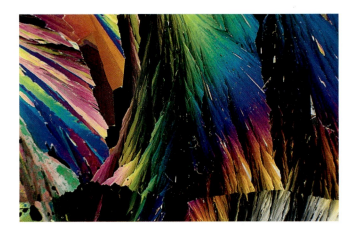

FIGURE 14.3 Salicylic acid crystals (2X).

without. You would have to shoot a few test rolls with "guesstimated" exposures at fixed magnifications and light-to-subject distances.

I only use Tungsten balanced film for crystal photos because the light losses are very high with two polarizing filters in the light path—8 seconds is a fairly normal exposure time at about 2X, so reciprocity failure can also be a problem. You don't want to lose an additional two stops by using a color-correcting filter.

I've found that the straight TTL reading seems to be quite adequate without any correction or bracketing unless there is a lot of black. You don't need a lot of depth of field either, since the crystals are micro-thin. Almost any aperture will do. I usually use f4 or f5.6, so faster shutter speeds can be used.

Don't use too high of a wattage lamp; about 60 watts is enough—and don't get it too close. Heat from it could cause damage to the polarizing filters and melt the crystals.

Turning out the room lights can reduce any stray reflections off of the glass surfaces. This also makes the crystals easier to view.

MAKING CRYSTALS

Crystals are made from chemical compounds, with each compound having its own very distinct patterns. They are produced by melting the compounds between two glass plates and letting the crystals form as it cools.

Some chemicals that produce good crystals for beginners are Citric acid, Salicylic acid, Ascorbic acid, and Sodium Thiosulfate. The first three can be obtained off the shelf from a drugstore and the latter from photo

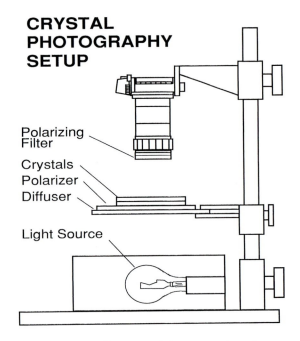

CRYSTAL PHOTOGRAPHY SETUP

Polarizing Filter

Crystals
Polarizer
Diffuser

Light Source

FIGURE 14.2 Transillumination lighting is used to photograph crystals.

supply shops. *The chemicals must be pure.* A pharmacist or chemist might be able to recommend some others.

You will need small glass plates. Kodak sells boxes of 2 × 2" thin glass slides in boxes of fifty called "slide cover glasses"—they are ideal, although small pieces of window glass will work. Additionally, you will require a hot plate or clothes iron (for pressing clothing), some clothespins, and perhaps a potholder or oven mitt. Do not use a stove—the elements get far too hot. Also, you should *not* melt the chemical compounds indoors because some chemicals may give off unpleasant or even toxic vapors if overheated.

A very small amount of the chemical is spread out evenly on one piece of glass, then another glass is placed on top of it. It is then heated over the hot plate until it melts and flows between the plates. I use a clothespin or two as handles to hold the plates and work with only one crystal at a time. Hold the plates just above the hot plate or iron. Do not put them directly on it as they may shatter.

When the compound has melted completely, it is removed from the heat and the plates are clamped together. Use a number of clothespins to squeeze the plates while the crystals form.

FUN WITH POLARIZERS

You can also have fun with plastic bags and wrapping under polarized light. Take a piece of the soft white stretchy plastic like that used for grocery bags or garbage bags. Using your fingers, stretch it a bit here and there. Pinch it between two fingernails and pull a bit (this gives a ripple to the plastic). Now put it over the polarizing filter on your light box and view it with the camera through the second polarizer. You should see all sorts of wild abstract patterns and bold colors (mostly blues, black, and oranges)!

CHAPTER 15

PLASTIC MODELS

The following chapter is primarily for scale modelers who want to photograph their creations. Much of it, however, applies to *any* tabletop subject or setup.

This is where I began in photography. I was an avid airplane model builder when I got my first camera and was looking for things to photograph, so I naturally started photographing them.

Model photography is an excellent way to learn about tabletop photography, lighting, and backgrounds, which all come in handy with close-up photography. It also teaches you to look at and study what you are doing.

It's quite easy to fool the average person with a picture of a model because they don't know what clues to look for. But to fool an expert modeler or someone who knows the real thing very well is what every model photographer strives for.

Let's start with just trying to get a nice picture of a model. This is essentially "product photography," so you might want to find a good reference on that if you really want to get into all the lighting and creative ideas.

Contrary to what many think, you will need lots of room to do tabletop photography right. The backgrounds are fairly large: about two to three times the size of the subject or more to ensure that you don't get the edges in the photo. You also need lots of working space for the lights and camera.

The first thing to consider, once again, is backgrounds. The simplest background is a plain one, such as a bare wall, a piece of colored card, or a piece of fabric attached to a wall, with the subject placed on a table in front of it. The same could also be used for a base underneath. Unfortunately, these setups usually limit the viewing angles you can shoot from because you will see a hard straight line where the base and background merge if you get too high, even if they are the same color.

Long single pieces of paper or fabric off a roll are the nicest. Pinned to a wall or other supporting frame and flowing down over the table forming a curve, they create excellent backgrounds. It tends to be hard to keep the wrinkles and ripples out of fabric. You often have to keep tugging here, pulling there, and sticking pieces of tape everywhere as you position and reposition your subjects. If you are careful with your lighting, you can often hide the little wrinkles you can't eliminate.

The ripples may be very hard to get rid of with single-source lighting. When you position the light for the subject, the background, being further away, will be in the underexposure region of the film. This not only makes the background show up darker, but all the little ripples jump out at you. You should consider a separate

TWO SIMPLE BACKGROUND SETUPS

Two Piece
Vertical backdrop and base.

Single Piece
Paper roll or fabric.

FIGURE 15.1 The two-piece background is the easiest to work with, but the angles that you can shoot the subject from are limited because the dividing line between the two surfaces can be sharp and unsightly. The single piece or "seamless" background is very nice because there is no dividing line between the base and vertical backdrop.

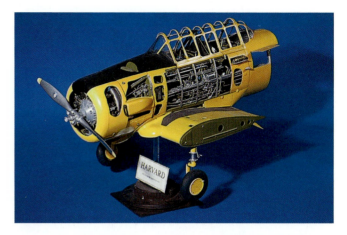

FIGURE 15.2 This 1/12-scale North American Harvard model was photographed using a 100mm macro lens and two floods. The fill was a half stop less than the key to reduce the intensity of the shadows. A single-piece paper background was used.

light source (or sources) on the background as well if this is a problem.

When lighting the background with a separate source, you cannot just place the light wherever you want to. I used to do exactly that when I started, not knowing anything about lighting, and I got a lot of really badly lit photos. You must position the lights so the background is evenly lit *and* so you get the desired exposure on the background. Lighting the background first then lighting the subject is often the easiest way to go.

If the light reading off the background is the same as the reading for the subject, the background will show up the same tone and shade as it actually appears. If the reading is higher, the background will be lighter, and if lower it will be darker. By controlling the lighting on the background it is possible to get a whole range of tones.

If you don't have separate lighting on the background, you can adjust the tone a bit by moving the background back and forth. Use the methods mentioned under backgrounds in Chapter 11, "Miscellaneous." It isn't hard to make the background darker (move it back), but you may not be able to move it close enough to the subject to make it as light as you'd like. You won't be able to make it appear lighter than it is as it would have to be placed in front of the subject!

Single-source lighting is good for "dramatic" shots where you want lots of hard shadows. If you have the light too close it will produce a "spotlight" effect on large setups, which can easily be seen on film (a bright central area with darkening towards the edges). It is not advisable to use single source lighting if the setup is too large. It will look like your pictures have all been vignetted.

Using a diffuser will help soften the light and shadows, but the problem here is the size. A diffuser has to be larger than the subject to work properly, and that can be pretty big. A soft box diffuser for portrait photography can be used if you have one. If I am photographing in a room with a white ceiling, I have used a high-power flood aimed at the ceiling to diffuse the light. It works well, but you will use longer exposures than with direct lighting. Diffusion umbrellas or pieces of drafting paper placed between the light source and subject also work well.

Experiment a lot with positioning of the lights until you see what you like. I keep the key light higher than what I'm photographing, probably because that's how we see most things—lit from above—so it seems natural. That may not be the right thing to do; I should really try other positions to see what the results are. Consider who will be viewing the photos too, as most people will judge them by what seems normal to them.

Play around and try all sorts of lighting angles and configurations to see what you can get. Also try special

FIGURE 15.3 I thought I had a terrific shot of this P-61 Black Widow until I enlarged it and discovered shadows of the trees on the hills and sky at the right.

effect filters, colored filters, colored lights, unusual backgrounds . . . let your imagination run wild.

When metering, check the exposure both for each light independently and with all on. Correct the exposure for extension, filters, and reciprocity if necessary, then shoot.

Always pay attention to the shadows—how dark they are and where they are falling. They can ruin a photo being big ugly distractions, hiding important details, or falling just where you don't want them.

Floodlights are better than flash because of the difficulties encountered aiming flash. You need a lot of batteries to do all the test firings to make sure the lighting is correct and the shadows are where you want them.

If you use flash, never use the flash on the camera itself—it will put big beautiful black shadows on your background. Invariably, the shadows will always fall where they look the worst. If you use flash, use an extension sync cord so you can position it away from the camera and control where the shadows will fall.

Watch the shadows. On the base may be acceptable, but on the vertical part of the background they look amateur. Before shooting, always scan the background well.

There is a "scale effect" with light: it doesn't bend around or shade a tiny object the same way it does with a large one. A very good example of this is with the faces of model soldiers. Modelers actually paint in all

the shading and shadows on the faces. If they don't, the faces are practically featureless when lit.

MAKING THEM LOOK REAL

When it comes to trying to make a model look real, my basic philosophy is "to make them look like the real thing you must always treat them as though they are the real thing." Everything in the picture must be as it would appear if you were looking at a picture of the real thing.

This leads me to another related bit of advice. If you want your picture to look like the real thing, study pictures of the real thing. Remember these points. They apply equally to tabletop nature photography.

Look at how the real thing appears in photos—the depth of field, lighting, background, horizon location, and even the angles the pictures were taken from! You have to be able to duplicate these characteristics.

Many don't consider the picture-taking angle! If you watch people take pictures, the vast majority take them from a standing position or sometimes squatting. Try to simulate the view as someone of average height would see it, not someone who is eleven feet tall, or four stories up.

A poorly constructed model or one with exaggerated details are dead giveaways. Sometimes a bad glue joint, a bad bit of painting, or a decal can be hidden by

FIGURE 15.4 Taken outside in bright midday sunlight and deliberately overexposed, this B-17 crash shot has fooled many.

shooting at an angle where it can't be seen, or hiding it behind something, but there is really little the photographer can do about this.

LIGHTING

If the real thing is usually outside, then you must try to reproduce sunlight. It has to be bright, and the entire scene must be lit evenly and as though the light were coming from a single source up in the sky. Shadows underneath will be hard, not softened or eliminated by fill, unless the model is supposed to be sitting on light sand or snow.

If there are hot spots (especially on the vertical background), or if the lighting appears to come from more than one direction (multiple shadows or absence of shadows) or from an impossible direction (below the subject), it's a dead giveaway.

I have found that the very best way to simulate sunlight for models is to use real sunlight! Set up everything in the yard or on a picnic table on a sunny day—you can't beat it.

DEPTH OF FIELD

When photographing a model at relatively close range, you will run into depth of field problems. This is one of the times you must stop down as far as you can, especially if you want the background sharp. With the exception of photos of the real thing taken indoors

using large apertures, it is rare that you will find a photo that is not reasonably sharp from end to end. If stopping down doesn't solve the problem, try shooting from another angle where the subject is closer to being parallel to the film plane so you don't need as much depth of field.

If you are photographing soldiers and the like, then shallow and select depth of field are permissible because the subjects are smaller. Such effects are often seen in the real photos.

When you focus, *focus where you would on the real thing*.

BACKGROUNDS FOR MODELS

Backgrounds that don't match the foreground, those that are poorly lit or blurry, and those with mismatched lighting, inaccurate scale, or locale, and so on, all instantly give away a model.

Many model photographers use railway backgrounds—landscapes that run across several strips of paper. Others might have a favorite landscape photo enlarged to poster size. They should be mounted on smooth wood as they tend to wrinkle after a while if on cardboard (these wrinkles are dead giveaways in photos too). Use a spray adhesive to glue them down evenly. Over time the posters will expand and contract with the humidity, so if they are only "spot glued" or held with two-way tape, the unstuck portions will swell, creating ridges and bumps that show up in the photos.

I used to make bases out of painted Styrofoam sheets. The base is set up against the background picture and the models are set on it. You have to watch two things closely: do not put the model close enough to the vertical background to cast shadows on it, and do not shoot from too high an angle or you will see the hard dividing line between the base and the background.

Horizons are another problem. Too high and they look funny (they look real funny crooked too, but a lot of people take pictures that way). Check real pictures to see where horizons lie relative to the subject. If you are looking downward on the subject from fifteen feet up, the horizon should not be in the same position relative to the subject as it is from ground level looking slightly up.

If your pictures don't have a horizon line (i.e., the flat base against the background does not make a convincing one), create a miniature one at the end of the base near the background. Look at the horizons in photos of the real thing and try to simulate them.

Very blurry backgrounds are uncommon, especially if the subject is large and the image is sharp. You have to watch the depth of field to avoid this.

Inaccuracies in the background can be fatal. These include items of the wrong scale, such as a 1/35-scale soldier behind or on a 1/48-scale tank; wrong geographic locations, like tanks and soldiers of Rommel's Afrika Korps with the Alps and snow in behind; or different eras in time, like revolutionary war soldiers using a civil war cannon. You may think that nobody will notice these errors, but I did a diorama of a Japanese Zero that crashed on a South Pacific Island, and someone informed me that the type of palm trees I used don't grow in the Pacific.

If you use photos or the railway backgrounds, pay attention to the direction of the lighting on the background. Your model lighting *must* match it. Most of the scenes I've seen are lit as though the sun were high in the sky directly behind the photographer. If you choose to light the subject from a different angle than that in the background, the incongruity in lighting may be quite noticeable. The background must also have been shot from an angle similar to that you are shooting from; a scene photographed from ground level will look bizarre if the background shot was photographed from the air.

Using the same background in all your pictures never looks good. Use different parts of the background. You can also shift it up and down for a different appearance. For example, if there are rolling hills and cloud, you can place it right behind and get

that scene, or lower it (or raise the model base) so you just get the upper parts of the hills or just the sky.

Often, the photographer may sit the model on a real piece of asphalt and get low and close so there is a real background in behind it. They do not stop down enough, and the bad depth of field may give them away; or they stop down too much, and the background gives them away.

The scale of the model versus the size of the objects in the background also must be watched. Tiny pebbles look like boulders and twigs look like tree trunks.

One publication I have shows a model of a large radio control airplane on a real runway. The model was placed on the centerline and there was a comment about how realistic the model looked. The model didn't look bad, but the centerline was so far out of scale that it was a dead giveaway. (Try putting a model car on the line in the middle of a road and see if it looks realistic to you.)

If you need realistic looking sand, don't use real sand! It looks like coarse driveway gravel. I believe expert modelers use colored talc to simulate it on models and in dioramas.

Smoke and fire are toughies. I've seen smoke simulated successfully with cotton pulled thin and wispy or sometimes smoke blown from a cigarette, but I have never seen realistic scale fire. I've seen photos where the photographer simulated a tank battle and lit real fires but they looked as phony as can be. Fire doesn't "scale down." Compare the size and shapes of a flame on a matchstick, a campfire, and pictures of a really big fire—they are all distinctly different.

Failure to frame the picture properly kills many shots, too: showing an edge of the background, light stands, reflectors, or something off to the side of the table is a big no-no. For some reason people are afraid to move in and fill the frame! Unless you do your own printing and can crop the images, you should always move in. If you are not filling the frame with the subject, be sure to fill it with the background.

Look for little things hiding near the outer frame edges. One mistake I made frequently was being just a bit too low and getting the front or side edges of my base in the picture. It wasn't until I learned that most viewfinders do not show 100 percent of the image that I was able to correct that problem. Just before shooting, loosen the tripod head and move a little bit to each side and up and down a touch, just to make sure nothing unsightly is hiding near the edges. I discuss this procedure in greater detail later in the section on nature photography.

Lenses Used

With a short lens (50mm or less), you have to get right up close to the setup. The wide angle of view takes in a lot more background, so the backgrounds have to be very tall and wide compared to the size of the model, so you don't get the edges in.

A 100 to 135mm telephoto lens provides a more realistic perspective, and the narrower angle of view and the extra working distance really make things a lot easier. The smaller angle of view allows the use of smaller backgrounds, and the working distance means it is easier to light the scene.

Wide-angle lenses are difficult to use because you need such big backdrops, and you have to get really close to get a decent image size, which may not be possible. Getting close with a wide-angle lens also increases the distortion, which can look really bad or even grotesque.

FIGURE 15.6 This and the previous flight shot of the F6F Hellcat (Figure 15.5) were taken outdoors. The model was sitting on a glass plate and I shot upward looking into the sky background. The spinning prop was accomplished by giving it a whirl and shooting at 1/60 second (the slower the speed, the greater the blur). Here, about 70mm was used so the distortion is less.

FIGURE 15.5 This is an example of what happens if you use a lens with too short a focal length (28mm). The tailplane, being closer to the lens, looks oversized and fat, and the wings look narrow. Everything gets disproportionately smaller and distorted towards the front.

Exposure

I shoot model setups primarily with black and white film because I can process it myself and because color tends to show up all minor flaws in the model and setup more readily.

With black and white I can use the wide exposure latitude to cheat. Deliberately overexposing by a stop or two, and continuous agitation while developing, gives a denser, more contrasty negative that loses much of the finer detail—which is okay, because it is often these real fine details (like rivet and panel lines) that give a model away.

If I am trying to do flight shots, I usually suspend the model with very light-colored threads and the overexposure will make them virtually disappear.

CHAPTER 16

THIS AND THAT

STAMPS AND COINS

Stamps and coins are popular subjects for close-up photography. In addition to just being interesting subjects that are easy to find, many serious collectors have their prize possessions photographed for insurance purposes.

FIGURE 16.1 Abe Lincoln between the pillars inside the Lincoln Memorial on the back of the U.S. one-cent piece. This shot was my first close-up photo, taken using a very low power metallurgical microscope.

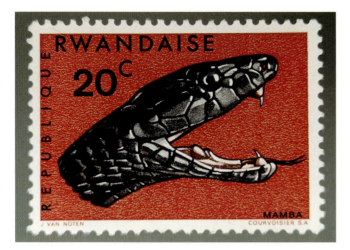

FIGURE 16.2 Stamps are a popular subject that demand edge-to-edge sharpness and flat shadowless lighting.

Stamps are basically copy work, and you should have edge-to-edge image sharpness. We can use either a macro lens or do some lens reversing to get it.

Most stamps and coins will be shot in magnification ranges of about 1/2X. If there is zooming in on details, it may go up to 2X or 3X. If you don't have a macro lens, you can achieve 1/2X by reverse-mounting a lens of about 100mm focal length. The higher magnifications can be achieved by reversing shorter focal length lenses (50mm and 24mm) or adding extension.

Stamps and coins are easiest to photograph using a copy stand, lying flat with the camera looking straight down.

Placing the subject directly on the background almost always leads to a hard shadow around the edge, which is not pleasing—especially with coins. I use the shadowless background method explained in Chapter 9, "Lighting," where the subjects are placed on a sheet of glass several inches above the base of the copy stand, and plain or colored backgrounds are placed beneath.

For stamps, if they are flat, just sit them on the glass. If they aren't, then place another piece of glass on top to keep them flat. Use two lamps, one on each side, with their beams directed so that the stamp is evenly lit overall. There should be no noticeable shadow underneath if the lighting is balanced. A polarizing filter will be needed to reduce glare.

Once the image has been framed and the focus has been set, I sit a gray card over the stamp and read it, then set the exposure on the camera and shoot. Since the subject is literally paper thin, you don't need much depth of field, so f4 or f5.6 is fine. This allows you to use a much faster shutter speed. The reason I use f5.6 is because my macro lens is f4, and I want to close down one stop just to be sure I have a sharp picture in the event my focus is a little off. If you are using an ordinary lens in the normal (as opposed to reverse) position, you should stop down more to reduce edge distortion that may occur.

The technique is the same for copying photographs or anything else that is flat. The primary concern is that the lighting on the subject be even.

Coins are lit differently than stamps because of the relief detail. If we were to use balanced lighting as with stamps, there would be no shadows on the coin's surface and the detail would all appear very flat.

The relief designs on coins are fairly low, so most ordinary lighting techniques don't work well. With this method, a glass plate is slanted between the coin and the lens at an angle and a light is shone in horizontally. The light reflected off the glass acts like fill and provides just enough balance that the image has a three-dimensional appearance, yet the shadows are not hard. The amount of fill is varied by changing the angle of the glass plate.

Meter as normal, using a gray card. You will also need a polarizing filter to cut the glare off the glass plates.

LIGHTING SETUP FOR COINS

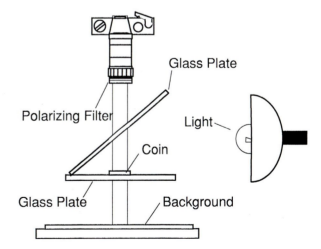

FIGURE 16.3 With this setup, the direct side lighting creates hard shadows and the angled glass plate reflects enough light to soften them. You have to experiment with the light position and angle of the glass plate. A polarizing filter must be used to eliminate glare off of the glass plates.

MECHANICAL SUBJECTS

This section covers all sorts of items, such as the insides of watches, circuit boards, nuts and bolts, needle and thread, and so forth.

Old and now practically obsolete mechanical watches make fascinating subjects. All the tiny gearing, springs, screws, and levers provide lots of interesting photo opportunities. You can do shots of the whole mechanism, right up to an individual gear tooth—all are fascinating to look at.

I do most of my watch photography using my camera, a copy stand, and one of the "helping hands" devices mentioned previously to hold the watch where I want it. I find it much easier than trying to work on a tripod.

For images up to life size, any lens works fine, but when going larger than that, I prefer short-mount

FIGURE 16.5 Lots of miniature gears, springs, and other mechanisms inside watches can keep one busy shooting for hours.

FIGURE 16.4 There are lots of picture possibilities with an old typewriter.

macros. Their tiny size makes it much easier to get in and around the subject and light it than the larger diameter of a regular lens.

With small objects, I use a single-source lamp (usually a 60-watt) about a foot or so away. I use little pieces of tinfoil glued to different-shaped pieces of card as reflectors rather than additional lamps, as there is often no practical way to get another light in, let alone direct it. The reflector has to be quite close to the subject in order to see any noticeable effects, and if you want to do any shooting in darker areas of the subject, you will need them.

This tight situation presents many problems with metering. You have to use either TTL or a spot meter because there is no way to get any other type in there

where it is hard to get even the tiniest of gray strips, I will take the best reading possible and bracket, shifting exposures more to the overexposure side. That is, instead of bracketing from one stop more to one stop less, I may go to two stops more and zero or one stop less because I know the darker area needs longer exposure but don't know how much.

Printed circuit boards can be fun subjects to photograph. You don't need a lot of magnification to photograph them unless you want to zoom in on a single component. But there are all kinds of pictures of rows, patterns of components, and "streets" of copper tracing connecting them all.

FIGURE 16.6 Miniature "grain of wheat" light bulb. Ordinarily, the filament would glow so brightly that to keep it from burning out the image, the rest of the bulb would be underexposed and quite dark. The trick here was using a voltage much lower than normal, so the filament just glowed rather than shone.

to get an accurate reading, and you may not have something that is 18 percent to meter. This is usually where I use my mini-gray-cards, the ones I make by cutting 1/4-inch or 3/8-inch strips off a standard gray card. Carefully maneuver one into position where the camera is focused, hold it so it is lit as the subject is, and read off of it. In most situations it works pretty darned good.

If I'm not sure about the reading, such as when I am trying to photograph a gear deep in a shaded area

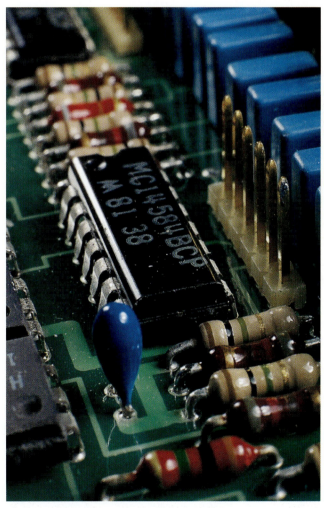

FIGURE 16.7 Printed circuit boards are like miniature cities and provide many an interesting photo possibility.

OTHER IDEAS

There are thousands of things you can photograph in the close-up world. I've done miniature lights, colored beads, needle and thread, small art works, rusty nail heads, ceramic figurines, jewelry, a dentist's drill, rocks and minerals, fossils, sea shells, and whatever other tiny thing I could find. I've also seen fantastic images of kitchen knife blades, some delightfully humorous photos of cod liver oil capsules, and abstracts using fabrics, ribbons, and laces.

If you are interested in photographing flowers, some commercial greenhouses and nurseries may let you bring your camera and photograph their plants.

Water drops present a myriad of possible ideas for pictures. Close-ups of drops hanging from a clothesline, flower bud, berries, or blades of grass are popular.

Water drops also act as magnifying lenses, enlarging the details of whatever they are sitting on. On leaves and grasses they will magnify the cell structure beneath them.

Tin foil makes interesting abstracts. Crumple it tight and unfold it so there are lots of lines and ridges, then photograph it using lamps and reflectors, placing different colored filters between them and the foil.

You can do some very creative stuff with an onion, berries, peas in their pod, and more. Cross sections of different vegetables or fruits provide interesting patterns and abstracts when photographed close up.

Jewelry, gemstones, and minerals also make excellent close-up subjects, with the fine detailing in the silver or gold or the gems themselves.

These are but a few ideas. There are close-up possibilities just about everywhere that you look. You only have to open up your eyes and your mind!

FIGURE 16.9 WATER DROP ON WILD ROSE HIP.

FIGURE 16.10 Food items offer all sorts of possibilities—lots of colors, shapes, and textures to experiment with.

FIGURE 16.8 Cockatiel tail feather detail.

CHAPTER 17

MICROSCOPY

Microscopy is very exciting for those interested in exploring the close-up world to the fullest extents. The only drawback is that it requires a good microscope with high-quality optics. It also requires a microscope adapter and may require special focusing screens.

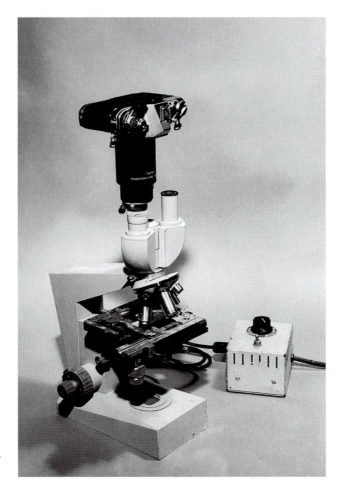

FIGURE 17.1 Typical microscopy setup: microscope, camera, microscope adapter, and rheostat-controlled light source.

With a microscope, you can magnify images from about 50 to 1500 times using transillumination or reflected lighting. You can also do polarized light photography.

Most photography with a microscope is purely technical. It is almost impossible to be creative or artistic as you cannot move around the subject, vary the lighting to any degree other than brightness, do much with backgrounds, or control depth of field. In fact, you have no aperture control at all and shoot "wide open" all the time.

Focusing is critical, especially at high magnifications, and it may be difficult at times because of low light levels, especially if doing polarized light work. A matte focusing screen is usually needed here, and some camera manufacturers have special "crosshair" focusing screens made especially for microscope work.

Determining exposure is not any more difficult than it is using any other form of magnification as long as you have TTL metering. You just meter normally and compensate for subject brightness in the same way you would elsewhere. If you don't have TTL, then you will have to run some tests shooting at various shutter speeds to determine a good starting point and bracket from there.

Exposures can be long if you are doing polarized light photography, up to thirty seconds, so the setup is very prone to any vibration. I do my work with the microscope on my concrete basement floor.

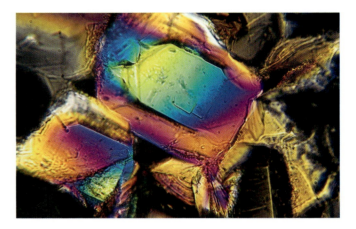

FIGURE 17.2 Borax crystal under polarized light magnified 200X.

CHAPTER 18

NATURE SUBJECTS

Nature photography presents some of the most exciting and challenging subjects around, from plants and flowers to insects and animals. This is by far the most popular realm of close-up photography.

FIGURE 18.1 Maple leaf floating in pond.

Almost all nature photography is done using color slide film. The image quality on print film doesn't come close.

The most popular focal length lens in use is 200mm primarily because of its working distance and angle of view (Chapter 2, "The Camera"). Many prefer a 200mm macro lens to a standard lens because it focuses right to 1:1, which means that you don't have to carry a bellows along. The standard 200mm lens is fine as the need for edge-to-edge sharpness in nature work is very rare.

Backgrounds are extremely important in nature photographs. They can range from blurry smears and out-of-focus streaks of color in close-ups, to razor sharp details in a habitat shot.

Something frequently done, and generally considered unacceptable in formal nature photography, is the "black background" that one commonly gets with flash. I have one book that advises that you use a black velvet backdrop when photographing wildflowers and to "be careful using colored backgrounds lest they look unnatural" (a black velvet background is natural?).

For the most part, black backgrounds are the result of improper use of electronic flash. Many people love these shots because the subject just jumps right out at you, despite the fact that they are hard, contrasty, and have lots of hot spots. Many nature photographers abhor them.

The only time a black background is considered acceptable in nature photography is if the photograph was taken of something you only see at night. In such instance, good photographers will often slip something into the background or position lighting, if they are able, so it is not solid black.

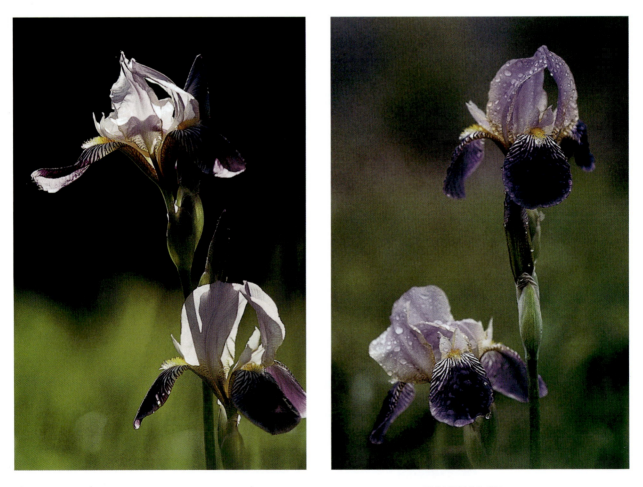

FIGURE 18.2A **FIGURE 18.2B**

FIGURE 18.2 The photo of the irises (Figure 18.2a) was taken mid-afternoon on a bright sunny day. The image is very hard and contrasty. Soft subtle colors and details of the flowers are nonexistent. Figure 18.2b is the same plant taken from another angle on a light overcast evening after a rain shower.

You don't have nearly as much control over backgrounds in outdoor nature work as you do in tabletop photography. You basically have to work with what you have, although you could use an artificial background outside if you like.

Without a doubt, the finest lighting for close-up nature work is diffused light like that on a light overcast day. Next best is early morning light, from predawn to about 8:00 A.M., and then comes evenings when the sun starts getting low. Shade is better than direct sun, but somewhat flat. Many nature photographers will use reflectors or even flashes to add a bit of fill when photographing in the shade.

If the sun is out, the hours from about 10:00 A.M. through about 5:00 P.M. in summer are the worst times to shoot close-ups. The sun is high and bright and the contrast is *hard!* You get black shadows and burned out highlights. Subtle and soft colors are almost nonexistent. They are not pleasant to look at and are "record shots" at best: pictures used to help identify a strange plant or insect but certainly not the kind of shot you'd hang on a wall.

To convince you of this, take two close-up slides of a flower like an iris or any other flower that has very subtle and delicate colors. Shoot one slide on a lightly overcast day and another similar shot in mid-afternoon sun. If you'd like, shoot another in shade. Shoot other close-up subjects under these different conditions, too, and then compare the results. Even if they aren't great shots, the differences in lighting should be very apparent.

Some people bring flash units outdoors for a touch of fill if needed. That is okay if it is not overdone, but there are some who set up multiple units to photograph flowers and other nature subjects, carefully lighting them as if in a studio. They do get creative and sometimes excellent photos, but they are not by any means "nature photographs," because the lighting is not natural looking. If it cannot be explained how the unusual lighting condition could have occurred naturally, it simply is not a nature photo.

For better image quality, if you have the option of using extension or optical methods of magnification (diopters, multipliers, stacking), choose extension, and avoid using filters.

WHAT SHOULD I CARRY?

Most outdoor work is restricted to a maximum magnification of about 2X, mainly because wind or other subject movement makes framing, focusing, and shooting very difficult if not impossible at higher magnifications. I used to go out into the field hauling everything I had, not knowing just what I'd find or need. It turned out there was a lot of equipment that just went along for the ride, doing nothing more than making me tired lugging it, so now I leave a lot home.

Invariably, the chances of seeing the perfect picture is directly proportional to the likelihood you left the one piece of equipment most needed at home, but that can't be helped. I carry two camera bodies in case one decides to malfunction; my bellows; a set of extension rings; cable release; tripod; 19, 24, 50, 100, and 200mm lenses; and a gray card. Sometimes I bring a flash. *Don't forget spare batteries for the camera, flash, and light meter!*

Some photographers will carry reflectors and diffusers as well. I rarely do because, besides being more to carry, they are difficult to use if you are alone. You can't tell just how they will affect the picture without looking through the viewfinder. Unless you have help, you need stands or other supports, and you are constantly running back and forth positioning them and checking the results.

Others carry white photo umbrellas or ordinary umbrellas to diffuse the light when doing close-ups of small subjects. (If you use any umbrella, make sure it is white or a neutral gray, otherwise it will add a color cast to the picture.)

The very best advice I've heard (but never seem to follow) was that of Rod Planck, who said to simply "decide what you are going out to photograph and take only the equipment required for those subjects."

A FEW GENERAL WORDS

I have one thing to say about nature photography before getting into the how-to of the field.

I live in an area that is rich in wildflowers and other natural wonders that people love to come out to see and photograph. If you ask the wardens in the parks here about people doing damage, they will tell you that *photographers do more damage than any other group of people visiting the area.* They carelessly wander off trails and stomp down all sorts of flora looking for that great subject, drop their camera bags anywhere, set out big plastic "drop sheets" to lay on, then proceed to "garden"—culling out any plant life or objects that may be interfering with their perfect subject so they can get that award-winning photo. (It is also rumored some will even destroy the flower when they are done "so nobody else can take the same shot!")

True nature photographers respect their subjects and *do not do anything that will cause damage to the subject or the surroundings*, often settling for a "best under the circumstances" picture or no picture at all.

The Nature Division of The Photographic Society of America (see Bibliography) has an excellent set of guidelines and ethics, recommended for all interested in nature photography.

PLANTS AND FLOWERS

The wide variety of shapes, colors, and sizes make plants and flowers some of the most beautiful subjects. The photographer can use a wide variety of creative techniques to produce outstanding images.

Plants and flowers are usually photographed in the 0.1X to 2X range, depending upon the size and composition of the shot. Unless you are doing a habitat shot, you do not always have to show the entire plant. Often, just the flower and a little bit of stem and perhaps a leaf work well. Sometimes a real close-up of details works very well.

Habitat shots are typically photos that show the subject in its natural surroundings. In these shots, the background is very important. It shows us the kind of terrain or environment where the plant can be found, such as in a swampy area near bulrushes and swamp grasses, in shaded areas clustered around the bases of certain trees, out in an open field, or amongst or on other vegetation.

Isolate the subject by cutting and cropping the background and controlling the depth of field so that it tells enough about the environment without itself

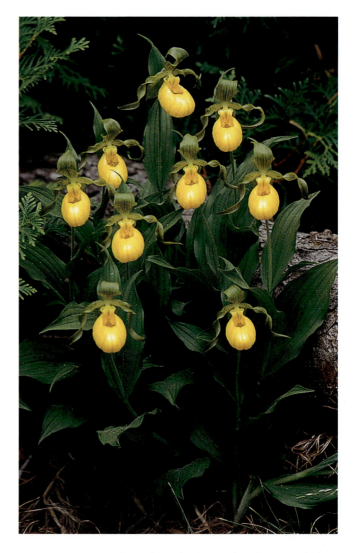

FIGURE 18.4 Habitat shot of Yellow Lady's Slipper orchids.

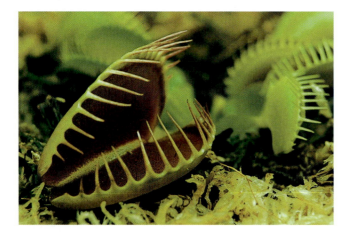

FIGURE 18.3 The ferocious looking Venus Flytrap.

becoming distracting or overwhelming the subject. The photo of the Venus Flytrap is one example (see Figure 18.3). The background was cropped so only other leaves of the plant were visible. The depth of field was selected so the primary subject, the big leaf on the left, was sharp but the other leaves remained in focus enough to be identifiable but not enough to be distracting.

Another example is the photo of a group of Yellow Lady's Slipper orchids amongst the trees (see Figure 18.4). In one area nearby there are dozens of clusters of these plants growing in shaded areas near the bases of cedar and tamarack trees.

When you use selective focus to isolate a subject, be very careful if there are brightly colored flowers

FIGURE 18.5 For this habitat shot of a trumpet-shaped fungus, taken at approximately 1.8X, I lay on a bog floor for about an hour to set up. I had nothing to support the camera so I set it on the ground and put a film box and sticks under the lens to hold it in position. I wasn't happy with the background, so I held a dead leaf in behind, wiggling it as I exposed (1 second f16) so the background would be indistinct.

tive focus and depth of field to create beautiful artwork. You can produce images that are impossible to see any other way than through the lens of a camera manipulated by someone's imagination.

I don't care what anyone may say, nature close-up work is the ultimate in creative artistry with a camera. The photographer takes a real subject and turns it into something surreal and beautiful right in the camera—no darkroom wizardry or computer image manipulation whatsoever. It's the real thing.

When looking for a subject among plants and flowers, I try to pick out the best examples if there is a group. I look for things like its condition, position,

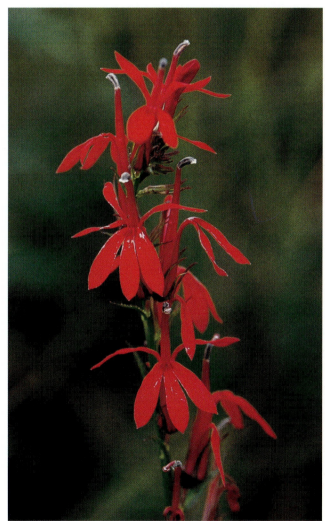

FIGURE 18.6 Cardinal Flower. These flowers grow on shafts as tall as 3 feet so even on a seemingly windless day they will be dancing in your viewfinder. I bring along dowel rods and twist ties to brace them.

or other objects in the foreground or background (especially yellow, orange, or white). When they go out of focus, they seem to get a whole lot brighter and scream "look at me!" The results can be disastrous.

If the day is overcast, it is a good idea to avoid getting the sky in the background of any close-ups, because you will likely be using exposures that will cause it to burn right out and create very distracting white hot spots.

Close-ups of flowers are much more pleasing to look at. Here you can really fly creatively, using selec-

location, what's near it, and whether or not I can get in there and photograph it without damaging everything around it.

If I am going out to photograph tall flowers like Cardinal flowers (see Figure 18.6), beautiful small scarlet flowers on long shafts approaching 36 inches in height, I will bring along pieces of dowel rod, twist ties, and masking tape to support the plant while composing and taking the photo. Even on seemingly windless days, long-stemmed plants sway quite a bit. I poke the stick in the ground at an angle so it crosses the stem a couple of inches below what's in my viewfinder and loosely tie it there. Remove any ties and tape when done.

Once I've selected my subject, I look for what angles may be good. Often I will use the camera viewfinder to do it, because the world close up looks a lot different through a wide open camera lens than the naked eye. The very shallow depth of field, for me, definitely makes it much easier to "see" a potential picture. *Do this with the camera off of the tripod.* When you see something pleasing, move the tripod in to where the camera is and set it up there. Far too frequently, if we set up the camera on the tripod first, we will tend to shoot the picture from that position with little variance and miss many other potentially better shots.

It is very difficult to say what makes a good picture. Most of my good ones have come about more by chance than anything else. I was photographing a Yellow Lady's Slipper one day and had a nice side-view all framed. It still lacked something but I didn't know what. While I was focusing, a mosquito sat on one petal and it was just what I wanted. I couldn't have set it up better (see Figure 18.7).

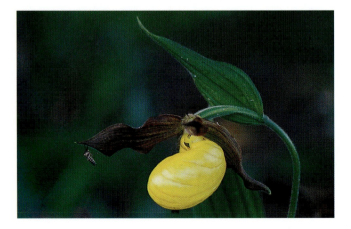

FIGURE 18.7 Yellow Lady's Slipper Orchid. Note the mosquito, which landed on the leaf just as I was about to take the shot.

Another one of the "general rules" says that there should not be any lines such as flower stems or branches entering or exiting from the corners of the frame. They do tend to appear odd, so all you do is reposition the camera slightly so the offending item now enters the screen from just above, below, to the left or right of the corner. You could also vignette to soften the stem (which I will describe later).

I usually avoid photos that "look down" unless there is no other way to photograph the flower. Get level with or a little below the flower to photograph it, if possible. This can be quite difficult with flowers that are low to the ground.

Low plants, like Pitcher Plants or Dwarf Lake Iris, grow in clusters on the ground and sit only a couple of inches high. What makes them difficult to photograph creatively is their proximity to the ground and other plants. Not only may it be difficult to get low enough to get on their level, but you also can't isolate your subject with depth of field. Enough depth of field to keep the plant in focus usually means everything in the background will be in focus, whether you want it to be or not. They are a wonderful challenge to one's skills and abilities.

Other low plants such as Sundews can be extremely difficult to photograph creatively in their natural habitat because they are so low and their size demands fairly high magnification. Unlike most other plants, they look their best in bright sunlight—the dewlike drops of glue on their leaves glisten and look spectacular.

My solution to the problems photographing Sundews was simple. I bought some and grew them in my basement, so whenever I want to photograph them, I take one out of the aquarium and set it up on my table. Using a 60-watt lamp for backlighting (or sun through a window), and shooting up to 10X, I get some spectacular and surreal images (see Figure 18.8).

Getting your camera into position can be a challenge at times. You may have to invert the tripod head to shoot if you can't get low enough any other way. This is not an ideal situation and is all the more complicated if you happen to be using a bellows. There are also ground spikes and various other kinds of clamping devices that you can clamp around a small tree or tripod leg.

Sometimes I will put my camera right on the ground itself. I've photographed Indian Pipe flowers by sitting my camera on its side, propping the lens up with a rock, and firing with a cable release. It is very awkward and uncomfortable, especially trying to see through the viewfinder without an angle finder, so I

FIGURE 18.8 Sundew plants are spectacular subjects, especially at high magnification (about 8X here). The circular specular highlights are caused by the many out of focus glue droplets. These effects are especially tricky to get because you must shoot wide open (if you stop down, the highlights will take on the multisided shape of the lens aperture and look strange). This means that focus is very critical, as depth of field is only about a millimeter, if that—not much more than the diameter of a single dew drop. Backlighting is used to get these effects, so one also has to be careful to avoid lens flare.

built a mirror housing that I can place at ground level and shoot.

To use, place on the ground, secure the camera in place using the tripod, and adjust the mirror until the desired view is obtained. Focus as normal. Note that the image in the viewfinder will be backwards. A vertical post and clamp, like that on a copy stand, could be attached to the back to make holding the camera easier.

When you've found your subject and have an idea of what looks good, then you can start composing. Decide what to show in the picture. The whole plant? Just the flower? The flower and a few leaves? Perhaps a close-up of the spider sitting in the center?

When the picture has been framed in the viewfinder, start to view it at different apertures using the depth of field preview button until just the right depth of field is achieved, then check the background and foreground for distractions.

Once you are satisfied with the background in general, look for other distractions and begin to eliminate them. Look for things like lines running at odd angles (usually grasses or sticks in the foreground or background), hot spots (bright leaves, stones, sky), and other disturbing items, then try to eliminate or hide them.

Finding the source of the distraction may seem difficult. All you may see is a dark- or light-smeared line or blotch in the viewfinder. A very quick and easy way to locate it is to focus on it. Once it's in focus, it can be easily located and either removed, moved, or camouflaged. If it cannot be removed or hidden satisfactorily, then vignette it out. As a last resort, you might have to change the view of the subject to eliminate the offending item.

PICTURES FROM GROUND LEVEL

FIGURE 18.9 You can get photos from ground level by building a simple mirror box. I used a mirror about 5x7" in size, hinged so that it pivots at the bottom front. The inside of the box was painted black and a black cloth covers the opening at the top. The cloth is secured around the lens with velcro and should be loose enough so the camera can be moved up and down several inches.

FIGURE 18.10 This ground-level shot was taken using the mirror housing illustrated in Figure 18.9. It's a bit awkward to use, but it is far easier and less damaging to the terrain than lying in the muck trying to shoot.

When you've done all that, take a preliminary light reading for the aperture selected (use stopped-down metering).

From experience you will learn just how slow a shutter speed you can get away with under different outdoor conditions. If you cannot use the speed the desired aperture requires, you may have to open up a bit and sacrifice some depth of field or reposition the camera so it is closer to being parallel to one surface of the subject rather than at an angle.

There are times when I am dealing with very small subjects that I will "fudge" the backgrounds, making my own by holding a few leaves in my hand far enough back so they will be out of focus. I once used a brown leather glove when I couldn't find anything else.

This is frequently done in insect photography when using flash in order to keep the background from being completely black. You have to be very careful though, because if your background is too close, patterns like the veins in a leaf may show up and ruin the photo, or you might frighten the subject away. If I can't get the items back far enough to be out of focus and am using a slow shutter speed, I will just jiggle the items around a bit during exposure so they will be blurry (this won't work with flash—the flash will freeze it).

Once everything is framed and focused, unless you have a camera that shows 100 percent of the image area through the viewfinder (few do), then you have to make sure there are no distractions within the tiny area around the edges that the viewfinder does not show.

Carefully loosen the tripod head just a bit and swing the camera a little to the left, then a little to the right, up a bit, and down a bit. If it looks clear then you're okay. If you notice distractions right near an edge, try to remove them. If you can't, see if a slight repositioning of the tripod head will eliminate it. If not, you may have to increase magnification a bit.

You can take the final light reading now. Set the camera's controls to the proper settings and shoot. If I'm not confident about my exposure, I may bracket.

MOST VIEWFINDERS DON'T SHOW ALL OF THE PICTURE!

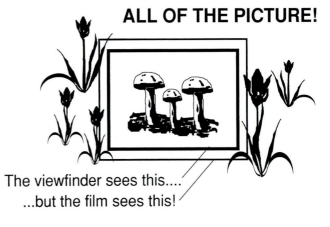

The viewfinder sees this....
...but the film sees this!

FIGURE 18.11 Most viewfinders only show part of the picture (about 95%). Here, what the viewfinder sees is represented by the inner square, and what the film sees is represented by the outer square. These little intrusions into the edges of the picture can ruin the shot. Move the camera around a little before shooting so you can see if any distractions like these are sitting just outside the viewfinder limits, ready to ruin your photo.

(There have been many occasions when I get the exposure right, but I like one of the bracketed shots better.)

This whole procedure can take a few minutes to an hour or more just to get a single shot right! That's why I say close-up photography is *not* for the impatient, and that's why nonphotographers along for the walk get impatient.

If you are fairly close to the subject and the background is quite distant, even when the aperture is stopped down enough to cover the subject, the background may be nothing but a solid, even, monochrome color. This is rather boring to look at, and it suggests that you just held a colored sheet of cardboard behind your subject.

If this is the case, stop down a bit more and see what starts showing. If there are distinct areas of different colors, they should start becoming more recognizable. If you stop down just enough so they still remain indistinct smears, it can add to the photograph as the various colors suggest there is more to the background than solid color. If stopping down doesn't work, then create a background with leaves, grasses, and so forth, putting them close enough just to break up the monotonous background, or try vignetting (discussed later in this chapter). You don't need much vignetting—just a hint will often do it.

If the flower or plant leans and the grasses in the background are vertical or lean the same way, stop down so you can just distinguish the grass as slightly darker or lighter blurry lines in the background. It doesn't work if the grasses are haphazard and leaning in any direction.

Check for these and other distractions before you shoot. Often, there may be a blade of grass cutting right across the screen diagonally and you don't see it until the film has been processed because it was very close in the foreground and a foreground check wasn't done. In some instances, photographers may ignore it because it is barely noticeable through the viewfinder, but it appears much bigger and more apparent in the photo. These wayward blades of grass can utterly ruin an otherwise successful photo.

Backgrounds with bright hot spots or very dark black spots don't work well either. The spots are too distracting. Get rid of them if you can by using the aperture, camouflaging them, or moving the camera or the offending items.

I saw a presentation by one nature photographer who used a single backdrop photo of leaves and branches printed out of focus in almost every slide. It had one shadow that was black, stood out boldly and was easily identifiable. After watching a tray of his

slides and no matter what the subject, or the angle he photographed them from, every shot had the identical background! Use several different backgrounds, or at the very least, different parts of the same one, and vary the distance so it is out of focus now and then. Don't use one taken in bright sunlight either, because it will be too hard and contrasty.

VIGNETTING

Vignetting is a method of deliberately placing objects between the camera lens and the subject to subtly diffuse or hide a hot spot, hide a piece of stem or unwanted leaf, add touches of color, frame the subject, or add lines and shadows. (This is not the same as the vignetting you get with the wrong lens hood or cheap equipment!) Vignetting can be done with almost any nature subject.

I must give credit where it is due. Maria Zorn taught me this technique in her nature photography class and workshops. She is a master at it.

You can use any number of things to vignette with, but most nature photographers use natural items like a handful of grass, leaves, flower petals, or even flowers. To vignette, you first have your picture all set up and ready to take. Then hold the vignetting material in front of the lens about arm's length, look through the viewfinder, and move it around to create the effects desired.

You can vary the amount of vignetting by the distance you hold the material from the lens—the closer, the more apparent the effect. When you are satisfied, take the picture. The results on film are often more pronounced (i.e., brighter) than what you remember you

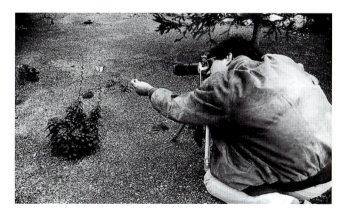

FIGURE 18.12 WHEN VIGNETTING, THE MATERIAL IS HELD BETWEEN THE CAMERA LENS AND SUBJECT.

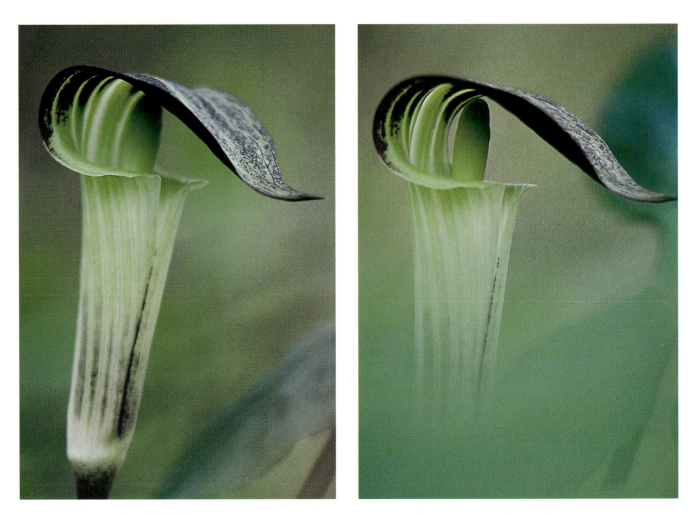

FIGURE 18.13A FIGURE 18.13B

FIGURE 18.13 The first photo (Figure 18.13A) is a nice shot of a Jack-in-the-Pulpit. The stem and leaf in the bottom of the picture are rather hard and distracting, however. Careful vignetting with pieces of grass or leaf held in front of the lens in Figure 18.13B hides the distractions and softens the appearance of the photo. (I have vignetted fairly heavily here so the effect can be more easily seen.)

saw through the viewfinder, so it is best to "underplay it" a bit. If it looks a little less than what you want, then it's probably just about right.

I use ragged-edged leaves and grass to hide the little imperfections. Something with jagged or uneven edges works much better than something with a sharp smooth edge because you want a gradual tapering of the effect and not a sharp dividing line. I pick something a little darker than the part of the background where I want to vignette so I won't get surprised with a real light spot where I vignetted. I will sometimes move the material very slightly while exposing just to avoid the possibility of getting sharp edges and making the effect softer.

If you work carefully, you will be able to selectively vignette almost anywhere on the frame. And if you become skilled at it, you can actually vignette several places in a scene at once! You can add touches of color to balance an image by using a petal from a flower (or even the whole flower), and you can turn a mundane shot into a winner by adding a touch here or hiding a bit there.

You should only add colors that are already in the picture, and only a touch. Most vignetting is done with shades of green and brown. Just as bright colors like yellow or white create problems when using selective depth of field, they are very difficult to work with successfully as vignetting materials. They are the "cayenne

peppers" of color—if you are not careful with them, they overpower everything.

You can also use this technique to enhance a background. Suppose you have an image set up of a butterfly on a sloped stick in which the background is a very plain-looking solid shade. Take several blades of dark grass between your thumb and forefinger and vignette. Hold them such that they are slanted the same direction as the stick, and place them so you just see very subtle dark lines breaking the background up.

Other methods of vignetting include shooting the subject through other plants, leaves, or flowers. There may be a field of flowers in which you want to isolate a single flower. You find a small cluster a little ways away and point your camera so it is looking through a gap in the cluster towards the subject. The subject is then "framed" by a blur of irregularly shaped smears of color.

There are many other ways to use vignetting, and it is best learned through trial and error. You have to get to know what kinds of materials to use, how they appear both in the viewfinder and on film, and how much is enough or too little. It is impossible to vignette when exposure is by flash, and nearly impossible with flood lighting.

Insects

Rule Number One with bugs (or any critters): *You do not refrigerate insects or small reptiles to slow them down to photograph them.* You can kill them or cause permanent damage to them if you do this.

A lot of books and photographers recommend this practice. I have one book that actually says: *"Placing it in a refrigerator for a few minutes might be helpful at times if the subject is a very active animal or insect."* When I first read that, I had visions of "Mom" opening the refrigerator to find the kitten or pet hamster in there stiff as a board because "Junior" wanted to photograph it!

Insects that have been chilled do not look natural in pictures, and pros can spot them right away (dead bugs are even easier to spot, but some try to use them!).

Bugs can be a real challenge, not only because of their small size, but also because some move a lot. Some, in fact, never seem to stop. I'll begin with the slow movers first.

Insects such as the praying mantis will sit almost motionless for hours at a time and are ideal to learn with, as are moths, butterflies, dragonflies, and a myriad of others found early in the morning just before and shortly after sunrise. They are "immobile" until they

FIGURE 18.14 In early morning, just before and just after sunrise, you can get lots of interesting photos of butterflies, moths, and dragonflies. They attach themselves to sticks and other places overnight. In the morning, if their wings are dew covered, they cannot fly until the sun dries it off.

warm up. If they have dew on their wings, they are unable to fly until it has evaporated, so you might have an hour or more where they aren't going to go anywhere.

Treat your backgrounds for insects as you would for flowers. Isolate the subject using only the amount of depth of field required. In most cases, you will shoot butterflies and moths from the side or above, depending upon how they have their wings. Your concern with them is the depth of the subject: it is much shallower

PARALLELING THE SUBJECT

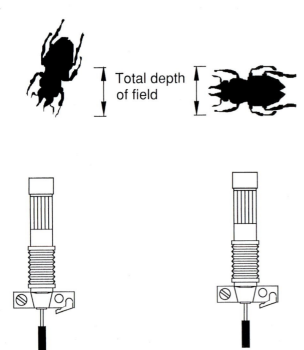

Total depth of field

FIGURE 18.15 BECAUSE THE depth of field can be very shallow when up close, it may not be possible to get a satisfactory shot from some angles (left) even when fully stopped down. In these instances, reposition the subject or camera so the subject is closer to being parallel to the film plane (right). The view may not be the best or what is desired, but it will be much sharper.

FIGURE 18.16 Birch bark makes an excellent background for all kinds of insects including this polyphemus moth.

when photographed in these positions, so it is easier to keep the entire bug in focus. (The less depth of field required, the larger the aperture and consequently the faster the shutter speed.)

If you try shooting moths, butterflies, or other large insects at other angles, you may find you either do not have enough depth of field to cover it all, or all sorts of unwanted things start showing in the background when you stop down. Insects can range in size from a fraction of an inch to several inches, so what works for one may not work for another.

Often, the shutter speed you have to shoot at may be too slow to allow small enough apertures. The insect may not be moving, but the plant it's attached to might be.

When you are doing bug portraits, as with people and animals, the eyes should be sharp.

Watch for the antennae. Sometimes they may be very difficult to see when you are stopped down.

If you can catch moths usually early in the morning, you can often place them on trees or other backgrounds. I've used pieces of firewood that I liked the bark on, tree trunks, an old moss-covered tree stump or rock, and strips of Birch bark.

Whenever placing insects on sticks, flowers, trees, and so on, you must always be sure that that is where they might naturally be found. If not, experts in the field will spot these errors immediately. A classic example I saw was a tarantula on a geranium flower. Tarantulas do not hide in flowers awaiting prey like crab spiders do, nor are they likely to be found naturally where geraniums grow. Pictures like this just look silly.

If the subject does not coexist with other elements in the picture naturally, then it is not correct to show it.

Something that is most important when using artificial lighting is that it must appear to be from a single source because in nature there is only one source—the sun. And the last time I remember seeing the sun, it

FIGURE 18.17 Look closely everywhere for subjects. Crab spiders like to hide amongst the petals of flowers to await their prey. Here one is hiding in a Purple Fringed Orchid. I didn't notice it until I had set up my shot of the flower and was focusing. I took several shots of the orchid, then closed in and did some of the spider.

always shines down, so don't light your subjects from below or other odd angles either.

I was having difficulties with a mantis one day. I put it on a stick, and it insisted on hanging upside down. I would turn the stick over, and it would turn over. Finally, I decided to let it stay that way and simply moved my flood down low and aimed it upwards, lighting the bug in the same direction it would be lit naturally if standing upright. I then took my shots. All I had to do was turn my slides upside down and the mantis appeared to be upright!

People are used to looking at subjects in certain attitudes relative to the ground. If there is no clear indication of where the ground may be, they will often instinctively turn a photo so the top and bottom of the subject appear as they normally see it even though the subject was actually in another unusual attitude. They fail to notice cues like how the subject is lit or where the shadows are falling. I've seen many examples of this in aviation publications where someone printed a picture of a plane flying right side up when the underside is brightly lit and the topside is in shadow—a clear indication that the plane was flying upside down!

For tabletop shooting, you can do all sorts of backgrounds, real or artificial. The key is that they must appear as a real one might. I've used suede jackets, blankets, leaves, sand, rocks, dirt, tree bark, and a lot more. I've even used a background that was painted using dark browns and greens in a lightly mottled pattern that resembled out-of-focus foliage. Photographs can also be used, but they should be printed on matte paper, otherwise there may be lots of problems with reflection.

Be careful with some insects indoors: there are some you don't want to bring in (like aphids, which may infest all of your houseplants), and others that may surprise you. I was photographing a Cicada one afternoon, and as soon as I turned on my flood light it flew straight for it and buzzed and banged into it until I turned it off. That, obviously, wasn't going to work. What I finally did was use an electronic flash.

Thanks to the electronic flash's high speed and light output we can do photos of insects never before possible. For fast-moving bugs, it is often the *only* way.

For studio work (tabletop), I use my flashes on high power whenever possible. For something the size of a mantis, I'll shoot at 1/4X to 1/2X; with a 200mm lens, I'm a few feet back. Even if I shoot at f16, I can still keep my flash about four feet back so I can put my background anywhere up to four feet behind before it goes black. I like to keep the background close, but if I find too much detail showing, the high power setting

FIGURE 18.18 Can you find this guy? An excellent example of insect camouflage.

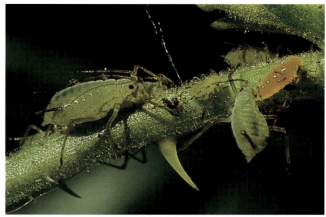

FIGURE 18.19 My mother's rosebush was infested with aphids, so I took my camera out and photographed them. They are only about 1/16 inch long or less so I needed my 20mm short-mount macro and bellows. Their movement was almost imperceptible so I was able to use exposures of a second or more.

allows me to move it back a bit more. If I'm using a larger aperture, I move the flash back further and have more room to move my background.

I do prefer using flash for smaller bugs. It gives me more freedom when it comes to aperture selection. I can shoot at much smaller apertures than with floods or sunlight, and the flash freezes all motion.

For many insects, electronic flash is the only way you can photograph them and hope to get acceptable results. They simply move too darned fast.

The drawbacks to flash are that sometimes it tends to reflect more than other light does, so shiny bugs like beetles often have burned out hot spots on their shells,

portions of the background go black because of distance, and uneven lighting occurs frequently. Keeping the flash as far back as you can often helps reduce the uneven lighting.

Flash setups for tabletop are basically the same as those with photofloods. All the rules of positioning them apply, but calculating the distances are a pain—which is another reason I prefer single-flash lighting for nature subjects (it is even better if it's a TTL Autoflash).

Insects in the field are now commonly photographed with flashes. There are two ways to do this: ring flash, and what John Shaw calls a "butterfly bracket" (so named because it was used primarily to photograph butterflies). Ordinary autoflash systems are quite useless here.

The "butterfly bracket" is a bracket with knobs, ball joints, and a flash mount that positions a flash unit directly over the top of the front element of the lens, pointing slightly down to a fixed distance in front of the lens where the subject is to be. If you have TTL Autoflash, you have it made. It will adjust exposure automatically for whatever magnification and distance you are from the subject (up to a point). If you don't have TTL, you can still use the flash, but it's a little more difficult and you will have to run a few tests.

Mount the flash and focus on a subject at a known distance and magnification. You can then determine

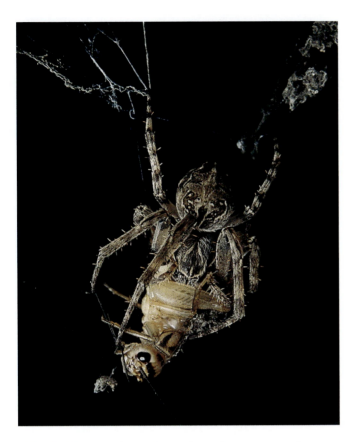

FIGURE 18.20 This garden spider and its prey were done with hand-held camera and ring flash. It was just outside an office window, so I taped a piece of light green paper to the glass to eliminate the reflection of the flash and keep the background from being pure black.

what the correct aperture should be with the flash distance formula, rewritten to solve for the aperture.

$$\text{f-stop} = \frac{8.5 \times \text{GN} \times \text{FL}}{\text{D} \times (\text{FL} + \text{E})}$$

where

GN = flash guide number
FL = lens focal length in mm
D = distance in inches
E = extension in mm

Example

I'll be using my ring flash with a guide number of 40, a 200mm lens, and a 50mm extension. I am 12" from my subject when it is in focus. (You will find that with this

"BUTTERFLY" BRACKET

FIGURE 18.21 A "butterfly bracket" is any type of bracket that allows the flash to be positioned directly over the center of the front element of the lens.

method, you cannot use a high-powered flash because your aperture likely won't go small enough.)

$$\text{f-stop} = \frac{8.5 \times 40 \times 200}{12 \times (200 + 50)} = 22.7$$

The correct f-stop should be f22. Now, pick a subject that is about 18 percent and shoot a few frames. Bracket two stops to either side, if possible. When you get the results, determine which aperture at that exposure gave the best results. You may find it different from that calculated because guide numbers are determined for the flash when it is used indoors where there is a certain amount of light bouncing off of the ceiling and walls.

Let's say the photo using f16 looks best. Now, whenever you are using the 200mm with extension and flash, you just set the aperture to f16 and shoot. Of course, you will have to reposition the flash accordingly each time you add or subtract extension.

Putting such a powerful light source so close to the lens means that you will have no choice but to use small apertures, which is okay under these circumstances because you need as much depth of field as you can get. You won't be able to take time to set up the shot and preview the depth of field here.

What is really nice about this lighting method is that as long as you keep the flash at the same point relative to

the front of the lens, the aperture setting will be the same whether you add or delete extension! Think about it: as you move the lens out, you also move the flash closer to the subject, which negates the light lost by the extension.

You, of course, must run a test for each lens you use because the lens-to-subject distances will be different and therefore the apertures will differ. The aim of the flash also has to be adjusted for each lens—just set up a subject and look through the viewfinder while testing the flash a few times to see if the subject looks lit evenly. Your first few shots will tell if you've made errors.

Ring flashes are excellent but can't really be aimed; they just shoot straight ahead. Multitube ring flashes let you control the light to a better degree because you can move or shut off the different tubes individually and thus create very flat even lighting or more directional light.

Some photographers don't like the lighting of a ring flash. Being closer to the lens, it is more straight-on, whereas the light above the lens can be directed so that it is more downward. This can make a difference when it comes to shadows, as the former sends them straight back, and the latter down and back—more "out of the way"—resulting in a little more texture. Whichever flash method you use, you will have to compensate for subject brightness.

Now we are ready to go shooting bugs in the field with flash.

Ambient light could be a problem with flash outdoors, so first set the shutter speed to the maximum sync speed and take a reading. If the ambient light exposure at this speed requires an aperture one stop larger, equal to, or smaller than the one set for the flash, you will have problems. This isn't likely to occur unless you are shooting in bright sunlight with very high-speed film.

Next, preset your focus. It could be on the infinity mark but it doesn't have to be. You won't be touching it again. If you have autofocus, turn it off. It will only cause problems if left on.

Here's how you are going to focus. Pick a subject (it needn't be a bug at this stage), hold the camera with your right hand, with your index finger on the shutter release and your left hand holding the left side of the body or lens barrel. You don't need to touch the focusing ring at all. Look through the viewfinder, frame the subject the way you want it, then *move the camera in and out* until it looks sharp where you want it to be sharp and shoot.

You probably won't realize it until the first time you try to take pictures of honeybees on flowers at 1X just how effective this method is. They move so fast that there is *no way* you can focus on them manually, and auto focus won't work either. Just framing the subject can be a challenge!

You have to frame and move in and out to focus very quickly and, because you are working very fast, you may be slightly out with the focus more often than not. Thus, in this case, you must use the smallest of apertures possible to have sufficient depth of field.

With slower moving bugs, you still do things the same way, only you can take more time to frame and focus. Shots of this nature are essentially "record shots" rather than creative shots. Speed and creativity usually do not go hand-in-hand.

TABLETOP SETUPS

Lots of insect photography is done as tabletop work. In fact, if you want to photograph the faces or eyes of a spider, a tabletop setup using electronic flash is the only way to go.

Tabletop photography is done inside or outside with or without artificial lighting or backgrounds. It might not even be done using a table, but it is still called tabletop. It is creating a natural scene in an "unnatural" way in a small area. It can be setting up artificial backgrounds on a table then placing an animal, plant, or bug in front of them, or even using a real natural setting for a background.

Artificial backgrounds have been mentioned earlier. In addition to backdrops, they also include bases. I have made bases by covering the top of a table with sand, rocks, twigs, leaves, and other natural items to create a realistic looking base to place my subjects on.

I've set up leaves haphazardly to simulate fallen leaves, and I've also attached a bunch of leaves to a piece of vertical cardboard that was far enough back so you only saw the blurred color in the image.

For bugs, I may find an interesting stick, position it in front of the background, and then put the bug on it and hope it stays. Sometimes I'll just cut off the bit of plant the bug is on and support it if the bug is the type that might not stay if moved. (I have found that some will sit for hours, but once you disturb them, they will not stay put!)

When all is set, the shooting can begin. With this method, you can move the whole setup (sticks and

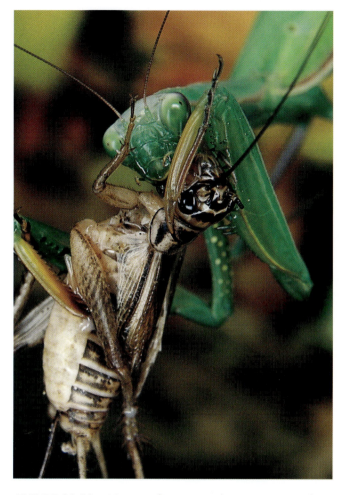

FIGURE 18.22 Mantis and prey. I set the mantis on a stick and taped some leaves onto a board for background, about a foot behind. My flash was set up about three feet back to insure good subject and background lighting, and I used f22 for maximum depth of field.

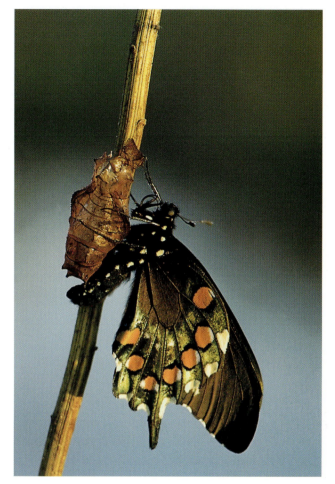

FIGURE 18.23 This shot was taken just after sunrise. The butterfly had emerged from its chrysalis earlier that morning. The stick was attached to a light stand and set up outside opposite a small pond that reflected the blue sky. The green in the background is from trees on the opposite side.

bugs) as a unit and take shots from all kinds of different angles—something that you can't do if it's on a plant or tree.

Another method of getting a good background is actually to take your subject to a place with a more suitable background. If you have a stick with a butterfly on it, you can attach the stick to a support such as an inexpensive light stand and place it in front of a nice background of green trees, or position it where it's overlooking a pond at sunrise (Figure 18.23). I've seen and done many shots like that using butterflies and even potted wildflowers.

Some bugs, though not necessarily fast-moving, just will not be cooperative. Like animals in the zoo, they

seem to know precisely when you are going to take their picture and turn or move away at that instant. I've found a method to contain them and get good photos. I call it a "Bug Box."

What you need is an aquarium, some tape, a couple of white garbage bags, your flash, and a flash extension cable. Sit the aquarium on its side so the open top faces you. Make a background of sorts inside by using leaves, dirt, or anything you want as long as it looks natural. Depending upon what you are photographing, you can use sticks or twigs or even a section of a plant mounted upright for them to climb.

Cover the side of the aquarium that is now the top with one or two layers of plastic from a white garbage

THE "BUG BOX"

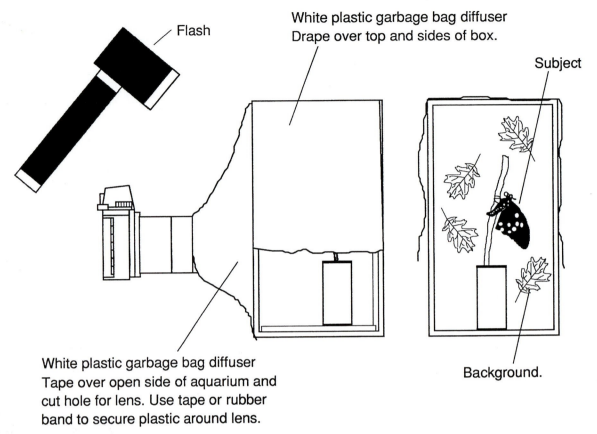

Flash

White plastic garbage bag diffuser
Drape over top and sides of box.

Subject

White plastic garbage bag diffuser
Tape over open side of aquarium and
cut hole for lens. Use tape or rubber
band to secure plastic around lens.

Background.

FIGURE 18.24 This is what I call the "Bug Box" because I created it to photograph bugs. They are free to wander around yet cannot escape. If you are patient, you will be able to get lots of good photos. Just preset the focus and then focus by moving the camera in and out.

bag. Tape another bag around the open side of the aquarium and cut a round hole in the middle.

Put your bug inside, slip the camera lens into the hole, secure the plastic around the lens (you can use a rubber band or tape to hold the plastic in place), and position the flash. Use a tripod or light stand to hold the flash so you can use both hands to hold the camera. If you have TTL flash, you can just shoot away, otherwise you'll have to run a few exposure tests because the white plastic will be diffusing the light so any exposure calculations may be incorrect.

Now you can move the camera around and chase the insect all over, shooting pictures whenever you like. The bug can't escape, and the white plastic acts as a diffuser, so you get nice soft light. You can use clear plastic if you like, but the results will be more contrasty. The scene is small enough that you can use a very small

aperture, and it is lit fairly evenly front to back (no black backgrounds).

To make your insect photos more interesting, don't just take a picture of a bug. Try to make your picture tell something about the insect, such as it's habitat, or the way it hides on a flower and camouflages itself to catch prey (or so it doesn't become a meal itself).

If it is an incredibly destructive bug, show it on a leaf that it has bored full of holes. If you can catch one molting, young emerging from egg sacks, or butterflies emerging from their chrysalis, you've got something really spectacular.

Butterflies emerging from a chrysalis are popular. I've found monarch caterpillars, raised them in aquariums, and after they formed their chrysalis, waited patiently until they were ready to emerge. When the chrysalis turns from an opaque turquoise to clear, they

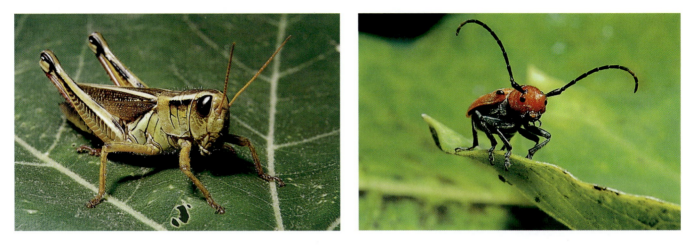

FIGURE 18.25A FIGURE 18.25B

FIGURE 18.25 This grasshopper and beetle were both photographed in the "Bug Box." The white plastic bag diffuses and softens the light—there are shadows, but not nearly as hard or contrasty. Because the light is much further away than it would be with a ring flash or a flash mounted over the lens, there is not the problem of black backgrounds.

will emerge very soon (within hours) so I get everything set up and wait.

Obviously, you will have to learn a lot about insects to know how to find them and what their behavior is like. But that's part of the enjoyment of the hobby.

Small Animals

I like photographing reptiles. Most will sit motionless and are therefore really easy to work with. The methods here will work for almost any small animal: domestic pets like cats, dogs, birds, and hamsters, or wild animals. The basic principles of backgrounds, foregrounds, and so forth apply just as with any other subject.

Remember that the eyes should be sharp as with people and insects. In addition, as for insects, photos that show the animal doing something other than just standing there, or that say something about the animal's habitat or character, are much more interesting, so look for these moments.

If your animals are being difficult to work with, sometimes giving them something to eat will cause them to settle down and sit still while you shoot.

Try to get down on their level, eye-to-eye, so to speak. Most subjects look better viewed from their level than from up above.

If your animal subjects are in water (like frogs or turtles), then you may need a polarizing filter to cut the glare from the water's surface.

Flash usually has disastrous results on frogs and turtles if they are wet, creating hot spots all over the place and an unnatural "glossy" look to the creature. I much prefer natural lighting, especially on the light overcast day. Flash with furry critters presents no such problem.

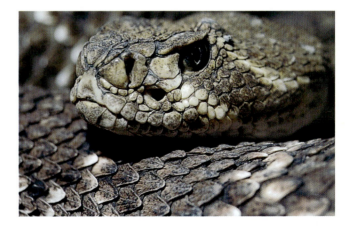

FIGURE 18.26 Western Diamondback Rattlesnake. This guy was behind glass otherwise I'd never have tried such a shot.

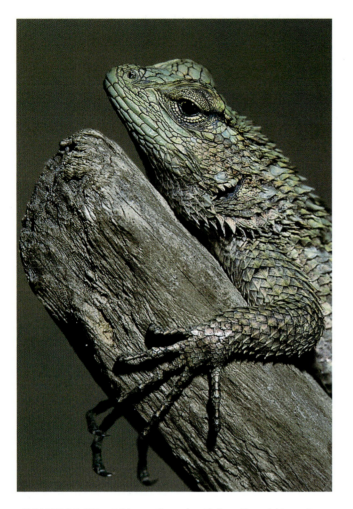

FIGURE 18.27 Tabletop shot of a Chilean Emerald Lizard photographed with 100mm macro lens and electronic flash. A piece of green fabric was used as a backdrop.

Perhaps the most exciting close-up work I've done was when I had the chance to photograph a few small rattlesnakes with nothing but about four inches of air between the lens and them. (**Do *not* try this!** There was an experienced snake handler standing by. The snakes were raised in captivity and were used to being handled, but they were still quite dangerous.)

During the rattler session I learned a little trick that I'd like to pass on about snakes—how to get a good shot of it "flicking" its tongue.

If you wait until you see its tongue out flailing away, by the time you hit the shutter button, it's back in. Instead of trying to shoot when you see the tongue itself, I discovered that every time it had it out, you could see the center of the lower lip form a small, dark semi-circle. The opening would vanish the instant it

pulled its tongue back in. If you shoot the instant you see that little semi-circle start to form, you get a beautiful portrait of a snake with it's tongue out.

There are a couple of no-no's when photographing small animals (and, I suppose, some insects) up close. Never get close enough that they could strike or bite you. Snakes can strike at least a third to half their body length; lizards can move real quick; snapping turtles have a razor sharp jaw on quite a long neck with a quick jab; and even a cute hamster can quickly inflict a painful nip. As a general rule, I do not trust any animal, especially a wild one. Even if it is used to being around people and being handled, you never know what might frighten it.

When working up close to animals, *keep your hands away from the lens!* Set your aperture before framing the shot and use the "moving in and out" method to focus that was explained in the section on photographing insects. Your right hand is on the camera body, your finger is on the shutter, and your left hand is holding the other side of body—for the snakes, my left hand was holding the flash in position.

Keep your mind on what you are doing at all times and be ready to react quickly. A fraction of a second's inattention and it's got you. My best advice when photographing anything potentially dangerous is to stay a long way away and use a long lens, or don't do it.

If you should be shooting animals through glass or aquariums, reflections off the glass surface present many problems, especially if you should be inclined towards using flash. In some cases, the use of a polarizing filter will solve the problem, but I find it best if I can actually

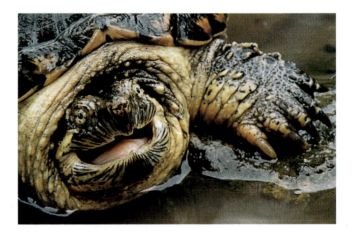

FIGURE 18.28 One misty day I put my pet snapping turtle into a shallow creek and took this photo with my 200mm lens on bellows.

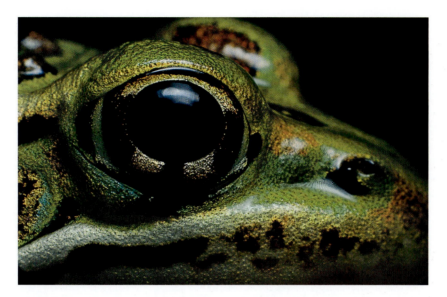

FIGURE 18.29 I put the frog in my "Bug Box" to take this picture. I used a 28-85mm zoom with extension rings and a TTL flash unit. Note that the catchlight in the eye is not nearly as annoying as that in the iguana eye from the ring flash (Figure 10.3).

put the front of the lens right against the glass. If you have a rubber lens hood, put it right against the glass and use its ability to flex to move the camera around slightly for better composition. Position the flash high as the sun would be and hold it back far enough so you are sure the whole scene will be lit evenly.

Last Words on Nature Photography

Once you enter the close-up world, you may find, as I have, that the number of subjects is limitless. Everything you look at has a potentially good picture hiding somewhere. Some things may be easy to photograph, some difficult, and a few turn out to be impossible, but it's the challenge and successes that make the time and effort spent worthwhile.

You will find a fascination in some subjects that will drive you to learn more about them. If you enjoy photographing plants or insects, as an example, you will want to learn more about them—where to find them and when, their habitats, and lives. Perhaps you might even raise your own! I know some photographers who have raised their own insects, and I grow some examples of the more exciting plants I like to photograph including Sundews and cardinal flowers. I have even learned the painstaking and exacting process of growing my own Pink Lady's Slipper orchids from

seeds; something I was told was believed "IMPOSSIBLE!" when I first inquired of a naturalist at the local national park.

You will also become very creative and innovative as every different subject poses an entirely new set of problems and challenges, which must be solved and overcome. You might need to purchase a new piece of equipment or even design and build your own.

Each time you take photos, you should always try to do something better than the last time. Some amateurs I've met told me that when they get their films back, they immediately throw out the bad and poorly exposed shots and just keep the good ones. You don't learn much that way—look at the bad ones and try to determine what it is you don't like about them and what you did wrong so you can improve the next time. Keep what you think are the best from each roll and date them, then some time down the line, pull them out and look at them. You will probably be quite surprised at how much you have improved. What you thought were terrific shots last year may now seem embarrassingly bad!

The most enjoyable part of close-up photography, I find, is that I am able to see things I have never been able to see before and most people would never see or take notice of—the small world that surround us.

Well, that's about all I have to say, so go out and start investigating the world up close.

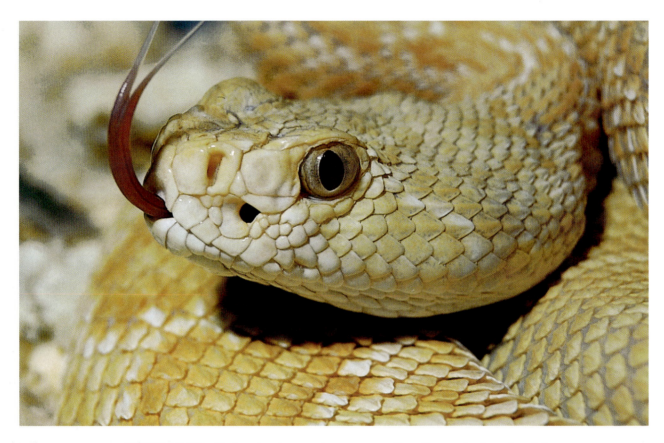

FIGURE 18.30 My favorite close-up photo—a rare albino Diamondback rattlesnake!

GLOSSARY

angle finder. A device that fits over the camera's viewfinder and rotates to allow one to look through it at right angles. Especially useful when the camera is in a position that makes normal viewing awkward or impossible.

angle of view. The angle of a scene viewed by a lens. It gets narrower as focal length increases. (Figures 2.3 and 2.4)

aperture, diaphragm, iris. A set of overlapping leaves inside the lens that can be set to make various sized openings to control both the amount of light the lens lets in and the depth of field. (Figure 2.2)

aperture ring. A ring around a lens that is used to select the desired aperture setting. It has been replaced by push buttons and digital readout on many modern electronic cameras.

auto exposure. Settings on electronic cameras that let the camera's built-in metering system determine correct exposure. They include:

aperture priority—The user selects the desired aperture and the system selects the appropriate shutter speed.

programmed mode—The system selects both shutter speed and aperture.

shutter priority—The user selects the desired shutter speed and the system selects the appropriate aperture setting.

stopped-down mode—The aperture is closed manually and the system selects the appropriate shutter speed.

auto flash. An electronic flash unit that has sensors that determine when enough light has reached the subject to expose it correctly and that shuts the flash off at that point.

autofocus. A system that focuses the camera lens automatically. Generally, the point on the subject that the user wants to focus on must be placed in a certain spot in the viewfinder to work.

automatic camera. Any camera that offers automatic exposure modes.

bellows. A device used to extend the camera lens away from the camera body to provide variable degrees of magnification. (Figure 8.8)

blur. Fuzziness in a picture caused by subject movement or camera movement.

bracketing. A method of improving one's chances of getting a properly exposed picture that is often used when lighting conditions are unusual or a shot cannot be duplicated again. It involves taking a picture at the exposure determined, then taking shots a half and full stop underexposed, and shots a half and full stop overexposed. (Some may take more shots, varying the range up to a couple of stops in each direction.) (Figure 6.5)

close-up lenses, diopters, supplementary lenses. Lenses that screw onto the filter threads of ordinary lenses and allow one to focus a little closer than normal. (Figure 8.5)

close-up range. Image size on film ranges from about 1/10 life size to life size.

copy stand. A stand used primarily for copying flat items like photographs, documents, and so on. It usually consists of a flat base with a vertical pole and movable bracket that the camera is attached to and may have its own lighting system.

depth of field. The amount of foreground and background in the picture that appears in focus. Controlled by the size of the aperture. (Figures 2.1 and 2.2)

depth of field preview. A button or switch on the camera that closes the aperture so the photographer can observe, through the viewfinder, the effects of the various aperture settings on the image.

diffraction. A phenomenon of physics caused when light is bent and separated into its component wavelengths (colors) as it passes through a hole, slit, or other medium such as liquid, gas, or solid. In work at

high magnifications, it can cause a "fuzziness" in the image.

diffused light. Light that is "nondirectional" or "scattered in all directions" such as that on a light overcast day or coming through sheer curtains. It is soft in nature and flattering to subtle details and colors. (Figure 5.2)

edge-to-edge sharpness. The image on film is sharp from corner to corner and edge to edge. There is no distortion or other loss of image quality near the edges of the frame, which is common when ordinary lenses are used at higher magnifications. (Figures 2.5 and 2.6)

effective aperture. The aperture marked on the lens barrel is only accurate when the lens is focused on infinity and no extension is used. When extension is used, the actual or "effective" aperture is much smaller than that indicated on the lens.

equivalent exposure. Any aperture/shutter speed combinations that result in images on film which reproduce the scene with the same tonality and contrast. Motion stopping and depth of field will, however, be different in each shot. (Figure 13.1)

extension. A method of achieving magnification by moving the lens away from the body of the camera.

extension rings, tubes. Metal rings or tubes in fixed-length increments that are placed between the camera lens and body to achieve magnification. (Figure 8.7)

film speed. A rating of the film's sensitivity to light used to determine proper exposure. Commonly referred to as the ASA, ISO, or ASA/ISO number.

filter. Colored pieces of glass, plastic, or gelatin placed in front of the lens or light source to alter the color of the light, create special effects, correct color, or alter contrast.

filter factors. Almost all filters reduce the amount of light entering a lens. The filter factor is a number assigned to a filter based upon how much it reduces the light. It is used to calculate the new exposure required to compensate for light loss.

flash synchronization, sync speeds. Flashes must be timed to fire at a specific time in relation to the position of the shutter so they reach their peak output when the shutter is fully open. The sync speed is the maximum speed that may be used with an electronic flash on cameras equipped with a focal plane shutter. Using speeds faster than the sync speed will result in a picture that is only partially exposed.

flat-field lens. A lens, usually a macro lens, that produces images that are sharp and distortion-free from one edge of the frame to the other.

focal plane shutter. A shutter, most commonly found in single lens reflex (SLR) cameras, that is made up of overlapping curtains within the body that travel from side to side or top to bottom in front of the film. Overlapping the curtains to form various sized slits produces the higher shutter speeds.

focusing rail. A device attached to the camera and tripod that allows the camera to be moved back and forth a few inches in very small increments.

focusing screen. The screen within the viewfinder used for focusing. It may have a plain matte surface or have one or a combination of several different aids to focusing. (Figure 3.1)

f-stop. Another name for the aperture, but more commonly referring to the actual setting of the aperture (e.g., f8, f4, f22, etc.).

guide numbers. Numbers related to an electronic flash's output power used to calculate the correct aperture to use based upon the flash-to-subject distance.

incidence light meter. A light meter that measures the light actually falling on the subject.

isolating the subject. Separating the subject from the background by using shallow depth of field, where only the subject appears sharp and the background is indistinct, or by using the narrow angle of view of a telephoto lens. (Sometimes called "select focus" or "select depth of field.") (Figure 13.2)

leaf shutter. A shutter made of overlapping metal leaves located inside a lens.

lens hood/shade. A plastic, metal, or rubber device usually screwed into the lens filter threads that projects past the front of the lens and prevents stray side-lighting from striking the front of the lens and producing flare.

lens reversing. Mounting a lens on a camera body backwards to achieve high magnification. (Figure 8.9)

lens stacking. Mounting a lens in reverse on the front of another lens to achieve very high magnification (Figure 8.10).

light meter. A device used to measure the light falling on or reflected by the subject to be photographed to determine proper exposure settings.

macro focusing lens. An ordinary lens that has its focusing range extended such that it will focus up to magnifications as high as about half life size.

macro lens. A flat-field lens designed to focus from infinity to magnifications as high as life size without the need for additional extension or other devices.

macro range. Image size on film ranges from life size to about twenty times life size.

magnification. The ratio of the size of the image on film to the size of the object photographed. Usually

expressed in terms of "X," where "X" is the life size. Thus, at a magnification of. 25X, the image would be .25 times the size of the object.

magnification ratio. The ratio of the size of the image to the size of the photographed object.

magnification ruler, ratio ruler. A ruler that, when placed in the scene being photographed, enables the photographer to quickly determine magnification and in many cases the required exposure correction. (Figure 8.3)

manual flash. An electronic flash where the photographer must determine proper exposure settings for the subject using guide numbers, charts, or calculators on the flash unit.

master flash. When several flash units are used, the master flash is the one connected to the camera. When it fires, photocell (or slave) units sense the light and fire the other flashes.

micro range. Magnifications that exceed 20X life size. A microscope is required for photography in this range.

microscope. An optical device used to magnify an object from about 25 to about 1500 times life size.

motor drive, power winder. A motorized device to automatically wind/rewind the film. A motor drive may wind at speeds up to 5 or more frames/second; a winder up to 2 frames/second.

multipliers. An optical device that when placed between the lens and camera body will multiply the focal length of the lens.

neutral gray (18 percent gray) card. A piece of heavy cardboard in which at least one side is a medium-gray color. Used for taking light readings to determine proper exposure.

normal lens. A lens having a focal length of about 50 to 55mm.

overexposure. Giving the film more light than it needs to reproduce the image properly. It generally results in negatives that are dense and prints and slides that are very light, washed out, and lacking in detail.

parallax. The result of the viewfinder and picture-taking lens being separated by some distance. Each sees the subject slightly differently. At normal shooting distances it is insignificant, but when you start getting close, the difference can mean the lens might not even see the subject at all. (Figure GL.1)

parallax error. The difference between what you see through the viewfinder and what the film sees through the lens.

plane of focus. An imaginary plane parallel to the film plane located at the point on which a lens is focused.

PARALLAX ERROR

What you see may not be what you get!

Single Lens Reflex

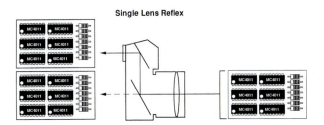

With an SLR camera, you are looking through the picture-taking lens when you compose your picture. What you see is exactly the same as what the film sees.

Rangefinder Camera

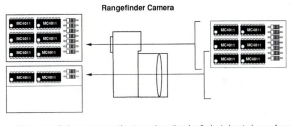

With a rangefinder camera or other type where the viewfinder is located away from the picture-taking lens, what you see through the viewfinder and what the film sees may be considerably different!

FIGURE GL.1

point-source light. Any light source emanating from a single point like the sun, a tungsten light bulb, or flash. (Figure 5.2)

polarized light. Light that has been passed through a filter that only allows light travelling in one direction to pass through it. It helps reduce glare off of water and glass and saturates colors.

range-finder camera. A camera where the viewfinder is located away from the picture-taking lens. Such cameras often use a "ghost image" method of focusing where you must adjust the focus until the ghost image of the subject and the real image overlap into a single image.

reciprocity failure. If exposures are very long, films may not record the image or colors properly unless a further exposure increase is made or filters are used. In some cases, the film may not be suitable for the purpose because of this problem.

reflectance light meter. A light meter that measures the light being reflected off of the subject to determine exposure settings.

reversing ring. A ring that permits mounting a lens on the camera body backwards to provide magnification.

ring flash. An electronic flash mounted right on the front of the camera lens. Originally a full circular flash tube surrounding the lens, but it may consist of two or four smaller tubes that can be positioned at various points around the lens. (Figure 10.2)

selective depth of field/focus. See "isolating the subject."

short-mount macro lens. A special lens designed especially for high-magnification work. Requires a bellows to focus. (Figure 8.12)

shutter. The mechanism that allows the light into the camera to strike the film and expose it, and controls how long it strikes the film. May be an overlapping leaf type or curtain (focal plane) type.

shutter speed. The length of time that the shutter remains open to allow light into the camera.

shutter speed dial. A dial used to select desired shutter speed. May be buttons and digital readout on electronic cameras.

Single Lens Reflex camera (SLR). A camera that uses a series of prisms and mirrors allowing the photographer to look right through the picture-taking lens and see exactly what the film will see.

slave flash. A flash which is triggered by a photocell unit when the unit detects the light from the master flash unit.

slave unit. A photocell device a flash unit is plugged into. It triggers this flash when it detects the light of another unit (usually the master flash).

spot meter. A reflectance light meter that measures a very small angle (1 degree), which allows very precise meter readings from small areas within a scene.

stacking ring. A metal ring that permits two lenses to be screwed together by their filter threads. (Figure 8.10)

stopped-down metering. A light metering method that allows the internal camera meter to determine exposure when the aperture is closed down (normally, light metering is done with the aperture wide open).

telephoto lens. Lenses having focal lengths ranging from about 70 to 2000mm.

transillumination. A method of lighting where the subject is lit by light passing through it rather than reflected off of it. Slides are viewed by transillumination lighting. (Figure 9.9)

tripod. A three-legged device used to hold a camera steady.

tripod head. The top part of the tripod that the camera is attached to. It may have several joints or a ball to allow positioning of the camera in many different attitudes.

TTL. Through The Lens.

TTL Autoflash. An automatic flash system that uses the camera's Through The Lens (TTL) metering system to control the duration of the flash for proper exposure.

TTL metering. Any internal light metering system that takes its reading using the light coming through the camera lens.

underexposure. Giving the film less light than it needs to reproduce the image properly. It generally results in negatives that are lacking density and contrast, and prints and slides that are very dark, "muddy," and lacking in detail.

viewfinder magnifier. A device that clips or screws into the viewfinder that magnifies a portion of the focusing screen to make fine focusing easier.

vignetting. The intentional or unintentional blocking out or shading of part of an image while exposing the film. Intentionally, it may be done using special cutouts or objects held or placed in front of the lens (Figures 18.12 and 18.13). Unintentionally, it is usually caused by lens hoods or filters that are too small in diameter, or by too many being used, and appears as darkened corners in the image. (Figure 7.2)

wide angle lens. Lenses having focal lengths ranging from 6mm to about 35mm.

working distance. The distance between the front of the lens and the subject. (Figure 2.3)

zero extension magnification (ZEM). Some lenses and magnification methods such as short-mount macro lenses and lens reversing provide magnifications near or greater than life size without the use of any extension. I call this base magnification "zero extension magnification." It is used in calculations of total magnification when these methods are used.

zoom lens. Any lens in which the focal length may be varied over a finite range.

BIBLIOGRAPHY

Paine, Sheperd, and Stewart, Lane. *How to Photograph Scale Models*. Milwaukee: Kalmbach Books, 1984.

Planck, Rod. Latow Photographers Guild Seminar. Unpublished seminar notes. Burlington, Ontario: March 1994.

Shaw, John. *Close-ups in Nature*. New York: AMPHOTO, 1987.

Shaw, John. *The Nature Photographer's Complete Guide to Professional Field Techniques*. New York: AMPHOTO, 1984.

Stroethoff, Pieter. *Photography for the Scale Modeler*. New York: Drake Publishers, 1975.

West, Larry. Latow Photographers Guild Seminar. Unpublished seminar notes. Burlington, Ontario: March 1991.

White, William, Jr. *Close-up Photography*. Kodak Workshop Series. New York: Eastman Kodak, 1984.

Wright, Catherine. "Macro Photography," Mohawk College course. Unpublished class notes. Hamilton, Ontario: Spring 1988.

Zorn, Maria. "Nature Photography," Mohawk College course. Unpublished class notes. Hamilton, Ontario: Fall 1987.

Zorn, Maria. Nature Photography workshops. Dundas, Ontario and Ontario's Bruce Peninsula: 1988–1992.

PLANS

Lewis, Dan. *How to Build Your Own Photographic Equipment*. New York: Images Press, 1992. Plans for the homemade focusing rail and many other pieces of photographic equipment.

Rattlesnakes (Figures 18.26 and 18.30) were photographed at the:

American International Rattlesnake Museum
202 San Felipe Street, N.W.
Suite A
Albuquerque, NM 87104–1426

Nature photographers' guidelines and ethics available from:

Photographic Society of America
3000 United Founders Boulevard
Suite 105
Oklahoma City, OK 73112–3940

Scratchbuilt aircraft models (Figures 1.6, 9.8, and 15.2) built by John T. "Jack" Constant and now part of the Canadian National Aeronautical Collection in Ottawa, Ontario, Canada.

INDEX